I'M 30

Now What?!

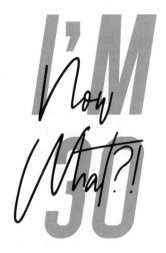

I'M Now What?! 30

A Woman's Guide To Living A Life Of Choice

BY KY-LEE HANSON

contributing authors:
Supriya Gade, Andrea Lampe, Amy Rempel,
Boryana Hristova, Chloe DeVito de Concha, Christa Pepper,
Erin Filtness, Jessica dos Santos, Jessica Gardner, Karem Mieses,
Katie Rubin, Kelly Rodenhouse, Lisa Mallis, Natasha Manchester,
Nichole Cornacchia, Nicole Singh, Saoirse Kelleher,
Shannon Figsby, Sherri Marie Gaudet, Kim Santillo

Published in Canada, for Global Distribution by Golden Brick Road Publishing House Inc.
www.goldenbrickroad.pub

FOR MORE INFORMATION EMAIL: KYLEE@GBRPUBLICATIONSAGENCY.COM
ISBN: trade paperback 978-1-988736-15-0
 ebook 978-1-988736-19-8
 kindle 978-1-988736-16-7

To order additional copies of this book: orders@gbrph.ca

TABLE OF CONTENTS

BY KELLY ROLFE

FOR AS LONG AS I CAN REMEMBER, my mother always said, "Wait until you live through your thirties, it has been the most incredible decade of my life to date." She would often refer to this as the decade where one is free from the internal battles with social pressures, body image, relationships, career, motherhood, and any other seemingly important topic in life. I used to roll my eyes at her. Since entering my thirties, I hear her voice in my head all the time. She wasn't wrong. I find myself feeling at peace within myself and if I am not at peace, I am comfortable enough with change to follow my heart. There is something so freeing about reaching a point in your life where your focus shifts from needing approval from others to suddenly needing approval from nobody but that beautiful face looking back at you in the mirror.

When Ky-Lee and I discussed the possibility of this book, we envisioned it as being sarcastic and humorous while dissecting the serious topics and similarities of being a woman in her thirties. This book did not come to fruition in the way it was initially thought of; there isn't as much humor as originally envisioned however, there is an abundance of knowledge and wisdom from a diverse group of beautifully empowering women. Being a woman in her thirties in 2017 isn't easy, but shit we surely have so much to be thankful for! We are stronger, bolder, and more independent than generations before us. We have the freedom of choice. We have the courage, tenacity, and determination to follow our dreams. We are on the rise as entrepreneurs and business owners. We juggle so many roles at once and do so with grace, class, and success. The women showcased in this book are raw and authentic and share their journey with you, the reader, with nothing but hope to inspire and guide you to continue kicking ass at being your authentic self.

I'm 30, Now What? will capture your attention from cover to cover.

As you read through the sections you will find yourself immersed in the celebrations and challenges of being a thirty-something woman. As discussed in section one, millennials are viewing family and parent-hood differently than the generations before them. Becoming a wife and a mother is a personal choice. Let these ladies squash societal expectations on what "should be" and help you validate yourself in whatever decision you make regarding your life. Let them share their experiences with you and shower you with the belief that there is no right or wrong choice when it comes to you taking on a life changing role. From there, section two and three are bound to be relatable to each and every one of you. These ladies are going to guide you through accepting that though life doesn't always go as planned, you can still learn to celebrate the beauty that unfolds when you appreciate the many opportunities you have received from life. They are also going to make you feel all the feels. Women just get it, you know what I mean?! They get that we have so much pressure ingrained in us from such an early age to be, act, dress, speak, and perform a certain way. These women are going to inspire you to overcome obstacles and expectations and just do and live life your way. Ladies, this book is going to take you to a place where you say f**k that! This book is going to make you appreciate that you are in charge of your own life. As a thirty something woman, you are wise enough to take life by the balls and make it your own. As you move into sections four and five, you will discover that being in your thirties is not always easy. It's not always pretty, but you will survive. These sections will take you through self-exploration, self-discovery and facing yourself. Often times, we have to go through our hardest times to discover our most rewarding times. These sections will guide you through that process. You will feel uplifted and empowered to face any adversity currently standing in your way. You will be shown that you are strong enough to get through anything, follow your dreams, change your mind, and change your life. You will be encouraged to rediscover who you are and who you want to be instead of who you've been elected to be or who you're supposed to be. Change can be scary and can throw you into the

depths of the unknown, but change is constant. Why not learn to be in charge of it? Why not learn to embrace it? Why not learn to view it as an opportunity for growth? Let this book take you to a whole new level of yourself. Let this book inspire you to be vulnerable with yourself, set goals, smash the shit out of them, and be proud of who you are. Although this book is not what we once thought it would be, it is truly incredible. I am so grateful to be part of it. I am truly grateful that Ky-Lee asked me to write this foreword and I am truly grateful to have the honor to be in the company of such incredible women.

FB.COM/KELLY.L.ROLFE | IG: @MAMA_GETS_FIT_AND_FAB

Preface
BY KY-LEE HANSON

THIS BOOK CAME INTO FRUITION when one of my contributing authors, Kelly Rolfe, from *Dear Stress, I'm Breaking Up With You* and the second volume, *Dear Limits, Get Out Of My Way*, and I had a talk about what to write next. Kelly also wrote the foreword for this book. She said it would be great to write for our age group. We have a sense of organized chaos at this point in our lives. She was saying how comical, depressing, and straight up weird the dating scene is now for our generation. I assume this is because half of our generation met their significant others in a traditional way, while half met in the online world, and the ones still "searching" are lumped into "abundance" to put it nicely, as literally millions of people are at your fingertips. I thought this book concept was a great idea, but for me, I have been with my spouse since I was a few weeks shy of age 20. I couldn't relate to her experience, but I was ever so curious about it and I could share from a different perspective thus making the book relatable to many! We decided that a blend of authors would talk about where they are at in life and how things look different from where we all thought we would be and where society required us to be. To share the diversity of our era and the 180 degree turn that most of us do when we hit the pivotal big 3-0. Naturally, this book took on a voice of ITS OWN and is the farthest thing from a dating book, *or maybe it is actually a perfect book for dating and relationships as it is all about the relationship with one has with oneself.* It is about finding ourselves and living as ourselves. We approached this book looking for humor, sarcasm, and real "not-perfect" stories, however, what we got was even better; a mix of realism and optimism filled with honesty, facts, realizations, and women being able to laugh at themselves. As much as this book pulls on heart strings, it will also make you feel understood, at peace, motivated, and happy.

The title *I'm 30, Now What?!* comes from a video blog (vlog) that I never produced. When I turned thirty, I was happy. I was so done with being in my twenties. Then I realized that I still had no idea about what I was doing, but decided to stop judging myself for that... it was a pivotal moment for me to realize that I DESERVED to figure it out. It was time to start living this life for me, and nobody else. It was time to stop thinking I had to be like everyone else and fit into society's mold; maybe I could actually have fun and enjoy life if I got rid of some baggage and pressure. So what if my education wasn't a traditional 4 year study in one field? It doesn't mean my combined and diverse education makes me anything less. So what if I don't have a crippling mortgage or 2.2 kids? I am not incomplete without these things. Each person is an apple to an orange. The release of the toxic brainwashing and conditioning that happened was intense! It was almost too much. To get clear on what I wanted in life, and what I was worthy of in life; it was like hitting my head against a brick wall. Finally, I did break out of it and I found the ability to laugh at myself, spend time with myself, and learned that I was my own best teacher. I found independence, I found solace within in myself, and I was proud and excited to be ME – finally!

How did I find confidence? A quick summary includes: a lot of self study, a lot of questions, a lot of detoxing my emotions and thought patterns, a lot of trying new things: classes, courses, jobs, businesses, travel, circle of friends, belief systems, etc – failing and succeeding and then changing course. You know – living and exploring, instead of simply existing on auto pilot. I found gratitude, yet there is still so much in life that I need to master. Turning thirty helped me realize it is okay to try, yet mess up, and then start again; it is part of the process, not the be all end all. "Reinvent yourself" – wow, doesn't that sound exciting and fun! I fell in love with growing, learning, and sharing – that is what this book is about, *for* and from all of the amazing authors. This book is going to tell you 20 stories from 20 women, filled with tips on how you are RIGHT to make your own choices; to design your own life. There is no "guide" to our thirties, but there is plenty we can share with each other. We can map out our own

adventure and change course when we see fit. Read our stories, listen to our organized chaos, feel our perspectives, and develop YOUR OWN guide to your life. We hope to provide you with inspiration and understanding.

FB / IG: @GBRPUBLICATIONSAGENCY
JOIN US: WWW.GBRSOCIETY.COM

Introduction

BY KY-LEE HANSON

WHILE GATHERING AUTHORS FOR THIS BOOK, we found women aged twenty-six to forty-five highly interested in the concept with even a few younger and older women pondering this stage of life, and how different it looks now. What I also found is how different people under age thirty and over age forty are from us. I am still wondering if it has to do with the "number attached to us," or if it was something significant about being born within a handful of years in each direction surrounding 1980. We get to age thirty, and society has laid out clear expectations of this decade. For women, apparently your clock is ticking not only to have babies, but for career and love! As if there is a bomb attached to love or something? If you haven't found it by now, it's dead for you. "YOU ARE PAST YOUR PRIME!" *Rolls eyes* oh okay society... So, I was curious to know if women are terrified of this number as that seems to be the stigma I grew up in. I was curious to know how other women currently aged thirty to forty were embracing their lives given all the changes and options we now have. *I'm 30, Now What?* is a book of stories, realizations, and essentially coping mechanisms from women all over the world who are currently in their thirties. We have all lived different lives in different places of the world and amongst different cultures, but the common thing we came to find is, our generation has experienced that life does not look how it used to for this decade, and moving forward, it will never look quite like this again. The younger generations have shifted back into traditional ways in some sorts and Nicole Singh will tell you all about "helicopter parenting" in her upcoming chapter *Expectation De-Generation*. The year is 2017, those born between 1987-1977 are in their thirties. 70% of these individuals are pegged as Millennials, which to most of us "Millennials" seems odd. It seems as though in the media they refer to Millennials as being slightly younger than we are, which is actually Gen Z. Multiple articles written in 2017 refer to

Millennials as currently aged seventeen to thirty - umm, so confusing. Professor Cary Cooper, of Manchester Business School, said that the term "Millennial" had become meaningless because it encompassed too many different groups.[1] The thing is, both my generation and the younger generation have been lumped together. *I guess we are a new world?* What I have found amongst both my generation, as well as the younger generation is a great sense of uncertainty with *where* exactly we fit. Growing up, my teachers would tell us that we are "the lost generation" - the babies of the 80's born during a time of immense change and not having a definitive identity. We just blended into a long drawn out generation of x-y-z. I grew up in Canada. By the time I'm old enough for it - pension reserves will be gone, Gen X ahead of us programmed all our jobs away, and boomers are literally grandfathered and grandmothered into jobs, not wanting to retire. Our environment (Earth) left in a state of disparity, and most of us were thrown on ADD or ADHD meds or anti-depressants as the older generation did not know how to deal with our sense of creativity; our drive for change. We did not have a life handbook titled, "Meet A Spouse, Get Married, Have Babies." We more so made up our own handbook titled, "Everything Before Us Was Wrong." We were more free to choose, and a lot of us did not choose a traditional home life or traditional career. Not that we had neglectful parents, but it seems that the women in their early thirties right now had progressive parents, a bit "hands off" parenting - parents were like friends to us. People my age should be the doctors and lawyers of today, but we aren't. We spent our younger years partying and traveling, while some of us went to school, yet many of us were changing career paths before they even started. By the time our parents were our age - they had kids, a home, and a job they would stay in for most their life; if not, for all of it. We are the gener-

[1] Rudgard, O. (2017, July 05). *Don't call us millennials': Majority of young people say term does not represent them.* Retrieved from http://www.telegraph.co.uk/news/2017/07/08/dont-call-usmillennials-brains-dont-change-decade/

ation that thrives on change and personal development so that we can lead fulfilled and purposeful lives. We are the "work hard, play harder" generation where we do not want to be shackled by a rat race of the "9 to 5," but want to work from the comfort of our homes, or a cafe, or essentially wherever our laptop currently is. We enjoy working in careers where we are offered mobility, flexible work schedules, and unlimited opportunities for personal and professional growth and development. If these opportunities are not provided to us, we are not afraid to walk away and pave our own path by saying yes to newer and more riskier opportunities. Our personal lives also follow a similar pattern in relationships, or even friendships. We are the generation that does not design our lives around our work, or the people in our lives, or even their expectations of us; rather, we create our opportunities so that we can live a life of choice and design. Older generations have the audacity to say we are entitled. We are the generation of dreamers AND settlers with no real identity to an era; what else do we have to work with? What does society expect of us? All we can do is hope, or settle. I'm not sure how that is "entitled." We have become the generation to not "start," but TO PUT IN PLACE diversity and self discovery. We do not identify or seek to identify as one specific collective, era, culture, or way of life. People can be their own individual, they can dress how they like, they can embrace their culture, love who they want to love, they can create their own dreams and who are we to say any different. I think this is why the younger generations are even more free because we lead with embracing diversity. There is no one size fits all method. We aren't programmed and we aren't scarce minded. We were lost, to figure it out on our own. We have been propelled to become the leaders of our own lives. If that is entitled, well so be it.

WHY IS 30 SO PIVOTAL

It comes down to two things:
- Management of your life
- Making choices for **yourself,** not others

These two things are the pivotal changes, or better yet "goals-reached" that happen in our thirties. To lump these together and all aspects of them, it is known as self-love. Maybe you are a mom and have realized your need for self-love, but feel guilty that your kids aren't the only thing you want in life. The same can be said about your career if you are a business woman. It also goes for your marriage. We realize at this time of life what is important to us and what might not be as important anymore, OR not the only thing / aspect of importance in our lives. Historically, women were not suppose to want more.[2] If you have ever watched the tv show, *The Masters Of Sex*, which is an American period drama that takes place in the 1950's-1970's, they were studying the female orgasm and sexual pleasure, and completely dumbfounded around it all. Really... only fifty years ago it was foreign for a woman to enjoy sex - no joke. We didn't see women in the same roles then we see them in today either. This was really not that long ago. Our parents were alive and when they were children, in the USA women of color were still segregated to "colored" washrooms and the back of the bus. Women stayed home, ran the house, and tended to the children; it was rare and has made history if a woman did otherwise. A great book and also historical movie based on a true story is *Hidden Figures*. Our generation is the first to actually have equal options around lifestyle, careers, and babies, still with judgement, but we have made it a new normal. And it has taken until our thirties to really see it; for it to be an accepted way of life. As a child, my mom ran her business. She was a source of strength for me, and I didn't realize it was so uncommon until later in life. My dad is First Nations, and I did feel stigma, racism, and segregation when I was young as being half First Nations prevailed over my Caucasian heritage. Not that it was a "bad" thing, but we were segregated and had a "special hour" class where only the First Nation children were taken to a room to study

[2] Cohen, Nancy. L (2012, February 05) *How The Sexual Revolution Changed America Forever.* Retrieved from http://www.alternet.org/story/153969/how_the_sexual_revolution_changed_america_forever

different material. Yes, a "special class." As I aged, I religiously dyed my hair blonde and emerged myself in ONLY white, western ways. I had zero interest in being categorized, yet looking back, I was trying to fit into the "easy" mold. I don't hold shame or regret for doing so, but I do plan for my future to be different; to embrace my diversity. But, that is a whole other book.

I also remember being quite aware while growing up that boys always did have more options than girls. When my gal pals looked for work, they got babysitting and food service, yet boys could do both of those plus anything else they wanted. I remember a few girl friends and I got a painting job with a local construction company; all the girls never received a pay check, all the boys did. I remember my best female friend getting bugged for working the kitchen at the local fast food place - only the boys worked *that* position. As well, we weren't allowed to do closing shifts without a boy or man on shift. *Why do women need to be protected? Why do men need to protect us from other men?* I also remember almost every single guy I can think of going to further his education and many receiving grants related to sports. I do not remember us girls having these options and if a girl did, she was a "tom boy." Later in life, I took a YMCA *Entrepreneurs Under 30* program and was 1 of 2 girls in the entire class, the same went for a business management course I took. This was during the early 2000's - not the 1950's, yet it was still somewhat uncommon to see women pursuing non-domestic related careers.

Earlier this year, I learned about the 3 Percent Conference and movement. Until recently, only 3% of women were in high powered Fortune 500 roles in corporate America. That has only slightly shifted; it is not much, but it is something. Only 7% of air pilots are women for example. We have, however, made waves in home based business models, start ups, and creative work. There is still a need for women-only tech groups, women in business support groups, female-only entrepreneur networking and support groups - as we really do need to support each other when sometimes it feels easier to give up. We must achieve more for our gender globally. In our western

society, and in first world countries we have choice, we have to flex that "choice muscle" for all the women who do not have choice in this world. The more we do it, the larger its impact on a global scale. We have started to see a glimpse of hope for global equality, but we are still extremely far from that mark.

IT IS SELFISH NOT TO PUT YOURSELF FIRST

If you are not putting yourself first, I assume you expect someone else to? You may not even be aware you are doing so. I wasn't aware when I was doing it. Your boss, your kids, your spouse, your friends? Why aren't they planning a surprise for you, why don't they ask you how you are doing, why don't they go out of their way for you sometimes? Why don't you get the leadership and opportunities from your boss that you want? Shouldn't she / he realize your potential? Well, let's ask this instead - are YOU doing any of this for yourself?

I see a lot of people waiting for opportunity instead of creating it. I see a lot of people wanting others to invest in them, yet they do not invest in themselves. I get requests from people who want to be published authors, yet they have done nothing in the field; you cannot be a guitarist without a guitar, songs, and practice, so how can someone expect to become a successful writer or business person without first investing in themselves... It doesn't make sense. We set the tone for how people treat us. What example have we set? People judge and learn by actions, not intentions. We have to lead the life that we want. We have to actively do so for opportunities to come our way and to start living the reality we imagine for ourselves.

This book will share with you that it is okay if you do not feel fulfilled - there is NOTHING wrong with you. There is room for more. You are allowed to want more, handle more, and not feel guilty about it. Be a passionate woman. Being YOU, and growing yourself does not have to take away from your career or family, you may find that it will strengthen your relationships. It may just strengthen everything we are working for.

LET'S SET THE TONE

THAT FEELING WHEN YOU'RE SUPER SICK
AND YOU WANT YOUR MOM...
BUT THEN YOU REMEMBER YOU ARE THE MOM,
AND NO ONE CARES.
provided by Shannon Figsby (Chapter 17)

Scenario: Making Monday (or other) night is ME time; bath and relax.
Possible Problems: At first, husband is going to interrupt with a million questions about dinner, kids are going to climb into the bath, cat is going to scratch at the door, colleagues will be emailing and calling non-stop wondering why they can't get through, roommate blasting music, etc.

Reality: Probably some of the above, yet **following through** is key. After a few weeks of this, by creating this habit, others will fall in line and it is now routine. People will flex and work around change, it is just never instant. There are growing pains in us and amongst others every time we try to grow in a new direction.

Outcome: The husband and kids, or boyfriend / roommate / colleagues, etc may take this time to fill their own cup too. They begin to know you are not available on Mondays, you do that (whatever your "that" is) on Mondays. If you set the standard, if you set the time, you are setting the tone of how to be treated. It will rub off on other people.

Truth: If you don't do any of this and continue to cook clean, do laundry, and crash into a wall every Monday evening, that sets the tone too. Your environment currently expects that of you. You set that tone. You can also change it.

MOVING ON

Wow, moving on becomes so easy at this point in life. Choices made, next! We have a lifetime ahead of us, yet so many dramatic lifetimes already behind us! Luckily, those times are going to stay back there, at this point, old habits are a thing of the past. Over it! At this stage,

we move on from obsessing over our skin, obsessing over what people think, we move past high heels on the regular, we move past the constant clubbing and need to be social – we find ourselves and realize she is our best friend. Why did we keep her trapped under all this false garbage for so long? We stop dreading the grey hairs and embrace them. We love our healthy weight and no longer see it as fat. We embrace ourselves and learn what else we have to offer. We move past the need to satisfy the expectations others have of us. We will career how we want to career, and we will mom how we want to mom. Right? Um... Maybe it's not yet that easy for all of us. Easy – what does that even mean? What in life has ever been easy or became easy? Give. Me. A. Break. So, at least we know we have all been in the same place of struggle in some way, shape, or form. Struggle for self identity mostly is what we are going to chat about. It's hard to be ourself in a cookie cutter society. None of us want to be forced into a box, yet we are programmed to desire exactly that – a 9-5, kids, with dreams of romance and a yearly "approved" vacation, repeat.

Snore. Namast'ay in bed.

That kind of life is not for me. I choose to live beyond the cookie cutter mold. That is what this book is about. Women making their choices, but let me be honest, it is easier said than done. A good place to start would be by aligning yourself with the right 9-5, the right environment, the right things for YOU, and realizing that now is the time to make changes where you aren't happy. You can raise your kids how you want to raise them, and that vacation and romance does not have to be a dream - it can, and should be your reality. This is about CHOICE and programming your life as YOU see fit. Life can, and will change in an instant, but the good changes need your help. They don't just show up. They only serve those who ask, struggle, grow, and show that they deserve it. Know your worth, yet also know your need for growth.

The key is that you are your priority. Your kids, your job or business, your spouse ALL need you, but they need a happy, fulfilled you - not an empty and lost version of you. Sorry, but you need to come first.

Even as a mom, there will come a time where your days go back to being only about organizing you, or as a wife I hate to say this, but what if it doesn't last? Or as a bosswoman, your industry interest might change, or your company may grow to a size where you are less needed, meaning you actually get some time off. If you devote yourself only to outside things, who are you going to be when that day comes? Who are YOU without the title of wife, daughter, mother, or boss? Maybe the unique SHE should never be put on pause.

Instead, she should be nurtured as much if not more as everything else.

SECTION I

My Purpose Isn't "Just" A Man, Nor "Only" Two Feet Tall

Featuring
Boryana Hristova, Sherri Marie Gaudet,
Erin Filtness, Chloe DeVito de Concha

OPENING COMMENTARY BY KY-LEE HANSON

Section 1 Opening Commentary
BY KY–LEE HANSON

CAN YOU HAVE A PURPOSEFUL LIFE with, or without a family? Many people, both men and women, view having children as the purpose of life, which is okay, but for some of my authors and myself, we disagree. Society has also led us to believe happy kids and functioning adults only come from marriage (be that from a happy marriage or not, as long as it is just not a broken home). For some bizarre reason, women are led to believe that they are incomplete without children, and a man. The purpose of life, to me, is to share life with others.

Can we achieve this "purpose" outside of sharing life with our children and spouse? I know the answer to be, yes.

I see "life" as an exploration. Why am I human? And what can I learn while here? What can I teach and share with others? What can I learn from them? What can I learn from this earth and all the experiences it can and is willing to present to me? I think that is bigger than simply having children; having children is one part - one option - of this exploration. There are many ways to venture, many experiences to be had. There is just not only one. So, this brings us to the title of this section *My Purpose Isn't "Just" A Man, Nor "Only" Two Feet Tall.* FIRST, let me address, this section is not anti-kids nor full of Hansel-and-Gretel-like witches and furthermore, it is not full of man-hating, self-righteous feminists. *Side note - that is not what a feminist actually is, but I am using the description for stereotypical emphasis. I am obviously a feminist, just not what we have been stereotyped as.* There are both mommies and not mommies, independents and married alike in this section, and ALL are addressing the topic of how important YOU are, and that YOU DO HAVE CHOICE around these social conventions.

What we want to help women realize is, you only get one shot at YOUR life, *but* you can live many ways within this life. Here is the key

though, those many ways do not have to be one after the other, you can be *many* all at once! If you do have kids, your child has you involved in their life and they live their own life, you need to live yours also and not just theirs. What happens to you when they leave the nest? Did you develop your life alongside theirs or INSIDE theirs. What have you done lately for YOURself and YOUR future? For some of us, we have an empty nest, it has always been empty, but we like it that way. Some of us want it filled one day, and some of us have it filled already with kids, or in other ways. There is nothing wrong with a childless woman, it does not stem from fear or having lack of purpose, nor does it mean they have more purpose. Each story is different.

How can we achieve "purpose" in other OR multiple ways? As women, most think children first. Does family *need* to be blood? Or can you *choose* family? Can purpose be found through mentoring, adoption, opening your doors to neighbors, starting a business and helping people achieve their goals, being a role model, nurturing animals and the earth, sharing and educating - how about listening? How about sharing happiness and gratitude? I feel there is potential for purpose all around us, not only coming from our uterus... Not ONLY what we physically create, but also from what we can influence.

Moms seem to live in a type of organized chaos. They are strong! Stronger than a childless woman - no - just a different kind of strong. There is no way I am getting up at 4am to deal with a crying baby. It just isn't happening. My chaos is keeping myself sane, happy, and influential to a world of people while growing many businesses. That is enough for me. I am trapped inside 4 walls all day long nurturing a career, clients, an image, and a big purpose in life. Just as a mom is, but her attention is focused on one (or multiple) little fireball(s) of energy. Do some women do both, yes. Could I do both? Sure. Would I enjoy it? No. That is okay to say. This book is about sharing perspectives honestly and helping each other see things in multiple ways. With this, we have a greater understanding of the human condition and inturn, a greater understanding of ourselves. Could I run my company as well as I do if I had kids? Maybe... if it were up and running, and planned out

strategically already. But it feels like it is a baby to me... it cannot take care of itself. It requires undivided attention, long hours, and sometimes I have to do things I do not want to do. However, if I were to be raising children while building this company, since I do work almost 100% with women, my position would never be jeopardized due to having kids as it could be in a man's world, instead it would be understood. This is why my passion in life is to create female leaders in business. They have what it takes and what our society needs from leaders. I feel a business [just as kids] is a huge priority. Both require constant attention and some self sacrifice. Some of my authors will help you find balance in the organized chaos of having both kids and a career, and some of us will nurture just one side. And for those that do not believe in the theory of balance, you CAN still thrive in many areas even if it's going back and forth between things - dropping one task or responsibility to pick another up unequally, and sometimes flying by the seat of your pants in a very imbalanced way. Yes, you can still get done what needs to get done without losing yourself.

We cannot say all women our age choose not to have children, choose not to buy a home, choose to work equal to men, etc. We cannot say we were the first, or the last to be this way. We can say though, there is not only one way to live. There is no cookie cutter model that works for everyone. We can say, however, that we are the generation to prove that.

CHAPTER 1

I'm 30, Now I Have To Be A Housewife

BY BORYANA HRISTOVA

"History repeats itself. Therefore, the past is the best teacher."
~ Unknown

BORYANA HRISTOVA

WWW.IWCONNECTED.COM
WWW.ABC2GROUP.COM
IG: @BORYANAH
T: IWCONNECTED
IN: BORYANA-HRISTOVA

Boryana Hristova accomplished her master's degree in journalism and mass communication from the University of National and World Economy in 2007. She works for bTV (a Bulgarian national television channel), attends classes at the Bulgarian business leaders forum, and also works with the Sofia Music Enterprises' team, organizing concerts for world renowned artists and musicians.

Her love for travel and adventure led her to become a flight attendant for Bulgarian Airlines, which is how she met her husband. Boryana's life as an expatriate wife challenged her to settle and live away from home in Slovenia, Austria, and later in Turkey. Despite being a mother of two, she spends her time writing articles for different online websites, travels frequently, and always seeks to learn more. Through her travel, Boryana built a global network for herself. This ignited an idea within Boryana – to establish a multi–city digital and real-life business platform for women. Several months later, the platform – iwconnected.com launched in the U.K, Australia, Austria, Turkey, and USA. This platform consists of a community for every city, a business catalogue filtered by location and occupation, separate online magazines – IWL, IWS, IWI, IWV Magazine and access to IWConnected events.

Boryana's passion to support and help those around her propelled her to cofound the company A.B.C Communications Group with her university mate Anna Yaramboykova. Together, they work as life balance and business coaches for corporations, as well as high performing executives.

Boryana currently lives in Istanbul, Turkey. She travels the world expanding her business, meeting incredible people, and building her own future, because "motion creates emotion."

WHEN I WAS A LITTLE GIRL, I used to spend my summer holidays in the courtyard with my grandparents. There in the small house, surrounded by the fields and other small houses, my grandmother used to give me some domestic work. She believed she should be the female role model to me, and she required me to follow her strict instructions on how to become a good housewife. Every time I accomplished my tasks, she would look towards the sky and say, "Hey, Prince! Did you see how nicely my granddaughter washed the dishes? She is a hardworking girl. One day, you can make her your wife!" She was telling me that there was the perfect man for me somewhere in a chopper above our village who was searching for his princess. My granny's imagination was spectacular, I must admit. But this story is not about her, nor is it about me. It is about free choice.

The pressure women face nowadays is extreme. If we decide to have a career, or a family, or both, there is always somebody to point their finger at us and ask why. Having a family especially after thirty, is a common obsession not so much among the women themselves, but society. Not having a family by the time you are thirty is a choice. And everybody has this choice. At the age of thirty and above, we need to realize that everything we do, every single day, is our personal decision, and it is up to us to decide how to structure our lives from now on. Women in this situation should stop playing "the victim of their circumstances," and organize their minds to work for themselves. Not for others. If we try to satisfy our parents, or friends, and always try to blend in society, we risk losing our identity and freedom. Not settling for less is a choice; not being a 24/7 housewife is also a choice. A woman over the age of thirty, who is not married should feel good enough in her own company, in her own skin. Being a successful professional, or a caring mother is a matter of our free will, which modern women need to understand. This is a conviction that comes from within. It is only when we are comfortable with ourselves inside and out, that we will be able to command the respect and appreciation we deserve from society.

Let's start from the beginning. Let's take a look at the Bible. There,

our life is strictly summarized and explained. The values we should follow are very clear. We are supposed to love, appreciate, help, understand, and cherish each other. We should live as brothers and sisters, and must take care of each other, existing as one. We are supposed to establish and accumulate true friendships, and create decent sized families. I believe that at a certain point, maybe people from the past used to do exactly that. Maybe they were more successful in their family bonds than we are today. The fact that divorce rates today have increased exponentially than the past speaks for itself.

The poorer and smaller regions are famous for their stability in family bonds, mostly because there is not so many other things to do there. The word "family" is sacred and no matter what, people must stay together. The idea of divorce does not even exist. I cannot say this is the right way, but nor is it wrong. To be able to feel the stability of your parents staying together is absolutely priceless. Nevertheless, husbands and wives who tend to keep their problems away from their children create an illusion of never-ending perfection. Being a child in such an environment could help in the early years, but definitely as grownups we know there is no such thing as perfect individuals, and we feel as though we were lied to. Conversely, living in an unstable environment without care, love, and support, having parents who constantly fight can bring the worst out of a child. The patriarchal model's values are very clear and must be followed strictly. The father is dominant - he is the breadwinner, and takes care of the financial aspect, while the mother is the homemaker, the caring one - in many cases, she is not well educated and has no right to work outside. Her job is to give birth, and devote her attention to the new generation. To have a successful marriage, in many cases, means to get married young. When you meet your partner when you are both eighteen to twenty years old, you grow up together and get used to each other, so no matter what happens, it cannot tear you apart. You unify your expectations from the beginning, and you grow and develop together, as one unit. Additionally, you are both guided by the older families such as your parents - you always have a solicitor to get advice from, and you are never left unattended,

more or less like the suitcases at the airport.

As women, we try our best to multitask and achieve the impossible; being at work on time, being at home all the time, so nothing is missed and everything is perfect. In our delusional dream for the glamorous knight on the white horse, we have lost, and still lose so many other opportunities. Especially when we deny ourselves our own rights, which we started to take for granted. We have many examples where women are ready to deny their own skillsets and identity in the name of just being married, and being called "wives." Even if we call ourselves new generation divas, there is nothing much left in terms of freedom and capability outside.

Let us take into consideration what women's rights stand for according to Wikipedia.org:

"Women's Rights - the rights and entitlements claimed for women and girls of many societies worldwide, and formed the basis to the women's rights movement in the XIX century and feminist movement during the XX century. Issues commonly associated with notions of women's rights include, though are not limited to, the right : to bodily integrity and autonomy; to be free from sexual violence; to vote; to hold public office; to enter into legal contracts; to have equal rights in family low; to work; to have reproductive rights; to own property; to education."

Female emancipation is a turning point of the world history. Women achieved the right to live equally as men. They achieved the right to have a life. They were still running their families and doing everything needed in the best interests of their children. They were respected by their partners, which led to dividing the job at home. I must admit that by working outside the home, women are still highly respected and get a better attitude from everybody, not only their closest ones. Nobody said it is easy to take care of your family, raise your children, and go to work - all in one lifetime. Especially when we are aware that we cannot achieve it all at once. No matter how far we have

come today, the truth is that it is still a man's world. A report of the EU for 2015 says that working women inside the EU get paid 16% less than men in the same field. Women have still been discriminated against for their desire to have children. Questions such as, "Do you plan to get married and get pregnant in near future?" asked by the employer are very common nowadays. Women, of course, are aware of that and due to a lack of other opportunities, they feel pressured to climb the professional ladder equally with men, bearing in mind, that this is never going to happen. The clock is ticking, we take the burden of all the social pressure - an unmarried woman after thirty is like a dead end. She pushes her hardest at work, and struggles to meet everybody's expectations regarding her personal life as well. The question of getting pregnant anytime soon is even more frustrating when you hear it from your own mother saying, "At your age, I already had two children, and you were both going to high school!" Being unmarried above the age of thirty is like a curse. No matter where we live, despite our other achievements - this is still an issue. You acknowledge it once you see your former girlfriends swinging their engagement rings under your nose and organizing "wives societies" when you meet for coffee or dinner. A random afternoon tea turns to a baby zoo with screaming children. You find yourself in something akin to Alfred Hitchcock's movie The Birds, but instead of birds, there are kids. You start doubting yourself, and ask yourself if you were not woman enough to not have all these boxes checked off, and the worst is when you feel bad, because you think this is the last piece of the puzzle that you need in your life to feel happy and complete. You are aware that the newest generation of hot twenty year olds are coming out every new year. This brings a bad taste in your mouth and you probably start wondering what is wrong with you. The answer is nothing – it is an illness of the society.

Living in a big city with the many opportunities we get does not equal finding a proper husband. Being a modern woman in the capital of any country brings too many fish in your pond. However, none of us women want to marry just any fish. We need to get the big fish. Because the

bigger our fish is, the better our future will become. We have maybe learned our lesson to not settle for less, so we settle only for the best. It is not only about wealth and fortune. For example, in the jungle, the female chimp waits to see the strongest male chimp, because she knows if she mates with him, her offspring will be healthy, protected, and survive all attempted attacks from the chimps from the other tribes. We are not so different. Money means security. A smart man means the ability to make money, which means security. It is very simple. But here is the funniest part, what happens with us women when we get the "Big Fish," and we become a stay at home mom, a.k.a a housewife?

The generator of world's economics is the hard working man. The one who is always on the run with a clear vision, and devoted to his mission to conquer. Man's nature is to be hunter. They need to chase in order to feel happy and completed. This could be everything in the spectrum - power, success, respect, a better lifestyle with better assets. Not every man of course has this kind of a profile. This is a profile of a leader, and all too often, women are attracted to this type of individual. They feel secure, just like the female chimp. The problem is that the female chimp has nothing else to do, but reproduce, eat, sleep, and enjoy her life in the jungle.

The modern, well-educated woman can achieve many other missions and worthy activities. However, we observe something very strange which is happening nowadays. Women who have found their "Prince Charming" tend to leave their career and personal life opportunities for the sake of being with such a man. They prefer clinging on to the successful man who gives them the right to not work, to stay at home and take care of the kids. They lose their own character and identify themselves with their husbands. You will mainly find them introducing themselves somewhere as, "Hello, nice to meet you, I am Tasha, Mr. Johnson's wife." Then silence. How pathetic is this? The sad truth is that the modern woman is ready to voluntarily go back to the kitchen! She has nothing against being used as an asset, and being outside whenever necessary, and staying inside whenever her presence is not required, just like an object. She is left in her big house with housekeepers and

drivers, doing nothing, and caring for nothing; realizing at a certain point that nobody really cares about her either. And after all that, those women are still considered to be "lucky."

Aiming at this kind of lifestyle has been common for women above 3☉. Imagine yourself sitting with your "successfully married" friends, who care for nothing but the latest fashion trends. You spend hours discussing which airlines have the best business class, newest Michelin star restaurants in town, whose babysitter is lazier, gossiping about one another, and whose husband has gifted them the bigger diamond. Endless, empty conversations where you, being 3☉ + , unmarried, and fully dependent on yourself may feel awkward. Those kinds of surroundings may trigger only one question again – *what is wrong with me?* And again, the truth is – you do not have to blend in with such places or people.

At the age of thirty, we need to admit one thing – we create our own reality, and everything in it must be there because we want it. Individuals who are no longer interesting or can only give you a fake feeling of reality, are not people you should want to spend your time with. People who do not appreciate you because you decided to work hard, and chose not to attach yourself to the so called "Prince Charming" should not be among your closest friends. It is our responsibility to create, educate, integrate, and upgrade ourselves the best version of our-selves. To be inspiring role models and motivators for our own children, to be worthy human beings – this is our moral obligation, as much as our initial right.

Throughout the Bible, it discusses the gift of free will – something which we all have. We need to remember that it is our free will, and our own perceptions that matter the most. There is nothing shameful by being a wife and dedicating your life to your children, watch them grow, educating them, and being there for them anytime they need your help. However, there is nothing wrong with being single, chasing your dreams and finding your passions, and making plans for the future either. We have come a long way, and we have the right to choose who we want to be.

No matter if you are married with children, or are single, a crazy multitasker, a mumpreneur, or an "I don't want children" type; they are all totally okay, as long as the choices you make resonate with your inner self, and make you feel happy. Our generation is the luckiest, because we can afford to be both at the same time. We decide which values to follow, and how to combine them so that we can achieve success as well as inner peace and satisfaction. Thirty is the new twenty, we are grown ups with a clear vision of the paths we want to take. To walk, talk, and act with confidence is now allowed. And we are here to show it out loud.

CHAPTER 2

It Didn't Break Me... It Created Me!

BY SHERRI MARIE GAUDET

*"Sometimes, completely losing yourself turns out to be the best thing
to ever happen to you... it allows you to reinvent yourself."*
~ Sherri Marie Gaudet

SHERRI MARIE GAUDET

WWW.LIFESTYLEOFSHERRIMARIE.COM
IG: @LIFESTYLEOFSHERRIMARIE
FB.COM/LIFESTYLEOFSHERRIMARIE

Sherri Marie believes you should always live in the moment. She is positive to a fault, and will always find a way to make even the most boring task fun. She is all about finding the good even in the worst of situations. She loves to have fun, but understands there is a time and place for everything in life. Sherri Marie loves being around her friends, both new and old. She can walk into a crowded room and not know anyone and within a few minutes be found chatting away with a group of new friends. She has always been one who sets her mind to something and no matter how hard it is, will find a way to accomplish it.

Although she didn't always know what she wanted to do when she grew up, she always knew that she wanted to be someone who helped people. She was always a risk taker, often times doing before thinking. She always believed that nothing in the world was impossible, often doing her best work when the odds were stacked against her. Sherri Marie tried out many different career paths during her twenties before finally realizing that her talents were best spent helping others as an entrepreneur and business leader.

Sherri Marie is a professional network marketer. She strives to help people believe in themselves and design lives they love.

B-R-O-K-E-N! I can't believe this is what my life has turned into. Here I am, thirty years old and I feel completely embarrassed, ashamed, lost, sad, mad, and heartbroken. I keep thinking, how could a strong, independent, and successful person let a man completely turn her life upside down? I always rolled my eyes at "pathetic girls"; always thinking "toughen up buttercup, it's just a boy." I made it twenty seven years before I fell head over heels for someone, only to be left completely heartbroken, and completely broken as a person. It was never supposed to be like this, not when I waited twenty-seven years for this to happen. What was I ever thinking by letting my guard down? I am so upset with myself for being vulnerable, and falling so madly in love with someone during the first sunset on the first night we hung out. How many of you can relate to this? Even as I sit here writing this, so broken as a person, I have to stop and smile. Heartbreak, isn't that something everyone experiences at least once in life? Pour yourself a glass of wine, and raise a toast to yourself if you have experienced and survived heartbreak!

I have spent the last few weeks of my life, scratching my head wondering how I let this happen. I should have ended this relationship before it even started, I should have then ended it six months in, a year in, and instead, it took me almost three years! In life, I like to take what I refer to as the "scenic route" with everything I do, so why would a breakup be any different? Ladies who have successfully survived a breakup, I raise my wine glass to you! Surviving a breakup is no easy task! I want you to reflect for a minute; when you look back on that experience, and you thought your life was falling apart, was your breakup really just a stepping stone for you? A defining time in your life that would shape the rest of your life? A time that you can now look back on and dare I say, be thankful for? I am not 100% there yet, heck, I am not even 50% there yet. So who am I to be sharing my story? I will tell you who I am! I am growing to become one very strong person who has already been able to find a lot of positives from this horrible time, and trust me ladies, if I can do this, so can you! If you are currently a broken mess like I am, stock up on coffee, wine, and M&M's (I suggest the coffee flavored ones, they are AMAZING) and

let's ride out this heartbreak together.

Only in the movies does the, "I fell in love watching the sunset the first night we hung out," really happen! Flashback to the summer of 2014, I had my own personal Hollywood experience! June 23, 2014 is a sunset that I will never forget, a sunset that would change my life forever. I was twenty seven at the time, living a really good life. I had an amazing son, owned a gorgeous house, and had built a successful hair salon business. When I wasn't working, or being a mom, I could always be found having fun! My friends always called me the life of the party, a title I was proud to have. I had just gotten back from an amazing trip to Miami and had all intentions of having the craziest summer of my life. My life was not the traditional, married with 2.5 kids, a dog, and a white picket fence. The way I saw it, life was too short for a boring life like that. In hindsight, I think it was definitely something I convinced myself of because isn't that what we do when we want something we can't have? We think of all the reasons why it wouldn't make us happy, and convince ourselves we are better off without it. It wasn't that I had trouble attracting men, but I couldn't be bothered with putting in the effort into a relationship. I looked at dating as missing out on fun. If a guy somehow did get me to hang out with him, I would spend the time wondering what kind of fun was happening without me. I just didn't understand this settling down phenomenon, but little by little, I was losing more friends to the world of "settling down." Months before we hung out, this boy was trying to get my attention. I could not have been more oblivious, he went as far as coming into my salon for a haircut. Did I cut his hair and set up a date night with him? No, I most certainly did not! Instead, I ran around the salon with soaking wet hair, no makeup on yet, completely excited that the state was finally allowing us to wear sandals! It wasn't until we were tagged in a Facebook post together a few weeks later that he finally caught my attention when he sent me a private message. It was a boring Monday afternoon and I entertained him for a few minutes. Little did I know how life changing entertaining him would be; how he would turn out to be the biggest stepping stone and lesson in this journey called life. I think it is safe to say

I had blinders on instead of sunglasses the last three years of my life. I knew how toxic our relationship was, yet I couldn't get enough of it.

Raise your wine glasses ladies if you have fallen in love at least once in life, now take a big gulp (I mean sip) if your prince charming turned out to be just like mine was - nothing more than a toad! I remember like it was yesterday, I had all the intentions of blowing him off, but just never got around to it. I went from being an out of control party girl to domesticated overnight. It was the absolute best six months of my life, or so I thought at the time. Looking back now, I should have never stayed in this relationship for more than two weeks. After the "best six months of my life," a curve ball was thrown and life got hard. I don't do anything easy in my life, a relationship wasn't going to be easy either. Turns out my "the one" was really the one. He was the one who stressed me until I had shingles. The one who would stress me out to the point that clumps of hair fell out. The one who stressed me out so badly, I lost my sparkle. The one who told me that my positive outlook on everything was the absolute worst trait in life I could have. The only one who has ever broken my heart, and been the root cause of endless nights where I cried myself to sleep. How many of you reading this so far are shaking your heads because you have been there? This crazy relationship lasted for three years; it turns out, he was also the one who never wanted me to end things with him. He was also the one who was always finding a way to get me to forgive him one more time, when I said no more. My life went from pretty and put together all the time, always out having fun, to puffy, bloodshot eyes sitting home alone, spending many nights crying. All those days and nights I was a hot mess at home, he was out having fun with just another one of his "friends." My gut knew it was wrong, but he was "the one," so we were going to get through anything. Oh, the one he was!

I tried to hide what was happening; I knew if I admitted how I was feeling to anyone it would be real. I did not want to admit that my relationship had failed; that I had failed. I was strong, independent, and successful; I prided myself in being able to make anything work, especially anything that I put my heart and soul into. I loved digging

43

deep, and not quitting when the odds were against me. I just couldn't grasp that I had failed at making this relationship work. Guess what? **It is actually okay to fail! Yes, I said it. Sometimes, failing is actually succeeding! Failures can actually lead to some of the best things, failures help make us better people!**

Ending a relationship where you are not respected, that is not a failure! A failure would be staying in a relationship where you have done so much to make him happy, that you are not even yourself anymore. A failure would be putting his happiness before yours. A failure would be staying with the wrong one.

When my relationship ended, I was broken. Heck, I still am broken, but it does get easier everyday. For the first time in my life, I had no idea who I was, what I was doing, or where I was going. I had grown and experienced so much during our relationship that I wasn't sure of who I was anymore. I knew that I was not the crazy party girl who had no feelings and didn't want love, yet I had no idea who I was. I loved the life we had together and now that it was over, I had no idea what to do with myself; I felt like I had nothing but time. I felt an overwhelming sense of loss and emptiness. We had anything but an ordinary life, but it was our life together. I loved the day trips we took, the adventures we would go on, the projects we would do together, and all our inside jokes. When you think something is going to last forever and then it goes away, you can't help but feel like you lost it all. I am slowly starting to realize that the biggest losses bring the greatest gains.

Looking back, when it looked like I had the most of everything in life, I actually was the most empty I had ever been in my life. I had lost my sparkle, and my positivity, which were traits that made me unique. I allowed someone to treat me with so much less respect than I deserved. It was during the hardest days of my life that I discovered an incredible opportunity that would turn out to be completely life changing and help me become the girl I always had the potential to be. This opportunity helped me find myself again, the girl who I lost because I allowed myself to love someone more than I loved myself. Ladies, never allow yourself to love anyone more than you love yourself. At the

end of the day, the one thing in life that will never leave you, is YOU! Yes ladies, it does still hurt when I hear about him and how amazing he's doing, and I can't help but wonder, *was I not good enough?* No, I was good enough; actually, I was too good for him. It has been a few months now, and I am still figuring out who I am every day. I still have days where I struggle to accept that here I am, thirty years old, and I haven't yet succeeded at love. I am not going to sugar coat it for you and say my life has instantly changed and I am back to myself. No, I am going to be real with you, my life is still a hot mess! Yes, you read that correctly, I am a hot mess. Every single day is still a struggle to find myself again; to find the person I was before this relationship happened. I let a relationship break me and change me as a person. I have said more times than not, who am I to be helping people find the best version of themselves? How can I help someone, when I am not the best version of myself yet? Who am I to be helping people design a life they love, when I am still designing my own life? Who am I to be telling people trust me and I will help you, when I still don't have the confidence in myself to trust myself? How can I tell people, that leaving that relationship and starting a new chapter is the right thing to do, when I still question it myself sometimes? I am going to tell you how; I stepped up and became a leader. If I can do it, so can you. All it takes is a few easy steps and then not only will you survive your breakup, you will also grow into the person you always had the potential to be! And let me tell you a big secret, these steps are not about what has broken you, they are about YOU!

I am my own worst enemy. How many of you reading this can attest to being your own worst enemy? Raise those wine glasses proudly, and don't think for one minute that mine isn't raised with you! I am going to clue you all in on something, what you believe to be true is exactly what is going to come true. I have been so broken down in my last relationship that I believed the only way to be a leader and a role model was to be perfectly successful, and I couldn't be more wrong. How many of you reading this have thought this too? Come on ladies; raise those wine glasses with pride! It's okay to be wrong! I am

not just talking about leading in business because let's face it, being an entrepreneur isn't for everyone. I am talking about being a leader in everyday life. The truth is, everyone, even those who may seem like they are perfectly successful without a worry in the world, still has their own share of struggles. **Struggles help make us stronger people; they even help make us stronger leaders.**

One of the keys to success is walking the way, and your intentions will follow. I am not a six figure business earner yet, but you bet I act like I am already there every chance I get! I started walking and talking the way of my intentions and guess what, life changed! I stopped looking like a hot mess daily and started portraying to the world who I wanted to be. And not only did people take notice, but in a very short time, they started treating me differently and they wanted a piece of my pie. They knew whatever I was doing, it was changing my life for the better.

I don't have all the answers, nobody does. **The only thing I am 100% sure of is this, I personally don't want to be just another average girl floating through life. I want to build a name for myself. I want to be a leader. I want to change lives!** I look back on the girl I was when my relationship ended and she is nothing like the woman I am becoming everyday. I dug deep, pulled up my big girl panties, and changed my entire mentality, which boosted my confidence back up, in turn, really honing my ability to be a good leader. I look back at the broken girl I once was, and hardly recognize her anymore. This makes me so excited to meet "me" in another few years! Ladies, I want all of you in similar situations to ask yourselves this, have YOU changed? Or are you standing still? Raise those wine glasses with me and toast to changing YOU and your life.

I promise you this: you are good enough, you're actually too good to ever allow a man to break you! And it is 100% okay to be thirty, and single! Cheers to all the single, strong, successful independent ladies!

CHAPTER 3

No Kids, Now What?

BY ERIN FILTNESS

"I have one foot in adulthood and the other foot in the bar."
~ Erin Filtness

ERIN FILTNESS

WWW.CATSOFINSTAGRAM.CA
IG: @CATSOFINSTAGRAM

Erin Filtness is a thirty-three year old woman who has no idea what she's doing, and she's incredibly happy living like that. She grew up in a suburb of Vancouver, and now calls Vancouver home. She lives with with her boyfriend, dog, and two cats whom she loves unconditionally.

She started a very popular Instagram account @catsofinstagram which means she gets tons of great products for her cats in exchange for advertising them. She also runs her own sales agency representing prom, bridal and bridesmaids clothing lines.

Erin is an only child who grew up in a very happy home with two parents who are still in love, and are still best friends to this day - which is something she too would like to have with her future spouse - things are looking up. Erin has a passion for travel, animal welfare, cooking, her pets, and her friends. She is a fur-parent and content as can be. Also, no she does not want to hold your baby.

I'M THIRTY-THREE YEARS OLD, and I still don't want to be a mother.

I do not know why I started with that, but unfortunately, it has become an issue for me. Originally, I was going to write about how funny it is to be thirty-three with half my friends having babies, and half my friends being drunk all weekend, but for some reason I have the "having kids" thing on my mind. **You see, it's 2017, but it's still considered taboo if you do not want to be a mother, and I don't know why.**

My friends range from mid-twenties to late-thirties, and we are all still loving the nightlife. All nighters, night clubs, music festivals, pre parties and after parties accompanied with its fair share of alcohol still take place. Every. Single. Weekend. If I wanted to, I could have at least 5 people at my place getting drunk on any day or night of the week; my friends are always up for a party. I don't do this, but I could. And I wouldn't live my life any other way. I travel, I shop, I spend all afternoon reading a book with my dog at the park, and I go to nice restaurants - whenever I want - because I don't have children. And it's amazing. Last summer, I went on three trips in a row - London, England for a week, a road trip to Alaska for two weeks and the Shambhala Music Festival for a week. Several small camping trips and weekends visiting out of town family. All from June 20 - August 20. Two full months of travel, music, sun, family, and friends. How could I possibly give up that kind of life?

I should tell you, I have a job that affords me almost unlimited free time, and a very large pay check so it makes this life easy. I own my home and I own 2 businesses that are both operated from my phone so I can work from anywhere at anytime. I save money all winter, so I can have amazing summers full of fun and traveling.

I also have friends that aren't drunk every weekend. Well, they are... kinda, but instead of shots at the bar, it's wine on their couch. These are my "mom friends." I hardly see them anymore - unless we make plans weeks in advance and it's for a quick meal somewhere while the kids are left with dad. Their lives revolve around their babies. Their money goes to their babies. Their time goes to their babies. And they seem to love it. It's all some of them ever wanted - to be a mother.

And I feel so sorry for them. At home all day with a crying baby, having hardly any contact with adults and the outside world - at least, that's what I see. Yet on Facebook, they all seem to love it - what am I missing?

I've come across a few articles that have kind of answered that for me; mothers that regret becoming mothers. Some thought they wanted children and then ended up hating it, others were on the fence and took the plunge because their friends and family insisted they would love it. Turns out, a lot hate it and resent their children and spouse. Why aren't we talking about this more? As I said before, it's 2017 and it's still considered taboo to not want children. Well, I think it's time we started talking about how wanting children and not wanting children are both perfectly wonderful ways to live your life.

According to many of my "mom friends," I'm missing out on the "purpose of life," the most fun I'll ever have, having a mini-me, leaving a legacy, and experiencing real, true love. I'm told that if I don't have kids, I'll regret it later in life, and it will be too late. I'm told to just "jump in" and do it. They promise I will love it, and I'm told that I'll never know what love is until I have a child. *But what if I don't love it? What if I regret having children and resent them?*

Friends with kids tell me that I'm missing out on real, true love. I'm told that I have no idea what love is until I have children. What a horrible thing to be told. So I don't fully love my family? Friends? Partner? Pets? How can a person know how I love anyone in my life? Being told these things is hurtful, and it makes me question my decision that I'm very comfortable with.

What if I "jump in" and hate my life and I'm now stuck being a mom? What if it's the exact opposite? The more I read about how there are many women who actually regret having children and hate themselves as a result of losing themselves in this process really makes me feel like I'm not the loveless monster that society leads me to believe I am.

I feel torn between two lives. The "responsible, grown up" life and the "fun, party till you drop" life. I have one foot in adulthood, and the other foot at the bar.

I often look back on the generations before me; my grandparents were married with a home, 2 kids, and a dog by the time they were twenty-six and twenty-eight. My parents were married with a home, had me, and 2 dogs by the time they were twenty-five and twenty -seven. Two kids when my Grandma was just twenty-six years old! That is insane to me. When I was twenty-five, I had no business raising children. The difference between then and now is astounding. Women are waiting longer to start a family; they are working on their careers, waiting to buy the big house, waiting to marry the right person, waiting to find out just who the heck they really are, and only then are they having children. It's interesting to see the age of new moms change as time goes on. Instead of 2 kids at the age of twenty-six, it's one kid at the age of thirty-six, and I don't think that's a bad thing.

I'm thirty-three, and I'm running out of time.

My doctor told me that I would have to make my decision soon, thirty-five is pretty much the maximum age that I want to be having children; medically speaking. Oh yes, she knows the trend of waiting till your late thirties, but that's not the healthy choice, she tells me. I need to decide and get busy now if I want to have a healthy body.

So it's a race between me, my body, the man I love, and society.

Who would you let win?

I went out for lunch with one of my best friends from high school. She's married, travelled all over the world in her twenties, has lived in different cities and countries, and has recently had a baby. She always wanted to be a mother and she seems to be loving her new life. As I sat on the floor with her six month old baby boy who kept laughing at me with a massive smile on his face, I thought about how much fun it would be to have one of these. I'm lucky to be with a man who supports me and loves me unconditionally, and there's a very large part of me that wants to see him be a dad. There's an even larger part of me that wants to know what our children would grow up to be, but I just don't think that the curiosity of my future children is bigger than the feeling of not wanting to have children.

So after all these things, what choice am I left with? Well, I'm an only

child so the obligation of having grandchildren falls on me. Knowing my parents won't be grandparents makes me feel an insane amount of guilt, but I can't make life decisions based on the guilt I feel for my mom. That's not the right reason to have a family. And then there's the man I want to grow old with, he wants to be a dad. And I'm terrified that I'll be facing a choice one day - stay with him and have children, or lose him and don't. It's a very real fear and I really think if faced with that, I would choose him and children, but how can I choose that knowing I would become resentful to them? Does that mean I have to walk away from the man I love? On the other side, does that mean he resents me for not having children with him? Do I end up alone with a bunch of pet cats? I feel like everyone wants me to have a child except me, and unfortunately, it all falls on me and my uterus. And I don't think that's fair.

I'm thirty-three years old, and I feel like I have to make this decision now, or it will be too late and that's a horrific thought. The very idea that I may miss my opportunity is scary and I'm worried I'll make a choice in the next year or two that I will spend the rest of my life regretting becoming a mother. So where does this leave me? Obviously this has been on my mind a lot as "the clock keeps ticking." Here are my options: adoption, fostering, freezing my eggs, surrogacy, or becoming a mother.

I love the idea of adoption because there are so many children out in the world that need a loving family; and I love the idea of providing that home for a child, but again... What if I hate being a mom? Freezing my eggs isn't an option unless I pay for a surrogate because I really don't want to give birth. That leaves me with the option of becoming a foster parent and that really seems like the only thing I would like to do. There are so many children in the system that need love in a temporary situation, be it for a few months or several years. I really feel like that is the path that I most want to venture down.

Will I miss out on true love? No, I have true love everywhere; my friends, family, pets, and especially with my partner, James.

Will I miss out on my "purpose in life"? **No, I believe our purpose in**

life is to be the best version of ourselves as possible, love as hard as you can and above all, always be exactly who you want to be. Don't apologize for anything that makes you who you are.

Will I miss out on having a "mini-me"? This one I will miss out on, but I really don't think that's a good enough reason to have kids.

Will I miss out on leaving a legacy? No, my legacy is how I live my life and how I leave my mark on this planet; be it with my career, my friends, the animals I help rescue, or even the stranger I smile at as I walk by. **Your legacy is what you make of it and it can be as big or small as you want.**

At the end of the day, I think it's important we stop putting so much pressure on women. *Find the perfect work / family balance, have the perfect career, be a perfect mom, be the perfect wife, don't be too fat, don't be too skinny, make sure you have ladies nights often with your friends, walk the dog, drive the nice car, contour your face, have the perfect hair, throw your kids the best birthday parties, drink a green smoothie every morning, keep your home spotless, never be behind on your laundry, bake cupcakes for your child's class, love being a mom every minute of everyday, don't be sad...* Isn't it time we tell society where to go? I don't want to be a mom and that doesn't make me a loveless monster.

CHAPTER 4

Oh Baby...

BY CHLOE DEVITO DE CONCHA

"If Valentino were a baby, I would be Octomom."
~ Chloe DeVito de Concha

CHLOE DEVITO DE CONCHA

IG: @CHLOE_DEVITO_DE_CONCHA

Chloe is a passionate traveller who has visited over forty countries in the last seven years. Having studied broadcast journalism at the Southern Alberta Institute of Technology, she prides herself in being a forward thinker with an acute interest and curiosity for her surroundings. Upon completion of college, Chloe worked as an on-air radio DJ and weekend news personality before going on to pursue a career in fashion. Chloe has always been an out of the box thinker who dreaded the mundane conformities of society.

Much more comfortable paving her own way, her free thinking attitude mixed with her drive to build an exciting future, has led her to live a life out of the ordinary. Chloe has spent the last seven years living and working onboard some of the world's biggest and most impressive yachts. During this time, she has had the pleasure of working alongside her husband, and together they have built an exciting life that has them traveling the world whilst maintaining a base between Miami and Vancouver. As she continues to explore her dirty thirties, she eagerly awaits the surprises that lie ahead.

THERE ARE APPROXIMATELY 7.5 BILLION PEOPLE on this planet and UNICEF estimates that approximately 130 million babies were born in 2016. This statistic does not include the unregistered births around the world.[3] That's a lot of people, and A LOT of babies. No pressure. If 130 million or more women on this planet are giving birth, then where is this maternal clock everyone speaks of, and why has it not struck me yet? I keep waiting for it to strike... this elusive "urge" everyone speaks of. Friends... actually no, STRANGERS, always tell me that one day I will wake up and have the "urge" to have a baby. Yup! Strangers. And not that it's any of their business, but how would they react if I told them about my REAL urges! I get urges all the time! The urge to buy myself a new handbag, the urge for a new pair of shoes, last week, I got an uncontrollable urge to buy tickets to go see Lady Gaga. Love it or hate it, these are my urges. If Valentino were a baby, I would be octomom. With my upcoming thirty-sixth birthday, it is safe to say that until very recently, I have NEVER thought about, fantasized about, or felt the urge to have a baby. Babies, to me, were and still are, those mythical little creatures that pop up daily on my Facebook and Instagram feed. While they can (occasionally) amuse me, it's usually not long before I am scrolling past them and staring at Kim Kardashian's butt or a juggling dog. What can I say, I am who I am, and until very recently, I had been so wrapped up in my cozy narcissistic bubble that I had never questioned my views on any of this.

The amazing part of turning thirty is that you finally start to understand who you are as a person. You finally start to let go of the confusing nonsense that plagues your twenties, and you finally start to be able to answer that golden question: Who am I? This is a question I struggled with for a very long time. It took me years, decades even, to actually figure this out. Born an only child in a small Canadian town to two European parents, I was one of the lucky kids who travelled a lot. My parents always believed cultural experiences outweighed the

[3] World Odometers. (n.d). *World Population*. Retrieved from http://www.worldometers.info/

traditional and very boring elementary school system. Cursive writing could be taught from anywhere, but not many children from my town had ever wandered the streets of a Moroccan market, sipping mint tea and visiting hammams recreationally. Our travels took us all over the world. With this culture came knowledge, and with knowledge came ambition. To say I was an ambitious child was perhaps an understatement. I wanted to do everything. I ski raced, snowboarded, danced ballet, jazz, AND tap. I attempted karate and gymnastics. I even tried to sing once or twice. There was also the ten years I spent playing piano and secretly hating it. I wasn't very good. I knew three songs really well, and could fool people into thinking I was better than I actually was. You could say I was a spoiled child, and never ended up dancing in the Bolshoi Ballet, or composing some mind-blowing concerto, but I was always raised to believe I could do anything I wanted.

I met most of my close friends in my early twenties, those friends that stay with you for a really long time. My twenties were an amazing blur of parties, freedom, and friends. By the time I turned thirty, I had been through three major career changes, two serious relationships, and had packed up my entire life into a 20 x 20 storage room and moved to a different country to start a completely new life. Looking back on everything I had done, it wasn't surprising that the idea of settling down and having children was so foreign to me at the time. I was living the dream! Traveling the world, earning a good living, and doing something I loved. Where did children fit in? And did I even want them?

As a recently married woman to an amazing and supportive man, the next step in my life would seem obvious to most. I, on the other hand, do not see it this way. In a society where we are programmed to have children upon adulthood, where does my ambivalence come from? And, are we less of a person if we choose not to have children? How does one hit the reset button in your brain that is programmed to conceptualize adulthood with children, and are we ever really prepared to deal with the reality that we are deviating from the biggest expectation placed upon us by society? How do so many women make it look

so easy and attack motherhood fiercely and fearlessly while I find it terrifying? What am I so scared of?

As a thirty-something year old woman in today's world, I find myself constantly being scrutinized by friends, family, and sometimes complete strangers. Everyone assumes that because I am "finally married," I should "finally" be trying to get pregnant. When I tell people that we are unsure whether or not we will have children, I am often stared at blankly or looked at with ridicule. "OF COURSE you want children!" I am told. "Don't say that! You HAVE to have children," they say. WHY? Why do I HAVE to have children? Who says we HAVE to have children? Most importantly, why is it okay for people to ask such personal questions?

On a global scale, it would seem I am not the only woman having these doubts. Recent studies have shown a declining birth rate amongst first world countries.[4] We have also started to see a significant increase in the age at which women are choosing to bear children. Many women are citing cost, career, and personal time as reasons for the delay. In my direct group of friends between the ages of thirty to forty, currently, only a few have kids. Most of my child free friends would agree that children just don't fit into their life plan. Some have recently changed careers, gone back to school, or chosen to travel the world. As we continue to navigate a world of limitless options, these are luxuries that women of today are afforded. This seems to clash with the expectation that society has placed upon us that "family" means "children," and not having children must mean you are either infertile, or incredibly selfish.

Selfish or not, I will be the first to admit that having children at thirty-six seems daunting. My life until now has revolved around me, myself, and I. I have become accustomed to (happily) looking after my

[4] Holder, J & Okai-Kweifio, C. (2016, June 28). *Over-populated or under-developed? The real story of population growth.* Retrieved from https://www.theguardian.com/global-development/datablog/2016/jun/28/over-populated-or-under-developed-real-story-population-growth

husband and myself. While some might say that our life is incomplete, we would argue that this is simply not true. In today's complicated world, we choose to see the beauty in taking care of ourselves and putting ourselves first. We have the luxury to work in an industry that allows us to travel. We are able to see the world, and afford a lifestyle that we otherwise would not be able to if we had children. Like many other couples and (singles) facing these same decisions, priorities have shifted and are not what they used to be.

I had sushi with my beautiful and talented friend Hana the other night. At thirty-four, Hana has been rocking her new career change. Having left her corporate New York City job in search of a career that would allow her the opportunity to travel while still making money, she found herself living in Florida and working on super yachts. She also recently launched an exciting start-up and in her spare time, has been pouring all her extra energy into making it a success. Next week, she is moving to Nicaragua for three months to work remotely. When we started talking about life, career, and family, the topic of children came up. When asked if she saw children in her future, Hana said she didn't see herself ever having children. Her drive and passion to be a successful businesswoman outweighed the desire to settle down and have children. Hana agreed that the freedom associated with being a financially stable woman in her thirties, unattached to children, gave her the freedom to live her life on her own terms. This meant being 100% committed to her own happiness, and manifesting her dreams on a very personal level. "Having children means you are locked in for life... actually, until death!" she said. This made me laugh... that was one way of looking at it! It also got me thinking. *Was this part of my own fear? Being thirty-five years old, was it possible I had "outsmarted" myself out of having children? Had I overanalyzed it so much that I was too scared to go through with it?*

Let's look at the facts: If I were to have a baby at thirty-seven, I would realistically be sending my child to university at fifty-five (my parents were retired at that age!). When my child graduates from university (pending they actually went, and didn't turn into a delinquent little

asshole), I would be sixty! Since it is a known fact that college doesn't necessarily secure a well-paid job and future, there would be a good chance that I would be helping said child after college. Therefore, my retirement would likely be on hold. I have always pictured myself retired by the beach and learning to golf by age sixty! Of course, there was always the chance I would give birth to a little genius, thus eliminating the above mentioned fears... but was this a chance I was willing to take? This also puts into perspective the argument that having children ensures you will be taken care of later on in life. If my children are barely adults by the time I am seventy, how will I ensure I am taken care of... given the state of our highly proactive and well adjusted "Millennials," (insert sarcasm) there is a higher probability that I will still be taking care of them! Having children does NOT ensure you will be taken care of anymore then WebMD will diagnose that weird neon pink mole on your arm. While the idea is a novel one, we cannot predict the future or rely solely on this. One of my best friends recently said to me, "Always remember that your friends are your family too." I thought this was wonderful. The word "family" can be so many things on so many levels. You can build a family any way you choose.

While I could easily see myself happily living with my husband sans child, what would my life look like WITH children? People always speak of the unconditional love you feel for another human. They say it fills a void in your life that you never knew existed. The experience of having children is always described as being indescribable. Not to confuse you anymore than you might already be, but the common consensus seems to be that parenting is the most rewarding part of life! So why does everyone who has children (in my opinion) look so stressed? And why do so many studies conclude that children can actually be bad for a romantic relationship?[5] Could it be that people are so obsessed with

[5] Johnson, M.D (2016, May 05). *Have children? Here's how kids ruin your romantic relationship.* Retrieved from https://theconversation.com/have-children-heres-how-kids-ruin-your-romantic-relationship-57944

the age-old homage that you HAVE to have children in order to be happy, that they fail to look at the factors that come with parenting? Lack of personal time, decreased intimacy with your partner, an increase in child related stress, and financial burden to name just a few! And that is not to assume that life without children is any easier, but let's be honest... not having children frees up your social calendar for life!

Is it also a possibility that society's harsh, and at times, very conservative expectations could be bullying women into having children? After all, no one questions a thirty-five year old man who doesn't want children, but those brave women who dare to say it out loud are often belittled and scrutinized. It's a sad fact that women today are scrutinized for everything they do. Having children too young, or too old, or not having them at all! God forbid a woman has a baby, and doesn't lose her baby weight fast enough... and never mind a woman who chooses not to breastfeed... well that's just child abuse! What is it about the thirty something year old woman that has people so riled up, and where does this leave me?

The truth is, I actually just don't know! I DON'T know if I want children, I DON'T know if having a child is the answer to my happiness! YES, I am almost thirty-six. YES, I know that my insides are practically "dead" in terms of prime childbearing years, and YES, I am aware that I need to make a decision soon! But the decision is mine to make, and I will NOT be pushed into it. Who is anyone to assume that I am "missing" something in my life? Maybe my life is full just the way it is! I am a successful, mature, thirty-five year old woman who has the privilege of being able to make this decision for myself, and NOT for anyone else. I have the full support of my husband and my loved ones. People always ask what will I do if I want children and it's too late... For me, this has always been an easy answer. I'll adopt.

SECTION 2

I'm 30, And Living In A New Era

Featuring
Nicole Singh, Katie Rubin, Andrea Lampe, Jessica Gardner

OPENING COMMENTARY BY KY-LEE HANSON

Section 2 Opening Commentary
BY KY-LEE HANSON

ALTHOUGH WE LIVE ALONGSIDE OTHER GENERATIONS - be it in the workforce or at home, a key difference is that the prior generations are not as introspective as our generation today. As mentioned before, we thrive on constantly seeking change and discovering what it is that fulfills us, whereas our parents are from a time where living in line with the status quo was the only widely accepted way of life. There were no questions to be asked, and change was seen as something negative. Our way of living and thought processes differ vastly from the older generation such as our appetite for frequent change, and our openness to living consciously and compassionately. We don't really know exactly what caused our generation to think differently and more freely. Some could say, we saw what our parents did and we didn't want to do that. We could say it was the uprise of equality or we could give thanks to the connectivity that technology brought, in turn teaching us diversity and expanding our knowledge. It still doesn't answer the question - "why now?" Why are we now open to receiving and respecting the thoughts of others? Why are we finally moving towards a collective world - or maybe we aren't - maybe I am naive on that front... I haven't done a calculated analysis, but I can share with you how I feel and how I notice a lot of energy being directed towards actual free thought and respect. We should be able to live independently, respect our diversity and protect our planet while encouraging others to do the same. Of course, not everyone's vision of a "great country" or "great world" is the same. However, the root desire for safety and opportunity is all the same. Society just needs to clear up it's understanding of fear and respect, and not let either blur with control and greed.

Our societies have history and we are just now starting to view women as equal and seeing women define their roles in society, or lack there of having or wanting a definition. It is mind blowing that an

entire gender and entire races were seen as less. There are theories I find fascinating about energy shift of the earth, golden eras, new eras, earth cycles and a raise in frequency and consciousness. Whatever it may be, I am happy to be here in this era and am going to take full advantage of it and do my everything to make it better.

I find this next section to be truly unique and well rounded. First, Nicole Singh is going to help us with demographical information to see exactly where we fall, and the economical obstacles we have commonly been facing and the consensus outlook on that. Then, Katie Rubin takes us on an awakening journey though conversation to show us what we have been chasing, or not chasing, and maybe why it is not achieving a purposeful feeling. How can we be many, and live in a non-linear way? She helps us to get centered with our desires instead of living for everyone else. And she does this in two ways that are "new era": 1. She asks for help ("asking" used to be a taboo practice and was avoided like the plague as you could be seen as weak) and 2. She is guided to find those answers within herself on an energetic and spiritual level (which the past eras held fear around not being able to "see" this, and would treat it as voodoo and pseudoscience). What if we simply want to CHOOSE to be happy and share that happiness with others; can that be purpose?

Not only are we the generation who have experienced financial turmoil, and are on a never ending quest for happiness and fulfillment, we have also experience loss in many diverse forms. Now in our thirties, loss is a real thing we experience, often. Our generation has been plagued with illness, losing people too young. Andrea Lampe shares with us her story of loss and how she is taking the empowerment from her late mother and living a life filled with new experiences. Our generation was raised differently and is living in a new and abundant way. We have talked a lot up until now on the ability for women in our generation to be "many" all at once. Jessica Gardner ends this new era section with showing us just how she is living it all and bringing new life into hers. She shares how our generation lives and makes choices "based on intuition, logic, and love," and not just by society's plan.

CHAPTER 5

Expectation De-Generation

BY NICOLE SINGH

"People try to put us d-down (Talkin' 'bout my generation)"
~ My Generation, The Who (1965)

NICOLE SINGH

NICOLE.JR.SINGH@GMAIL.COM
FB.COM/BOOZOOBABY

Nicole grew up in Moncton, New Brunswick, before moving to Ontario for university at the age of twenty-one. While pursuing a degree in biological sciences, Nicole became extremely involved in student life and government. This helped her realize that rather than spending her life working in a lab or doing research, her true passion lay in helping others achieve their fullest potential and making a difference in the lives of others.

Since graduating university, Nicole has held positions in post-secondary institutions, in the fields of student and residence life, working on programs to help students succeed both academically and para-academically. She has also worked in the private sector, helping to develop an exclusive concierge program for a major retailer on the west coast.

In 2011, Nicole met her now husband, Nigel, and son, Ethyn. They were married in 2015, and welcomed a beautiful baby girl, Freya, in October 2016. While focusing most of her energy raising their children, Nicole is happily designing the life she loves with network marketing and most recently started her own home-based business making and selling baby clothing and accessories.

I'M A MILLENNIAL. Now why does that feel like such a dirty word? Every day, we read about how Millennials (also called Generation Y or Generation Next) are part of the "me, me me, now now now" generation who can't do anything that isn't self-serving or "less" than they perceive they are worth.

I was born in 1984, which makes me four years too young to fall under the Generation X umbrella, even though I was raised in a similar environment to that of my counterparts, who are not much older than myself. The expectations that have been ingrained within us differs for each generation. Societal expectations influence our own personal expectations which go on to impact our lifestyle and choices - be it career, family, relationship, or even health goals. Ritter gives the following distinctions between the two generational cohorts:[6]

	GENERATION X (1961–1979)	*MILLENIALS (1980–2000)*
THEIR PARENTS	- Worked full time - Minimal involvement in children's lives	- Worked full time - Hyper-involved (helicopter parenting)
THEIR CHILDHOOD	- Came home themselves after school - Raised on Television and TV dinners - Independent	- Made to believe the world revolved around them - Lost concept of "failure" (rewarded just for showing up) - Very dependent on parents
THEIR ADULTHOOD	- Cynical "been there, done that" mentality - Moved away from home as soon as possible	- Immature, still dependent on parents - Continued parental involvement in higher academics and jobs - Live at home longer or return home after studies

[6] Ritter, B. A. (n.d). *"Rise of the Millennials - Why they know so much... Yet understand so little.".* *Real Truth.* Retrieved from https://realtruth.org/articles/080804-002-society.html.

While my parents were by no means neglectful, they didn't fit the stereotype of helicopter parents so often associated with Millennials. My sister and I were encouraged to pursue activities outside of our academics, and were definitely busy, but our parents appreciated the value of failure as much as that of success. We were raised to be independent and to think for ourselves, but to be humble enough to ask for help when needed, and take ownership for our mistakes. Never in a million years would they have dreamed of trying to talk a teacher into giving us a better grade, a coach a bigger role, or try to defend or cover up our mistakes if we were legitimately in the wrong. Having worked in higher education, I will never forget the phone calls I've received from parents wanting to discuss specific details pertaining to their (adult) children's files with the school, or their outrage when I had to explain to them that privacy laws forbade me from doing so. The idea of doing this, even with my own children just baffles me, yet I know this has become the norm for many.

We currently find ourselves in a unique time where both Gen X-ers and Millennials are in their thirties, and yet their approach to life is completely different. While the previous generation was expected to be married and have two kids by the time they hit thirty, and then some-times found themselves suffering from "midlife crisis" in their forties or fifties, many Millennials are going through what has been referred to as a quarter life crisis. Having either started work straight out of high school, or pursued college or university studies and worked for a few years, in their field of study or not, Millennials are suddenly "finding them-selves" and pulling a complete 18⊙ degree turn, both personally and professionally. For instance, my friend Melissa went to university for a few years right after high school, but life circumstances made it such that she had to put her studies aside and work full time. After a few years in menial jobs, she found herself a stable position she enjoyed in an established company, and could easily have worked her way up the ranks there by taking some college courses in her spare time to expand her knowledge base. At the age of twenty-seven, she decided she needed a change and enrolled in nursing school. While Melissa

had always imagined that by age thirty-two she would be married with a couple kids, she has instead just completed her degree and is essentially starting at square one, both personally and professionally, having put everything on hold to achieve her new goals and establish her career.

KEEPIN' IT REAL – THE PURSUIT OF LIFE, AND EVERYTHING IN BETWEEN

In preparation for writing this chapter, I reached out to a group of new moms (holla at my November 2016 mommies!) to see how their experiences compared to my own. This group includes first-time and repeat moms in their twenties, thirties, and forties to whom I asked two questions: What are expectations you have or had for yourself for your thirties, and what, if any, of that have you achieved? I've sorted the information into three categories: Generation X-ers (born before 1980), Millennials in their thirties (born 1980-1987), and Millennials in their twenties (born before 1987).

	GENERATION X	MILLENIALS IN THEIR 30S	MILLENIALS IN THEIR 20S
EXPECTATIONS FOR 30S	Get married, buy a house, have kids, have stable (permanent job), have savings		
FAMILY REALITY	- all are married - all have one or more children	- some are married (others have no intention) - all have one or more children - most planned the pregnancy	- some are married (others have no intention) - all have one or more children - many would have preferred to wait to have children

FINANCIAL REALITY	- some have higher education degree - all have stable job	- some have higher education degree or diploma (many not working in their field) - minimal expectation of remaining in same position until retirement	- some have higher education - most have no idea what to do when they "grow up" - difficulty finding permanent work
CAREER REALITY	- all own their home - most have no significant retirement savings (no major stress)	- many own their home (some are house poor or won't be able to afford home until they are in their 40s) - most have anxiety over lack of proper retirement savings	- some own their own home, most will not be able to afford one soon - no savings - financially uncertainty due to lack of proper career options

As many individuals are having children later, having spent their twenties (and some of their thirties) focusing on their education or career, and trying to find the right partner, we are faced with an interesting challenge being sandwiched between two very needy generations. Our young children require our undivided attention and pose a significant financial responsibility, while our baby boomer parents are becoming senior citizens with all the related health issues. While my parents are still in their fifties, my husband's parents are in their late sixties, and though everyone is currently relatively healthy, the reality is that this can quickly change.

THE FLIP SIDE
We've talked about women with children and how they may or may not have met expectations for their thirties, but what about those women who don't yet have children, or who don't want them? Until recently, the thought that a woman does not want to have a child was almost unheard of, or it was assumed that she wasn't able to conceive them.

Research however, is now showing that the number of women in the U.S. who have made a choice not to have children has doubled since 1970.[7] The reasons women give to not have children vary greatly, and DiDomizio provides a few. For many, the cost of having and raising children makes it financially unfeasible, especially if they have student loans to repay. Others quoted health reasons such as the fear of passing down mental health issues if there is a family history or existing fertility issues affecting younger individuals which makes them change their minds in regard to whether they want kids. Not all women have maternal instincts, and some have no desire to undergo the physical ordeal that is pregnancy and childbirth. Some women gave a more socially conscious reason, such as not wanting to contribute to the overcrowding of the planet or bring children into a less than perfect world. Others mentioned not wanting to assume the responsibility that comes with being a parent or the pressure to make perfect choices for another being. Many women simply do not want to have to sacrifice their own personal and professional ambitions to raise a family, or they recognize that having children would not fit into their chosen lifestyle.

Ultimately there does not need to be a REASON why a woman doesn't want children; that is her choice, and what we are finding is that for Millennials, that choice is more widely accepted (not that it matters either way).

THIS IS MY LIFE. WHAT DID EXPECTATIONS LOOK LIKE FOR ME?

If you had asked five-year-old me where my life would be by the time I turned thirty, I would have told you I was going to be a doctor, happily married with 2.2 children, and living in a big house without a care in the world. The story wouldn't have changed too much if you asked me the same question at age fifteen, except that maybe I wouldn't have everything done by thirty, but would be well on my way to getting there (at that point, I realized how long you need to study to become a doctor). By age twenty-five, I had spent eight years in various science programs at two different universities, having failed my first semester of pre-med, thus making medicine an unattainable dream. I would

[7] DiDomizio, N. (2015, July 30). *11 Brutally Honest Reasons Why Millennials Don't Want Kids*. Mic. Retrieved from https://mic.com/articles/123051/why-millennials-dont-want-kids#.c9gnDb6ld.

have told you that organic chemistry was evil, and university is hard, and that I no longer had any interest in pursuing a career in a scientific field. I was nowhere near being married, with no real prospects in that area, and I really couldn't tell you what my life would look like in five years, only that I wanted to be happy, whatever that meant.

By age thirty, I was with an amazing man, and his incredible son, we had bought our first home, and got engaged before the year ended. We got married when I was thirty-one, and a year later welcomed our beautiful baby girl into the world. My personal life is everything I ever dreamed of and more, even if I didn't accomplish everything by age thirty as I (or society) had expected.

But am I where I had hoped to be professionally? I have a job I enjoy, working with great people, but I am not working in my chosen field. My family and I are financially comfortable, but I still have tens of thousands of dollars of student debt I am working to pay off. Like many of the older Millennials I have spoken with, I have bounced around in terms of my education and my career. I transferred from one university to another after three years, only to then change my major again after two years of study. I spent eight years in university, and graduated with a bachelor of science with honors in biological sciences, only to decide a few months before graduation that I wanted to work in student services, and ended up completing a certificate in student affairs and services a few years later. I have worked to help start up a student affairs division, as well as in residence life, but when my last position was merged with another and became a permanent role within the institution, I did not have the seniority to apply for it as I was not a member of the union. While I kept looking for a post-secondary job, the reality was that the majority of entry-level positions are part-time or contract, and at the time this was not ideal for me or my family, so I had to focus my search in other fields. I did eventually find a job that I enjoy with a great company, but it is not necessarily what I would have envisioned for myself in the past or what I see myself doing until I retire.

While on maternity leave, I have started a home-based sewing business and expanded my network marketing to help create additional income streams which provide me with more financial flexibility and the ability to try to find another student affairs position, or to choose not to return to a conventional job, if that is what I decide. In contrast, while our parents expected (and were expected) to find a job (or career) for life, the reality for Millennials is to find a career for now. I remember being a student ambassador in university speaking with prospective

students and their parents and seeing so many still being undecided on a career path as they prepared to graduate high school. The parents kept telling their children, "Make sure you know what you want so you don't waste my money." And I would try to explain that the reason many first year programs are so broad and include classes in various disciplines is to allow students a chance to try a bit of everything before deciding on a major. This gives time to find their passion, and enable them to change directions (or disciplines) before getting into the upper year courses which are much more specialized. While I certainly wasn't encouraging spending "pointless" years in university, what I was trying to make them realize was that **it is okay not to be 100% sure.**

IT'S OKAY NOT TO BE OKAY

"Give young people a chance, we may just surprise you." ~ Marc Kielburger

So, you're thirty, or thirty-three, or thirty-seven and still don't quite feel "grown up"? You are still completely undecided on what you want to do with your life? I hope this chapter helped you realize that it is okay to be undecided, and most importantly, YOU ARE NOT ALONE. While it may be hard to have these conversations with family and loved ones, who may have grown up (or raised you) expecting things to be different, this is our day. Maybe that's why Millennials are often also referred to as Generation Next. Next job, next degree, next LIFE. We seem to have figured out that's it's not just about survival anymore. We aren't satisfied with working tirelessly just to pay the bills. One of my favorite sayings is, *"Design a life you love."* By doing this, we find ourselves no longer working, but living. I have managed to do this in many aspects of my life, as for the rest, it's a work in progress, and I'm okay with that!

CHAPTER 6

Murdering My Mind

BY KATIE RUBIN

"Your mind can only define the limitations of your reality."
~ Gary Douglas

KATIE RUBIN

Katie Rubin is a touring solo show performer and comic, regional theatre actress, writing coach, and energy healer.

Her seven-week class, Tell Your Story, facilitates solo performers, comics, authors, playwrights, and writers of all kinds in developing their work. Her classes welcome and support both beginners and more seasoned writer/performers alike and take place both in person and online.

Katie began her career as a writer/performer at Amherst College with her first original piece, PartyBoobyTrap. Her second play, Avoiding Less Blue, was produced through the 2000 New York Fringe Festival. Katie toured her first solo show, Insides OUT! at venues across the country for 8 years. Insides OUT! received a nine-week equity production at The Sacramento Theater Co. and has toured over 100 events and venues. Ms. Rubin's second solo show, Amazing and Sage was commissioned by Capital Stage. She has since created three more solo shows which have toured nationally.

Ms. Rubin's recent acting credits are as follows:

Lisette in, *The Heir Apparent* at The Aurora Theater; Tanya in, *The North Plan*; Mrs. Daldry in, *In The Next Room* (*or The Vibrator Play*), Wendy in, *Hunter Gatherers* at Cap Stage; Izzy in, *Rabbit Hole*; The Nurse in, *Wit* at The B Street Theater.

Katie earned her MFA in acting from UC Davis, and her BA in theater at Amherst College.

I RECENTLY HAD A SESSION WITH A NEW PSYCHIC. That's right. I've had so many sessions with psychics over the past ten years that, in this moment, I'm writing about a new psychic I saw. This particular woman began our session by channeling a being who said, "This one is many." Meaning – I am a lady who is many things.

The psychic then went on to tell me that, in this lifetime, I am, "finishing a number of projects from other lives." That I am, "tying up loose ends" this time around. When I then asked her if the network marketing company I'd recently joined was a, "good use of my time?"

She asked, "Does it help people?" I said, "Yes."
"Does it make you money?"
I answered, "Yes."
"Then, what's the problem?"
"Well, what about acting?" I asked. "I've been a professional regional theatre actor for many years, and find myself desiring to earn more money these days, and do other things."
"Sure," she said.
 "Sure, what?"
 "You can act."
 "Okay... What about all this healing work I'm doing with private clients?"
 "Does it help them?"
 "Very much so."
 "Then, cool. People who need that work will show up for it."
 "Okay..."

Now, here's why this particular conversation in this particular moment pissed me the hell off. I have subsequently, and in large part, spent most of my adult life looking for one, single answer to the question, "What is my purpose?" I've been desperate, in fact, to find it and live it.

My particular "find your true purpose" vision goes something like this: *I'll call this psychic and she'll be like, "Ahhh, you're clearly a healer. You're free to quit acting now and just do that." Or, "Ahhhh,*

you're clearly an actor. Focus your energies there and know that just by being - you are doing the healing work you love."

Another form my purpose-finding-fantasy-takes goes something like this:

Okay, I got it. I'm gonna go to this weekend workshop, do the writing or chanting or meditating work they assign, run a ton of energy work on my body, change all my cells until they are resonating at the frequency of pure consciousness, then I'll come out Monday morning CLEAR as a bell about my PURPOSE, and I will then get busy LIVING it.

So, this "psychic" - is telling me, "Sure, whatever - it's cool. Do all the things. For you, there is no one single thing. After all, you are many." Hence my frustration. Okay. So, that happened.

Then, some very different practices and energies entered my life. I started to play with the tools of a system called, Access Consciousness. Recently, I had a real clarity-inducing-breakthrough-holy-shit moment during an access class. The head dude there, a guy named Gary Douglas, says a lot of super insightful shit. And this one particular day, after having done a LOT of energy work, I admitted this to him in class, "I don't actually want to do anything anymore. Nothing I've been doing feels interesting or exciting in the same ways it used to." To which, Sir Mix-Master, Wisdom-Spewer Gary Douglas responded, as he often does, with a question. Or, in my case, with several questions:

> "Have you decided that in order to choose what to create next, you have to *feel* emotionally excited about it?" He asked.
> "Yes." I replied. "What else motivates people?"
> "Choice."
> "But why choose anything? When there is no drive left to choose anything in particular? It's like everything I thought was me, and everything that drove me before has been dissolved. It's gone."
> "Have you been running a lot of body processes lately?" He asked.
> "Yes." I said.
> "And as a result, are you way more vulnerable and present than you were before?"

"Yes."

"So, are you finally in a place where you could actually create a life that would be fun for you?"

"I don't know. It doesn't seem like it. I got to this place when I was on the Sufi Path as well. I feel like there's no ME left."

"Cool."

"COOL?!"

"Yeah!"

I asked, "But what do I choose?"

He said, "What sounds fun?"

I look at him incredulously, "Fun?!"

"YES! What brings you alive? What interests you?... You see honey, you've gotta start asking 'When was the last time I felt really alive?' And go do more of that."

"Okay. I've actually been asking that and it has me spending a lot of time in nature. Since that feels like the only nourishing, fun thing lately."

"Great." He said, "So go to nature."

"But that doesn't help me understand what work I'm supposed to do."

He explained, "You're not supposed to do anything. What would be fun for me in these *ten seconds*? That's the question."

"Well," I said, "When I ask that, I just get 'Go to nature.'"

"Great."

"But going to nature doesn't pay the rent." I mentioned.

"Nice conclusion. Is there a question in that?"

"No."

He went on, "So, what miracles could be created by you following the energy of what is fun for you? **REMEMBER, questions create. Conclusions stop creation. If you ask for work that would be fun for you, you might be amazed by what starts to show up.**"

"Okay..."

I paused. I thought deeply. Because I'm addicted, above all else, to

my thoughts. Well. My thoughts and espresso.

> "So," I started in again, "Why is the work that I used to do not fun for me anymore?"
>
> "Because honey, you've been living *for* the future, rather living in ten second increments and *creating* your future."
>
> "Okay, so, you're saying if I create moment to moment, and follow the energy of what is fun for me, or sounds interesting to me, you're saying, I'll maybe... *run into* what I desire to create, magically, moment by moment, rather than trying to think it up from my big fat brain in my tiny stupid living room?"
>
> "Yes. Exactly. Follow what's fun. Ask for more of what you'd like to have. And see what shows up."

And all of a sudden, something lit up inside of me. I felt alive. And in my mind's eye, I was shown several images of moments in my recent past when I'd done exactly what Gary was describing. Moments when I've popped outside into nature, felt at ease and happy, had an awareness of something that might be fun to create, and begun creating it. Right then and there. In fact, I realized, I'd been doing that a LOT. And I'd been ENJOYING it. It just also happens to be the case that what I'd also been doing, simultaneously, was judging the crap out of my creations.

The work I'd been doing was not serious enough, not real enough, not grown up enough. I was creating in a truly non-linear way, following the energy of what I truly desire to have, choosing weird, fun-for-Katie-stuff, rather than making a "reasonable plan and executing it." And that way of creating doesn't match my parents' ideas about how I "should be" creating. It certainly doesn't match what America says about how I should be creating. My way of creating, this moment by moment check in of what is light, what is fun, what is true for me – doesn't match ANYONE'S ideas about how I should be creating.

And that's when I really got it:

The only problem. Ever. Is judgement. The judgement, from my

mind, of the choices my body and being desire to make. What if it's actually true that my body is more wise and aware than my mind? What if it's actually true that my being knows everything, and my mind is this tricky creator of unnecessary complications?

And let's be clear, okay? By the time I was having this conversation with Gary, I was already well versed in the idea of the value of "living in the moment," and "being in the now." I'm as well versed in that idea as anyone on any kind of awakening path is in today's world. I mean, Eckhart Tolle's "I became conscious while living as a homeless guy on a bench," story is as ubiquitous as Charlie Sheen's "I went crazy on TV because of Hollywood and too many drugs," story. And Eckhart has been shouting, "LIVE IN THE NOW" to those of us who are listening, for years now.

And I mean, before my big Ah-ha moment, I cognitively got that this "in the moment" thing was what would make all things work, make creation easy, and give me ease, joy, and glory. But I have had a hell of a time actually living into that. Until this conversation with Gary, during which **I got the energy** of what living in the moment actually IS. **I got the energy of choice.** In ten second increments. And how truly, honestly and for real, that's all there really IS. Choice. Without judgement.

So. Okay. Great.

What does any of this have to do with the question: "I'm 30, now what?"

I am a person who has very deeply walked SEVERAL, not one, but several paths to enlightenment. Or at least just basic well-being. I practiced Kundalini Yoga for seven years and stopped when I started to feel super vulnerable and open all the time. It felt too intense. Then, I went to a Sufi Healing School, learned their stuff, practiced it very deeply and used their healing techniques with private clients for about six years. I stopped using it when I started to feel super vulnerable and open all the time. It felt too intense. Then I found Access Consciousness, which is an amazing system of tools designed to allow us to create whatever we'd like to create for ourselves and our lives. It has dynamically helped me get my financial life together. Lately, I've been in love with the Access Consciousness Body Processes, which have unlocked

everything old and stuck in my body such that I now feel... you guessed it... vulnerable and open all the time.

So, I'm thinking of leaving 'cause it's feeling too intense. But this time, I'm not gonna do that.

Here's why. After my chat with Gary, I decided to actively test his suggestion. I decided to ask a question, then follow the energy of what was light – what sounded fun to me. So, I went up to my hotel room. I showered because my body desired to. It felt clean and happy after that. Then, the notion to text my very successful and amazing friend, Jenna, passed through my consciousness with total ease. Dinner with Jenna sounded fun. And enlivening. And nourishing. So, I texted her.

> "Dinner?" I wrote. My body felt excited.
> "But Jenna is so cool and wealthy and pretty. She probably won't want to eat with us." Said the Big B, my Brain.
> "No, B." I replied. "Body and I are excited about this. So, we're doing it." My screen lit up.
> "Yeah, let's go now," Jenna wrote back, almost immediately.

FUN! I skipped downstairs, hopped in an Uber with Jenna and some other folks, and we floated our way to a lovely upscale restaurant.

At dinner, my body insisted on sitting next to Jenna. Big B said, "Don't be so insistent. Maybe someone else wants to sit with Jenna."

Judgement. I must be *wrong* for insisting on meeting my body's desires. "No, B." I told my brain. "Body wants this. So we are doing it."

Jenna and I chatted and laughed, connected and bonded, and about an hour later, all of a sudden, she suggested I come stay with her for 4 weeks during the summer at her beautiful ranch in the midwest. She offered to have me attend a four day class she's offering at that time, teach my improv stuff at it, and get paid well to do so. Ummm...

> Me: "Brain... ? Could you have come up with that one?"
> Big B: "I wouldn't have dared to, actually"

Me: "Cool. So, here's the deal. I love you and stuff. And. We need a new arrangement."

Big B: "Okay. What is it? I'm pretty tired, so I hope it involves me doing fewer things."

Me: "It does. Body and I are gonna follow what's light and fun from now on. We're gonna ask the Universe questions, and we're gonna choose people, places, and things that match the energy of what we're desiring to have, be, and create."

Big B: "Okay... What will I do?"

Me: "You'll be there when we need to write an article for a collaborative book about turning 30, for example, or structure a new joke, or balance the check book or whatever. But, until then, officially Brain, you're on the bench. Okay?"

Big B: "Okay. I could use a good sit down."

Me: "Rad."

And here we are. So, in summation, dear reader, allow me to say these brief words:

1. I've spent years and years, and thousands and thousands of dollars looking for "my purpose." You don't have to do that. Allow me to save you the trouble.

2. What if you stopped trying to "figure out" what your purpose is and started creating your life through tiny, fun choices?

3. What if there is no actual "right path" to find or follow? What if, instead, there are light, fun, empowering, enlivening energies, and heavy, tiresome, disempowering energies. And you get to CHOOSE which you'd like to have more of?

4. And what if choosing what is light, fun, enlivening, and/or all around juicy for you will create MORE of that same energy?

Did you know that that's how life works? That each choice you make has an energetic quality or vibe? And that the energies you choose to follow in this moment create *more* of those energies in your *next* moment?

It sounded fun to ask Jenna to dinner. So I did just that. While there, we created an entire future for my summer that I never could have conceived alone from my big brain. So, was the psychic lady "right"?

I don't care anymore. I've stopped trying to get my life right. Have I found my "life purpose"? I don't care anymore. Why do we feel compelled to guilt ourselves, and make ourselves feel wrong for not having found it? Or feel right if we think we have? Why does everything boil down to a dichotomy of right versus wrong?

What if you could live *beyond* right and wrong? What if you could live from actual choice? If you're choosing between your notions of "right" and "wrong"- how many choices do you actually have? Two.

If you're choosing from what would be fun, light, and enlivening in THIS MOMENT, how many choices do you actually have? A fuck ton.

And here's the nugget we all need to really get. Most people don't actually desire to have true choice. Or true freedom. Most people want to find answers, define their purpose, and have it all figured out. That way, they can get into stale marriages, choose "smart," boring careers they secretly hate or resent, and live "appropriate," lifeless, heartless lives.

Is that what you want? I know I'm getting kind of intense here. So allow me to wrap up, lest I scare you away forever.

Since I stopped trying to figure my life out and get it "right," or "find my purpose," I am having all kinds of fun, I am feeling more connected to myself than I ever have, oh, and I'm making about four times as much money than I've EVER made. Monthly.

On the practical level:

My private client base has quadrupled (just through asking questions - not through excessive marketing).

I teach 5 classes now instead of half of one.

I live in a city I adore.

I live in a home I LOVE.

I have a dog on my lap whose cuteness is literally murdering me right now.

I teach at Stanford (what? Remind me to tell you how THAT magically came about).

I write random books with people I've never met.

I travel to the midwest for creative adult-consciousness-day -camp adventures.

I go to cities like Seattle, Miami and Grass Valley to do stand up shows about consciousness all over the world - whenever I feel like it.

I wear sexy shoes. Except when I don't fucking feel like it. And then I don't.

And, as I go, I get to stop choosing the adventures that seemed fun, but turned out not to be.

And I get to keep choosing the ones that deepen, awaken, and enliven me. Because that's what I'M after.

What are you after?

What is the ENERGY of what you'd like your life to BE LIKE?

What can you choose today that matches that energy so that more of it will show up in your future?

And, most importantly, dear reader, what would it take for you to give up your marriage to your mind? I promise it doesn't have your answers.

Your being does. Your body does. Your spide-y sense does.

Those parts of you know what would be fun for and a contribution to you, your life and living in THESE TEN SECONDS.

Not FOREVER.

They know what is true for you NOW. So, do that. Right now. 'Cause now is truly all there is.

Ask Buddha, Gary Douglas, Pema Chodran, or Madonna. They all say it. And they all seem to be doing pretty damn well.

I say it. And I'm happier than I've ever been.

Thank God.

And with that awareness, and from that space of gratitude, I wonder, on your behalf...

What else is possible now? And now? And now?

CHAPTER 7

The Dance Of Life

BY ANDREA LAMPE

"The trouble is, you think you have time."
~ Buddha

ANDREA LAMPE

ANDREALAMPE@GMAIL.COM
IG: @ANDREALAMPE
FB.COM/ANDREA.LAMPE.58
IN: ANDREA-LAMPE-685056138

With an incessant optimism and enthusiasm, Andrea Lampe, approaches her journey with a passion and a zest for life.

As a young girl, she grew up in the bushes of Namibia, and even then had dreams of traveling the world. After a whirlwind of adventures, everything between studying Spanish in Madrid as a teenager, to exploring Antarctica, and 4x4ing in Mozambique, she stills calls Cape Town, South Africa, her home and sanctuary.

Whilst studying interior design, she realized she had an aspiration to build boats and made a bold move to dive into this new industry. Now having worked abroad a range of expedition vessels and high profile mega yachts, ranging from 50m to over 100m, she has marketed herself as a leading chief stewardess in the luxury yachting world, specializing in the newbuild construction and focusing on the interior setup and management. Her unrelenting drive never waivers and her ambition to learn and grow is equaled with her desire to promote and care for those around her. A lover of cultures and languages, an innate compassion, and a ridiculous sense of curiosity, has allowed her to succeed in a field so diverse and ambiguous.

Having lost her mom in her twenties, she believes she has been gifted with a career that surrounds her with incredible women, several from different parts of the world, many being a great support and inspiration to her. She is passionate about creating opportunities for those around her, and endeavors to mentor and encourage them through their journey.

THE REALITY

MY KNEES WERE COLD, and aching from crouching on the polished marble floor. My fingers, stiff, from vigorously scrubbing the tiles. I tried desperately to mask the pain, the heartache, the emptiness eating me up from inside. Despite my efforts, the harder I scrubbed, the stronger the tears flowed, each drop echoing, as they hit the floor, as if they carried the weight of the world.

What a tragic, blotchy-faced, mess I was. Six months after my mom's passing. And boy, did it hit me like an enraged woman's slap to the face. A punch to the gut, leaving me gulping for air...

She. Is. Gone.

THE GUILT

Here I was, hiding amongst all the tanned and happy faces, sunbathing and dancing on white sandy beaches of the Caribbean. Working aboard some billionaire's fancy yacht, so far away from any form of reality, I wouldn't have been able to tell you what day it was. No one knew my story and no one cared. My mind said: *you are free*. It was supposed to be my new, sparkly, fresh start – days filled with warm sea, salty air and delicious piña coladas, right? The reality was that I was a shadow of a person I once used to be; my soul heavy as steel, sprinkled with some fake smiles, and an exaggerated devotion to my new job.

The relief of not having to answer concerned calls from family members, or politely reply to condolence letters, or answer the same recurring questions of "How are you really coping?" was coupled with the unfathomable guilt of exactly that – running away. Or sailing away in my case.

No one teaches us how to deal with death. I failed tremendously and often. The guilt of not being a good enough daughter to my mother, the guilt of not knowing what to do, the guilt of not doing enough, or doing the wrong thing, the guilt of feeling angry. And most disgustingly, acknowledging the guilt of feeling sorry for myself. I wasn't the one dying of cancer, I wasn't the one having to leave her family behind, or having to accept the pain of never experiencing being a grandmother,

or seeing your children marry or succeed in their careers, or be there for them when they fall.

THE CALM

In hindsight, after many years, I can acknowledge that I did the best I knew how... at the time. Accepting that, was huge. And I still struggle at times. But it's relieving to finally be able to exhale, deeply, letting each breath cleanse me. I am living. And what a waste it would be not to. I will cherish each day, for my mom, not simply exist in a horror of depression and guilt. And also live, indeed, for me. And for the family and friends I have, who have shared this journey.

Sadly, I see so many women who carry their burdens alone; their heavy hearts locking away the painful journeys they have survived. In a world with so many people, fighting their own battle, we seem to have lost the worth of compassion. So many of us fronting a cover of calm and composure, pretending to the world, or perhaps simply to ourselves, that all is well in paradise.

THE STORM

"Life is a shipwreck, but we must not forget to sing in the lifeboats." ~ Voltaire

The unnecessary strain we put on ourselves is overwhelming and destroying. The world in which we exist is challenging enough without the personal pressure we place on ourselves. Social media, gender rivalry, financial expectations, false eternal beauty, and the list goes on. It is simply ridiculous and unnecessary. The pressure to be better, to be the best, is an ongoing internal battle, which I am sure many of us feel on a daily basis.

Particularly women of our generation - we are at war with ourselves. Not only are we expected to be leading career women, breadwinners, mothers, homekeepers, but at the same time, we are to measure up to artificial beauty standards, be fit, multilingual, and more educated.

More. MORE. It must stop. The reality is, we control this. Every single one of us has the power to be happy and refuse to accept the expected norms of society, which can be suffocating.

Of course, I am proud to be a woman of this generation. We are a generation that has a voice, power, and privilege. My parents gifted me the courage to be everything I wanted to be. I never grew up with any imposed limitations. I was told that the world was my oyster, and I jumped with enthusiasm towards every new dream or goal my imagination came up with. I was, and still am, blessed with bucket loads of encouragement and support every step of the way.

With this freedom, however, comes a lot of pressure to perform. And somewhere along the way, I got lost. I focused my energy solely on ambition and achievement. Yes, this can be admirable in small doses when balanced with family, love and friendship. Career success, salary, was a benchmark showing my growth and worth. The more hours I put into work, the better I felt about myself. The more emails I sent off and the more ticks I checked off on the job list, it made me feel good... a need to fill this weird obsession to please. None of this matters though. **No one will remember how clean your house was, or how many hours you slaved away at work, or how perfect life seems to be. So, why do we even attempt to keep up with the Joneses?**

I ask myself, when did the small things lose their importance and value? Looking back at my years as a naïve child, I was utterly happy, and it didn't take much. When my mom would prepare breakfast, I would drizzle honey over my cereal and every mouthful was a joyful surprise – hoping the next spoonful would satisfy my taste buds with sweet goodness. I played in the garden with my brother with plastic army men in the mud, there was no worry of being scolded for getting messy, as kids were supposed to play outside, a novelty nowadays. I danced with my dad, my tiny feet on his, so he could sway with me as the music cheered us on. Oh, was I happy!

Reminiscing about all the joyous moments, reminds us that those are the things that matter. In this world, a connection with others is valued less and less. The world we live in has come to an agreement

with this false satisfaction with everything else other than love, kindness, compassion and time for others. We hide behind schedules, stress, work, fancy clothes and big houses.

THE GIFT

"Go make mistakes." ~ Rose Lampe

This was the kindest thing my mom could have written – a birthday card note I will cherish forever. And all fear of failure, all concerns, and worries melted away in that one sentence. How did she know I needed to read them, to say them out loud, to hear them from my lips, to believe I had permission to live my life? A life that would make me happy, regardless of any expectations.

Be kind to yourself, first and foremost. Sounds so simple, doesn't it? Yet, how many of us come home late from work, no food in the fridge, and still prioritize chores and paperwork over rest and taking care of our health? Why not cuddle up with our loved ones and get a good night's sleep?

Be happy. Two words could never have so much meaning. Do not solely exist. Find something that you can grab onto that gives you laughter and excitement. Try something new everyday until you find your happiness. In the end, what other purpose do we really have other than seeking what makes us happy? That should be the ultimate goal in life. Yet, how many of us really make the time to search for it? How many of us allow time to explore within ourselves what matters to us?

Be truly content with your choices and your actions. Take risks and be bold, but do so consciously and with purpose. Live fiercely, this is it, our one chance. Perhaps your choices were wrong or unwise in hind-sight. But may they be filled with good intentions and love, for yourself and those around you.

THE DANCE

Not only did I feel lost and alone during my mom's struggle with cancer, I

felt like there was nowhere safe I could escape to. I am sure exhausted moms have experienced this with their children when tantrums would not stop, or with career women when they have felt no support from their male peers and had no one to ask for help, or wives with difficult husbands who never show them gratitude, or even perhaps women amongst their female friends, too embarrassed to open up as they might be judged.

I would cry in the car, in the supermarket, in the bathroom at university. There were days I would hide the tears, and there were days I had no strength but to burst out in front of a cashier. Until one day, whilst driving on a busy highway, I pulled the car aside and gave myself a talking to! It was long overdue but I finally accepted that I needed an outlet. And it was okay to want that. I could not go on feeling sorry for myself one more day. I only had myself to blame if I was consumed by this grief. So I decided to join a Salsa class, an accidental blessing in disguise. This was my therapy, and my joy in a place that seemed cruel and unfair. And as the music started, the dancers started to smile and the room was filled with overwhelming jubilation. Each song brought newfound excitement. Each twirl, a swing of elation and each wrong step a loud giggle.

Find your dance. And don't stop until you do so, as it could save your life. Find your bliss - Be it a book on the couch with a decadent hot chocolate, or a walk in the park with your spouse. If it is the next big promotion at work – then own it, and feel privileged to be able to work and not burdened by it. It is our responsibility to be happy, to be truly happy. We owe it to ourselves and to our children, our parents and our friends. Go put those dancing shoes on! And take someone with you along the way. Find value in sharing your happiness and helping others find theirs. These moments are all that will be remembered.

THE END

"*She had not known the weight until she felt freedom.*" ~ Nathaniel Hawthorne, *The Scarlet Letter*

Letting go of all expectations, of one's ego, and false desires, is far easier said than done. It is a cleansing process some experience due to wanting necessary change. Others intentionally work towards this everyday. And some fall into it when they have hit rock bottom, and a chain reaction forces them to reevaluate life and the values they have carried along the way. I believe mine was the latter. And I am grateful for that, as each day now is appreciated and valued with vigor and truth. Each day holds a dance for me, a happy moment. And should it not do so for some reason, I work hard at finding that playful rhythm and truly allow myself to be consumed with happiness and love.

"In the end only three things matter: how much you loved, how gently you lived, and how gracefully you let go of things not meant for you." ~ Buddha

Thank you mom, for showing me how to live a happy life despite a journey so cruel and difficult. Thank you for your love; a humble and raw love which has no end. Thank you for showing me a woman can be strong, powerful, and successful yet, warm, kind and gentle. Thank you for your truths, your honesty, and your unwavering moral compass, you guide me everyday. Thank you for this gift of life. I will dance everyday, Mom.

CHAPTER 8

Approaching Adoption

BY JESSICA GARDNER

"Be fearless in the pursuit of what sets your soul on fire."
~ Jennifer Lee

JESSICA GARDNER

WWW.JESSICAGARDNER.CA
IG: @JESSICA__GARDNER (DOUBLE UNDERSCORE)
T: @GARDNER_JESS_

Jessica Gardner is a student of the world. She has circled the globe twice, travelling to various places in Australia, Europe, Southeast Asia and throughout North America. The highlight of her travels, so far, has been living with a Maasai tribe while helping to build a school in rural Kenya. Travelling has given Jessica a love of people and culture, and developed a deep recognition and appreciation for the differences and similarities that connect us all.

Jessica doesn't shy away from a challenge and believes that personal growth is the goal. Her day job for the past thirteen years has been as an English teacher, but her nights are spent doing yoga, reading, and walking through Central Park or around her neighbourhood. However, she is most ignited when writing.

Jessica is best known for her generosity and perseverance; however, her true strength lies in her wide-open heart and her ability to find reasons to celebrate even in the most difficult situations. These attributes have helped Jessica thrive while waiting, for the past seven years, to adopt her children. She is currently writing a full-length memoir on the unbelievable journey.

Jessica has an honours degree in English language and literature from Wilfrid Laurier University, Canada, a bachelor of education and a master of teaching degree from Griffith University, Australia. She is also a certified yoga instructor.

Jessica is married to her husband, Jonathan, who is the grounding presence and lightning force that makes their life the wild adventure it is.

THE WORD ADOPTION comes from the old French word *adopcion* or directly from Latin *adoptionem*, which means to *"choose for oneself, take by choice, select, adopt."*[8]

I had always wanted to be a mother; I just never wanted to be pregnant.

While we were on holiday in New York City in December of 2010, we found ourselves at crossroads. I was thirty-three, and my husband was thirty-two years old. We had a great thing going; we were happily content with our relatively carefree life as a married couple. We had been together for thirteen years and married for just over four years. We were settled in the seventh year of our careers as teachers. Our only responsibility was to ourselves and each other. We could come and go when we pleased. We didn't think children would necessarily lead to greater fulfilment. But life had become so comfortable, it was kind of boring. We had a longing for more. We had a desire to take things to the next level.

What was our next step going to be? How was I going to combat the pressures all around me from friends and society to be pregnant? Not to mention, if one more person asked me when I was going to have kids, how would I stop myself from losing it on them? What if I didn't want to create a family the traditional way? What was the right move for us? These questions bounced around in my head as our yellow taxi pulled to a stop along the edge of Central Park.

We got out of the cab and stepped onto the sidewalk. The sun shone brightly but there was a dewy chill in the winter air. The ground was covered in a light frost, the sun would soon melt. I reached for my husband, wrapped my arm around his and pulled us closer together as we entered the park. With each step, the sounds from the-city-that-never-sleeps became more distant and the quiet power of nature took over. The contrast between the bustle of the city and the calm breathing space Central Park offered, delighted us on this walk. Hand-in-hand, we strolled in silence, taking in the magical peace.

[8] adoption. (n.d.). *Online Etymology Dictionary.* Retrieved from Dictionary.com website http://www.dictionary.com/browse/adoption

After a bit, I asked my husband, "So what do you think we should do? To be - just the two of us... or create a family? That is the question."

He chuckled, then, replied, "That is the question, isn't it!"

He started by vocalizing the thoughts I had just pondered. It was as though he had read my mind. He reiterated that he enjoyed the life we had. He didn't think children would make us any happier. He paused for a moment and then finished by saying, "But, we are only on this planet once and I don't think I want to leave it without having been a father."

I agreed. To me, living is about experiencing all the world has to offer. So we discussed what our next move would be. We chatted about the option to have biological children and contrasted that with the opportunity to adopt children.

Whether or not to take the biological route had been a topic of conversation for some time. Many of our friends had already had children. With every one of their pregnancies, I sat there and listened to women describe their bodily changes and recount birthing experiences in great detail. Every time, I heard about their growing, stretching, ripping, moving or leaking, I had the same physical reaction... repulsion. Sure I was happy for them and celebrated their choices but if a camera had panned to my face, as the discussion on physical changes progressed, you would have seen me visibly cringe. I'm sure my face would scrunch up and appear as though it were trying to withdraw inward or maybe the corner of my mouth pulled down and to the left, trying to make a run for it, hoping the rest of my body would follow. What you wouldn't have seen was my stomach do a lurch, my insides shudder, and my knees weaken. I happily supported my friends' lifestyle choices. I just knew it wasn't for me. That deep, internal, feeling right there awakened me to the fact that birthing a child was not something I had ever wanted to do. That feeling that began in my gut became the starting point of our conversation. My husband was in complete agreement and so our discussion grew from the internal to the external. Our birth, although different, would be similarly based on intuition, logic and love.

As we talked, the paved paths guided us along a route that meandered left and right, over bridges and under old oak trees.

Our conversation turned to the thousands of children we had taught. I

care deeply about all of my students but every year, there was at least one child who didn't have a loving, healthily-functioning, family. These were the ones that got the biggest space in my heart. I knew we could provide a life to children, like this, to meet their needs and help them flourish.

Partway through the discussion about our students, I pointed out, "Our role as teachers has really shown us that we could love any child." We had taught every type of child. We had learned how challenging children could be. We were aware of how different each child is. We also knew firsthand that every child is completely lovable. And we realized that if we were lucky enough to be chosen to parent a child, we would love him or her fully, and unconditionally.

We arrived at the most photographed path in the park, the mall. Majestic American oak trees rose high above us. Benches lined the wide walkway. We sat down. I asked my husband if having a genetic connection to his child mattered to him. He joked that it could be more of a drawback than a selling feature. He already knew how I felt about this. I liked the idea of a clean slate. Not knowing anything about our child limited our instinct to predetermine, to label, to fill in the blanks. I hoped I'd be a mother who helped that little person to become the best version of who they are, rather than asserting myself on them.

I liked the aspect of the unexpected that comes with adoption. Until we were matched, we likely wouldn't know our child's ethnicity, gender, if they had musical ability, or even if they would have dimples. This big reveal was the ultimate surprise bag. All of the not knowing seemed more interesting and exciting than the familiar. Plus, adoption was in my DNA. I had a long history of not knowing my family history. My maternal grandfather had gone from an orphanage to various foster homes, to finally being adopted at about the age of fourteen.

My maternal grandmother was raised by parents other than her young, single mother. She grew up never knowing who her father had been.

Most recently, my dad found out he too, had been adopted. He had always had a feeling he was. Then, one day just before his sixtieth birthday, the only mother he had ever known, felt it was time he heard the truth. The details about his birth family were few. After a lifetime with one

family, his longing to answer new, unknown questions showed me how important it is for everyone to know his or her story. His experience was, unfortunately, common and indicative of that time in history when an adoption was kept a secret and was something often associated with shame.

My husband and I agreed, in our house, our children would know they were desperately wanted and loved. In our family, our children's adoption would be a celebration. We were keenly aware that with adoption, came loss, and, in turn, trauma but we wanted to be the ones to help our child's struggle become a strength. All parts of our child's story would be known, cherished and his or hers to own.

Through my own eyes, I had seen that families were created through nurture, maybe even, more so, than nature. My family was just as true, just as bonded, just as loving, as any other. A family is never just created solely by biology. Love and connection must be fostered through caring and generous action.

By this point in our conversation, we got up and walked a short distance and arrived at the Bethesda Terrace. We stopped and looked over the fountain below and lake beyond. We made our way down the grand stair-case and walked toward the fountain. The angel at its centre seemed to welcome us, arms outstretched, to this enchanting place. The cherubs below her looked as though they were about to dance around her feet. We peered into the water and saw the coins deep below. We didn't toss a coin in with the others because we weren't making a wish, we were making a choice. That was part of the appeal of adopting. We were actively electing to be parents. The decision to adopt children felt like we had more control over the end result than waiting for something to happen to my body, or if it didn't happen than giving the control to a doctor.

I wanted autonomy over my body. A woman's body is always viewed, judged, and commanded by society for what it should or should not be. By keeping my body to myself, I was opting out of playing this game. I understood I wouldn't be getting any pregnancy points, but that was okay because I would be meeting my own standards. I had a desire to go against the norm and create my own rules. I would determine my worth rather than

measure myself against a public yardstick.

I looked up and into the distance, as we continued our walk. I saw the build-ings bordering the park. The walls created a concrete hedge and signaled the separation between the man-made structures and the organic green space. This image before me, seemed to parallel our place in traditional society. Here we were in the park, in many ways, opting to go against the typical, structured way to create a family. We had found this space to create in a different way. We knew that through the adoption process we wouldn't be choosing a child but rather they would be choosing us. In the vetting, we, as potential parents, would be heavily screened by a government-appointed social worker, who would complete a variety of background checks including, local and federal police records, and inter-national verification through Interpol. Personal character references would be needed from family and friends. Proof of financial, psychological and physical well-being would all be required, in order, for the social worker to write a report recommending us as eligible to adopt children. This report would then be sent to the government for approval. We would then be able to join an agency. The agency would be responsible for matching a child with us. Adoption is always child-centred, which means that the priority is the child's needs rather than the parents' wants. The determination to match a child is made in the best interests of the child, as it should be. We had travelled around the world and had seen firsthand the children locally and globally who needed families. We didn't feel the call to add more children to the planet when there were already so many who could be helped and taken care of. The act of deciding to have a family lies in the wants of the parents, but we hoped that by electing to adopt children, we were making a choice to help another and equally take into account his or her desire. We wanted our family's foundation to rest on a balance of choice, respect, and love.

There were so many aspects to consider in the decision to build a family but the greatest was love. I loved my husband without limit. He loved me in equal endlessness. Our love yearned for a place to expand to. We had a lot of love to give. We wanted to share this with children. We wanted to fill them with joy, happiness, encouragement, confidence, and our boundless,

unconditional, love. We knew that with our strong partnership we would be prepared to counter any unknown challenges. The desire to do our all was the best any parent could do.

We didn't have all the answers. We didn't even know all of the questions to ask. No amount of thinking and talking could explain what we intuited. In silence, we walked for a moment. Deep inside, in the truest part of our being, we sensed that adopting children was the way we were meant to create our family. It just felt right. We didn't know what the future would hold, but we both knew we would regret not taking the steps to become parents. We would pursue adoption with the belief that if it was meant to be it would happen. Trust in our instincts was the same way we had handled every crossroads, and our life had turned out pretty good so far.

I had entered the park with questions. Now, I realized I had had the answers too. The next step always had to be based on what felt right from where we were. If I felt strongly about my decision then that would give me the confidence to move forward and handle any external pressures. If I made my voice louder than the ones around me, I could overcome the comments and questions from people who saw a different path from mine. There was no right way or wrong way to live life. If I could feel that, and breathe that in my whole being, then others would come to accept it and maybe even support it. If they didn't support it or understand my choices, it didn't matter because I would be moving surely. The next level our society can strive for is to not only receive, but value the choices women make, even if they are different. This should become the new norm.

Just then, the path we were on rounded. Ahead, I saw children climbing on the Alice in Wonderland statue. I said to my husband, "So, we made our decision? We are for sure, all-in, on this?"

He replied with his charming grin, "Yep. We are adopting children!" With those words, I took a breath in. My heart filled and rose in my chest, like a helium balloon soaring up to the sky and into the future.

"When we are sure that we are on the right road there is no need to plan our journey too far ahead. No need to burden ourselves with doubts and fears as to the obstacles that may bar our progress. We cannot take more than one step at a time." ~ Orison Swett Marden

SECTION 3

I'm 30, And It Didn't Go According To Plan

Featuring
Saoirse Ke Kelleher, Kelly Rodenhouse, Kim Santillo, Jessica dos Santos

OPENING COMMENTARY BY KY-LEE HANSON

Section 3 Opening Commentary
BY KY-LEE HANSON

HOW MANY OF US HAD *EXPECTATIONS* FOR OUR THIRTIES? It could be expectations of ourself or expectations from others. Anyone that knows me, knows I LOVE talking about expectations and how, *dramatically put*, they are the root of all evil and self doubt. How many of us feared that if, by age thirty, we don't have it all figured out - we may be doomed? How many of us spent the first few years of our thirties feeling borderline manic and in a constant state of growing pains? Maybe you relate and maybe you don't, but some women in your life probably do.

While researching for this book, I came across an all to perfect article that states:

"Many things that happen in your life can disrupt your emotional health. These can lead to strong feelings of sadness, stress, or anxiety. Even good or wanted changes can be as stressful as unwanted changes. These things include:

- Being laid off from your job.
- Having a child leave or return home.
- Dealing with the death of a loved one.
- Getting divorced or married.
- Suffering an illness or an injury.
- Getting a job promotion.
- Experiencing money problems.
- Moving to a new home.
- Having or adopting a baby." [9]

[9] FamilyDoctor.org. (n.d). *Mind / Body Connection: How Your Emotions Affect Your Health.* Retrieved from https://familydoctor.org/mindbody-connection-how-your-emotions-affect-your-health/

In this section, Saoirse shows us what it means to persevere and have a strong foundation (be it learning a new skillset, getting further education, making more money, or even asking for help), and Kelly Rodenhouse shows us that you do not have to have a "Pinterest-esque" life - you do not need to only look for happiness and a sense of self within the title of being in a relationship, you can actually heal yourself, and find it within yourself. Kim Santillo shows us that it is never too late to walk away from a career that no longer fulfills you, and to really discover your true passion, while Jessica dos Santos shows us that knowing what you truly desire, and asking for help doesn't make you any less ambitious, devoted, or goal oriented. Instead, it can help nourish you and grow you to be a better woman.

In some way or another, we likely relate to you. In many ways, we are all connected. This next section tells stories of women trying to live up to social expectations, create a success routine to societies standards, and their own things-should-be-this-way thought patterns only to realize, they were not happy. This happens in career AND family life. So what did they do? What are they still doing? What can you practice as well?

CHAPTER 9

Perseverance Is Key

BY SAOIRSE KELLEHER

*"You have this universe in the palm of your hands,
now what are you going to do with it?"*
~ Saoirse Kelleher

SAOIRSE KELLEHER

S.KELLEHER@KW.COM
SKELLEHER.KWREALTY.COM
WWW.GOREAD.COM/AUTHOR/SAOIRSE-KELLEHER
FB: SAOIRSE KELLEHER @SK.KELLEHER

Saoirse Kelleher was born into a family of entrepreneurs, so it was only fitting that she became an ambitious entrepreneur herself. It's been a life of entrepreneurship that has run through her veins, and has also seen its fair share of ups and downs. Filled with many failures and successes, including a chapter of travel around the globe.

Although she can say her best successes yet have not been career related as she always imagined. Instead, she was taken for a huge detour in her entrepreneurial life by being blessed with 4 beautiful children. This blessing led her to reevaluate her view of entrepreneurship and build what seemed to always be missing. She realized that what was truly lacking in order for her entrepreneurial ventures to succeed, was a well thought out foundation. With the discovery of this missing ingredient, Saoirse has since been infusing this into her business and life. This has enabled her to study, finish, and join both the healthcare industry and become a licensed realtor, alongside her journey of motherhood.

Saoirse Kelleher looks forward to achieving the success that has been dedicatedly worked at since she was a child, and also showing her children how to do the same for themselves. She hopes to inspire anyone who has put their absolute all into something, while their boat has yet to sail in, to keep persisting. She is here to help empower others to never give up, to remember that perseverance is key, and to help them truly believe in themselves.

LIFE IS GOING TO KNOCK YOU DOWN. For most of us, it is inevitable. You need to pick yourself back up. Always, no matter what! Perseverance and sheer resilience is key – we need to believe this. It ain't no Disney fairy tale as we were taught to expect as kids. What it is though, is a windy road with an ultimate goal. We may have envisioned a straight line which could have made the sways and turns in our twenties very frustrating. By thirty, I now see that the ultimate goal can be reached, it may just not be point A to point B like originally imagined.

Here we are in a new decade which they call our dirty thirties – do you find yourself feeling like a failure or feeling unfulfilled, unaccomplished? Do you ask yourself why? A legitimate factor on how we arrive at feeling unfulfilled is simple. We were kids, teenagers, and then in our twenties with a perception of what our success looked like. Therefore, if our thirties doesn't look like our original vision, we may feel depressed and disappointed; dismissing that "life" plays a factor in how we got here. Allow me to alleviate any thought of defeat as I take you on a ride to discover that you may have already reached your success without realizing it. And let's take a look together at the next steps on how you can obtain your desired success.

THE JOURNEY

I come from an entrepreneurial background, filled with some success... and failures galore. Yet, I still pick myself back up, each and every time! I used to think in my early years that I was one of the lucky ones, as I chose my path at the age of sixteen. Off I went into the world, with the lack of wisdom, where all I had going for me was what I learned at my first sales job in British Columbia. Hence, I used to live by the motto, *"Fake it until you make it!"* (I don't do so anymore). With all the odds stacked against me, what I did know was that I strived to the highest degree, and was hungry for an entrepreneurial venture of mine to become a success. It was in my veins.

Much of my struggle came from the ongoing failure of these endeavors. I was under the impression that if you put your absolute all, your tears, your sweat, and your devoted time into your baby (your enterprise), there was no way it could fail. I found out the hard way that this is not always the case. In my twenties, this resulted in a constant battle with anxiety and depression due to

ongoing disappointment. Crusading such misfortune and refusing to surrender, I then travelled the world, literally. I've been to countries I could never have even dreamed of going to, living continents away.

During such ventures, I had a glimpse of my entrepreneurial success, at the young age of twenty. Lacking the maturity and not fully understanding the facets of human nature, it quickly came crashing down and sent me into a vicious spiral of negativity including hundreds and thousands of dollars in debt. Therefore, in hopes of not being deceived again, I went back to school several times to gain more knowledge academically. On the personal front, I also unfortunately at one point, had life sway down a winding road that led to a domestically abusive relationship. Being what I've always considered a strong woman and true feminist, this one came out of left field and was quite a shocker to me. Amongst all this adversity, I remembered the words of this song, *"I know I can be what I want to be. If I work hard at it, I will be where I want to be"* by Nas.

FAILURE & SUCCESS

If you feel like I do, you may be wondering that though you have already done so much and have had many experiences up until your thirties, why is it it that we still feel like failures? I have come to realize that this is because as a society, we are conditioned to place a monetary value on what we deem a success. So if, by the age of thirty, we have not met our "monetary value," we may start feeling like failures. I may not have reached success in the ways that society would call successful, as I'm still working hard and persevering down that winding road. Although, what I do have to show, and what will ultimately be my biggest successes are my four beautiful and healthy children, alongside unbelievable memories and experiences, and a foundation that I created to persevere in my thirties. Remember, **success is a state of mind, and not solely a monetary value.**

Give yourself the gift of writing down your uncovered successes as you need to be your number one fan, nobody else is going to be this for you. And stop being so goddamn hard on yourself! Instead, congratulate yourself on what has brought you to your thirties, and create this new chapter of your thirties for yourself. The beauty is that you bring with you all the

wisdom, lessons, and knowledge you have attained throughout your past years into this new decade. Embrace them all, whether you're sitting there feeling accomplished or whether you're feeling like a complete failure. Just believe that each back breaking obstacle has made you the beautiful person that you are today. In hindsight, wouldn't you say that is what our twenties were meant to be; tons of experiences and tons of failures? The trick is knowing how to turn that knowledge into your foundation to succeed.

Failures are in actuality our biggest success. Most successful entrepreneurs failed many times before having victory. Success is not easy, so failures are the learning lessons we need in order to thrive and reach our inner success.

CREATING YOUR FOUNDATION (ACTION PLAN)

To everyone's astonishment, I ended up with four incredible kids by the age of thirty. I quickly understood that being an entrepreneur with small children can be challenging. This did not stop me, instead, it created my new realization of needing a proper foundation to thrive. Therefore, I went back to school stepping away from my entrepreneurial path, and I entered into the world of healthcare. As with kids and all my failures entrepreneurial wise, I realized I was unable to provide the life I wanted for my children without any stability. I also obtained my real estate license which has allowed me to still spread my wings entrepreneurially, yet I'm doing it with a foundation this time.

I have to say though, none of this has been particularly easy after adding four young ones to the mix. It has been a challenging road, especially as I then decided to do this as a single parent. Studying and children do not go hand in hand.

However, it is never impossible to recreate yourself; it is just a bit more challenging as a result of having more and greater responsibilities. This glimpse into my world is to show that you are not alone; we have a path that we choose, but we get hit with life, and end up with winding turns we may have never envisioned. Yet, I am so thankful and blessed. If it wasn't for all of these detours, I would not be who I am today. These roads have taught me patience, compassion, determination and PERSEVERANCE only to name a few.

In our twenties, we may have had a vision of our success, but our priorities were way off. For most of us, our mind was not strong and developed enough to stay on track. In my twenties, I came up with a large down payment while working overseas. I knew I had to put it to good use. So I called my mother and asked her to hire her realtor to find a condo for me to buy. While she had her realtor looking into this for me, to my demise, I had a flight to New York. Losing sight of my goal while in New York, I thought I would experience what you see in the movies – shop till you drop. It felt like a natural high, there I was on Fifth Avenue literally shopping till I dropped with too many bags to hold onto. I managed to spend my down payment for a condo on a New York style shopping spree. Which cost me a good $20,000. In hindsight, I think, *How I wish I had such money now, or how my life would have looked different if I had owned that condo and what it would do for my family financially at this time.* However, what I definitely know now is that when I was twenty years old, my vision was there, but my priorities were clearly off, and it was easy to lose sight of my end goal. Now, in my thirties, I can rest assured that I would never fathom such silliness.

So, if you do not have a foundation built yet, how do you build your foundation? How do you determine where you're trying to go? Are there gaps in your road? Brainstorm and jot down what is missing, and what is holding you back from getting you to your dream life. Your foundation could be an educational upgrade you need to do, money you need to save, a career change, or creating more social connections. Add these missing pieces to your puzzle to achieve your desired success. Remember, **your foundation knows no fear.**

ACCEPTANCE

I feel we could agree that by the time we reach our thirties, we have all had our share of ups and downs. **Life is filled with uncertainty, however, what is certain is that we are getting older. So let's get wiser.** May we always remember that we choose our path and we can do whatever it is we put our mind to. Anything negative that we've encountered was not to our demise, it was just a stumbling block in our way. I choose to accept my deviations to my end result – do you?

The picturesque image of the white picket fence is so black and

white. It's marriage, a home, career, car, and two - no more than two - children. My life couldn't be farther away from this picture. I have four children with no marriage, *at one point the fancy car,* and now the falling apart lemon that sounds louder than a garbage truck, and of course the ongoing pursuance of ultimate inner success. When living in the city, I never found a level of comfort due to always feeling judged, especially because I wasn't part of the norm of having two children. Most days, I would have to constantly coach myself on our outings, as it felt like no matter where we went, I would get nonstop comments, or stares about all my young children. This was brutal, super uncomfortable, and seemed to last for what felt like a lifetime. I used to always think and repeat in my mind that people meant well. Just as any mother with one child would think it's overwhelming; one would imagine when they saw a mother of four, they would think - *how in the world do you manage that?* Or maybe they were thinking given today's cost of living, *how do you afford this?* No matter how I tried to swing it, I still felt like a zoo animal whenever we went out.

Therefore, when my kids started daycare outside of the city, it became the only place I ever felt comfortable trekking all of them to. It felt as if it was the only place we could go to where we did not feel awkward, or get unsolicited commentary. I always imagined that it was due to the other parents being busy and wrapped up in their own lives. Of course, the beauty of this came to an end one snowy and stormy day when I went to pick up three of my four children from daycare. As we exited the building, I was trying to guide them to the car. I had one of them in my arms, and was guiding the other two kids to hold onto me so that we could make it to the car with no accidents.

I suddenly heard this voice cackling and yelling out all sorts of things I could not understand. However, what I *did* understand was that they were sitting there pointing, laughing, and shouting out the fact that I had three kids, and how it was crazy, and how was I managing. I politely smiled and gave a nod replying, *"I hear you."* As I continued trying to focus on my children, I fell into a snowbank with one child in my arms, and the other two hanging on! Hysterical laughter ensued in the background.

With embarrassment, I got all three kids in the car as I tried to find my composure. Having no such luck, I burst into overwhelming tears. I was so upset at the fact that my one safe place had turned into everywhere else I go. To think that I would now have to put my strong face on and my nonstop confident talk to be able to get by all the comments and stares here too, was devastating. Slowly, myself-taught resilience kicked in and I started grasping onto anything that would make me feel better. I snapped out of that mind frame and thought, *haha, they're making fun of me with my three kids... they should see me when I have FOUR little ones with me, I wonder what they would say then.*

It finally hit me; once I was calmer, I came to accept the fact for the first time that I have four children who I adore unconditionally, and I wouldn't have it ANY OTHER WAY! Each of my children are so different in their unique ways; they have a piece of my heart and are now my perseverance, resilience, and happiness. If I had fewer children to avoid the non-stop judging and criticism, then it would mean I would have to give up two of my kids, which is absurd. So if it means that I'll have to go through this non stop judgement even in places where I once felt safe, so be it.

Is there anything kicking around in your life that is outside the white picket fence norm? **Discover it, own it, accept it and be empowered by it!**

NOW WHAT?

Create a new chapter in your life, use your thirties to STABILIZE your successful inner DREAM. At age thirty, are you done with the self-doubt? No. However, I choose to believe in myself like I used to, I choose ongoing success. We will encounter obstacles along the way as they are part of our growth process. A good way to get past these hurdles is to use positive self-talk, repeating in your mind in the hardest of times that, *"This too shall pass."* Remember with every negative, there's a positive that will soon follow. A good way to thrive when you're feeling blocked is to keep pushing forward and keep building your foundation.

This decade is based on believing in ourselves because if we don't, no one else will. Create your big WHY - why do you need to succeed? It has to be

larger than a choice; it has to be a fervent desire and need. I have no choice but to make it, as I have four children depending on me. They deserve an amazing life, and I have to create it for them. This is my powerful why - what is your dominant WHY? If what we are currently doing is not our ultimate dream, recognize that this is okay as well, and do not beat yourself up about it. Instead, see it as a gap being filled in your foundation to your ultimate goal. At 30, we need to believe that we do choose our life and we need to get back to basics, the innocence of being a child. When we were children, we felt we could do anything. Ask a kindergarten class to raise their hands on everyone who could sing, or anyone who could dance, or anyone who wanted to be a doctor, etc. I can assure you, all those little hands will go up. Then, we became teenagers where we had some fear; our twenties consisted of visions and lots of anxiety, and our thirties now need to know no fear. **May we allow ourselves to have the dreams of a child, but also a wealth of knowledge alongside it.**

Your thirties are "clean up and own up" time - anything that may hold you back that you've thought of over and over again such as, this isn't good, get rid of it! We need to stop living in our heads, and put our thoughts into action. Life is what you make it. It is an inspiring concept, yet it can be a challenging one to live up to. We may think, *how is this possible when going through rough times?* The key to this quote is perseverance. All I can do is scream out how important perseverance is. An important part of this process is that as women, we need to realize that unlike in our twenties, we are not against each other; rather, we need to pull together! We can, and we will just like our foremothers, create wonderful opportunities for ourselves, each other, and our kids and teach them the way. Create a foundation for yourself with all the bricks that have been tossed your way. If you already have your foundation in place and are successful, then never forget self-care and ongoing perseverance.

"Conquer anything you desire." ~ Saoirse Kelleher

CHAPTER 10

Learning To Live My Actual Life

BY KELLY RODENHOUSE

"At some point you just have to let go of what you thought should happen, and live in what is."
~ Unknown

KELLY RODENHOUSE

IG: @KELLYRODENHOUSE
FB: @THEKELLYRODENHOUSE

The quickest way to Kelly Rodenhouse's heart is with pineapple pizza and Jimmy Fallon. Born and raised in West Michigan, she spends her summers at her family's lake house and the cold winters wishing she lived elsewhere. Maintaining her "Auntie of the Year" status awarded by her six beautiful nieces and nephews keeps her grounded in "The Mitten State," but she dreams of life in the big city.

She's a medical transcriptionist by day, and an online health and fitness coach by passion. Behind a keyboard has always been a place where you could find Kelly. Her love of writing began long before she could spell, plucking away at random keys of her grandmother's typewriter tucked away in her closet.

As both a creative outlet and a way to process life, she returns again and again to writing. She has spent the last thirty-four years making people laugh, whether it be at her own expense or with a one-liner from the database of useless trivia she retains in her head. Follow her on social media to get your daily dose of humor, truth and inspiration.

BLINDSIDED

"I WANTED TO LOVE YOU IN THE WAYS THAT I SAID I DID. BUT I DON'T. I'M SORRY." He gently placed his apartment key on the kitchen counter and walked out the door.

For the next nine months, I felt like I was living in a fog or as if someone had turned the lights off in my life. I didn't know what was up or down, left or right, and nothing made sense to me anymore. The anxiety that erupted in my bones caused me to feel paralyzed and stuck; so much so, that on some days I had to be verbally instructed over the phone to get out of bed. "Put your right leg on the ground. Swing your left leg out. Scoot to the edge of your bed and sit up. Now stand. Are you standing?" The paralyzing anxiety stemmed less from the heartache I was smack dab in the middle of; but, more so from a deep, dark fear that this was how life was going to be from now on. Was this my new normal? To feel stuck in a world that felt confusing and chaotic? Would I always be lugging around this heaviness wherever I went? Would I be able to take someone at their word again? Would entering into new relationships be accompanied with underlying doubt about their sincerity? Was I going to drag around baggage of trust issues going forward? Would this cloud of darkness that was looming over my spirit ever evaporate?

I was in absolute survival mode. The main objective of so many of my days was simply to survive. My shower became a sacred space for me; a retreat in my tiny apartment where the cry of my heart would be drowned out by the fan and rushing water; a place where I hoped the neighbors couldn't hear the sobs escaping from my soul. My family and friends became weary trying to lift me repeatedly out of the darkness that surrounded me, and I soon found myself silently weeping in my doctor's office, embarrassed as I explained to him the reality of my world and was quietly being written a prescription for Xanax. I called on a counselor at the insistence of my loved ones and when I arrived for my first session, I sobbed the entire hour. He suggested that maybe I should give myself a few days to catch my breath and come back another time. He sent me on my way, but not until I had signed a safety contract that I wouldn't harm myself or anyone else after I left. I could probably uphold that promise, I

thought. But, friends were on standby and on call; you know, just in case. One morning, my parents both bailed on their jobs and showed up at my doorstep, feeling uneasy about me being alone in my current state. I sat there with my dad on my left and my mom on my right as I rapidly swayed myself back and forth. My mom finally broke the silence by quietly suggesting, "Maybe you need to be admitted. We just aren't sure what else to do. You need more help than we know how to give." I guess this is what my rock bottom looked like.

REWIND

Aware of how I had rushed relationships in the past, I let him take the lead. He set the frequency in which we spent our time together, I waited for him to say that four-letter L word first, and he painted an incredible picture of what our future together would look like, unprompted. While we snuggled up on the bunk beds at our lake house, I listened to his vision for our life together; my heart was freaking out on the inside, while I tried to play it cool on the outside. A proposal at Disneyland for my birthday, and married the next 4th of July so I would have fireworks for every anniversary. I remember responding as I wiped hot tears streaming down my cheek saying, "I just can't believe we are on the same page, and that you feel the same way as I do. I love you so freaking much."

My sister had introduced us on a Sunday, we shut Starbucks down being forced to leave against our will on Wednesday, and by Saturday we were inseparable. He was a freaking babe with incredible hair and stunning blue eyes. Over the seven months that followed, we fell in love. And we fell quickly. My favorite human, the love of my life - the one who I had been looking for was actually, finally here! I felt like having secured my permanent "Plus One" earned me some sort of credibility for life. I had arrived to the ultimate goal, right? I was about to secure one of the first big milestones in the American Dream! Bring on my built-in travel companion, my obvious game night partner, and a lifetime of memories and adventures alongside my favorite sidekick!

But it wasn't even two weeks later that the door closed and he walked out of my world. Wait. What happened to the 2.5 kids, the dog, and

the white picket fence? Disney? Fireworks? Where did that picture he just painted go? I was blindsided. My days were dark, and the hope for anything different than that seemed light years away. I feared this had become my new normal and that the anxiety that shook my bones would be everlasting.

From a young age, as I began to take in the world around me, I started to piece together and form what I believed an ideal, successful life would look like. From what I observed, it looked like finishing school, finding a mate, having a big wedding, and a few years later making some really cute babies.

My oldest sister got married when I was thirteen. We frequently consulted the forest green three-ring binder during dinnertime that housed the wedding planning necessities; swatches of colors, names of florists in the area, venue information; you name it, it could be found between the covers. This binder was the 1995 version of Pinterest. Falling in love, saying "Yes to the Dress," and then promising forever to your hunk in front of roughly 300 of your closest friends, complete with two white doves, a chocolate fountain and a photo booth, right before popping out babies was the norm in the culture that I was surrounded by. It's just what you'd do! But, what happens if you don't? I had a hard time naming someone I could ask! Single adults are like an endangered species around here!

As the years passed, especially as I entered my late twenties, and still single, I began to get prodded more and more with questions I didn't have answers to. Running into people I hadn't seen in a while made me want to duck and roll out of sight, and sprint in the opposite direction. I knew the questions that likely would be coming if I didn't. "Hey! Are you married?" "WHAT! Why not?! Why are you still single?! Where is Mr. Right?! Oh my goodness, I have a FABULOUS idea! I must introduce you to my cousin's co-worker's grandson! I heard he's recently single, so that means you two would be PERFECT together!" She would clasp her hands together and in slow motion raise them to the heavens, grinning from ear to ear at the brilliant love connection she had just thought of. I would likely politely decline her attempt at matchmaking, sheepishly smile, and wish her

a great rest of her day as I walked away, shuddering at the sheer awkwardness of the conversation that just took place in the middle of the supermarket with a woman I hadn't interacted with in well over twenty years.

I would leave, thinking about how I could have answered her question. *Why was I still single? Why hadn't I found my Mr. Right?* Maybe, it's because I never got the often highly sought after MRS degree at college. You know, when everyone goes to college and around their third year start to make moves toward the degree they were truly hoping to acquire, the MRS degree - "The future MRS. Smith." And maybe, that's where I went wrong. I'm a college dropout. I only made it two years before I bailed.

Perhaps I could tell them that it's actually kind of a funny story. I work from home and the bar scene really isn't my jam. Once I hit the ripe age of twenty-five and began to freak out as to how on earth I would meet Prince Charming, I did the next obvious step. I called in reinforcement in the form of Match.com. Maybe attention to details aren't really my thing; because, whoops, I accidentally listed myself as a MALE. And I did so for seven years! It's possible that I haven't found love because the only people I was getting matched with were homosexual men or women who were ultimately confused as to why they were being matched with me, clearly a woman.

I could also tell her that as a young girl, I assumed I would get married and have babies, but that truthfully, instead of dreaming of the "big day," I spent my time dreaming of living in a big city, hitting deadlines from my 100-story-tall office, while drinking lots of coffee. Would I dare to mention to her that I, generally speaking, don't mind being alone and that babies actually kind of stress me out, or would she go straight home to email the prayer chain?

Or maybe, I would reply that it's because I have spent the last 8 years digging myself out of a pit of darkness and picking up the pieces of my shattered world.

However, my new matchmaker probably didn't really have the time to listen to all of that, so I would just shrug my shoulders and say, "You know, I'm not quite sure!"

REBIRTH

Eventually, after countless counseling sessions, many conversations with trusted friends, and a new-found love for tackling life's ups and downs with fitness, my fog began to lift. I started to see the world a little bit clearer, and my world began to slowly stop spinning. The hope for normalcy in my heart began to rise. I was ever so slowly awakening with a fresh, new perspective.on life, love, and the pursuit of my own kind of happiness.

Maybe someday I will find the kind of love they make movies about. That would be awesome! Or, maybe I won't. And that's okay, too. I've deleted my "Dream Wedding" Pinterest board and replaced it with my "Dream Life" board. I've given myself permission to step into living the life that is buzzing all around me, and take the opportunity to define my own version of happily ever after. What if I dropped the heavy load I had grown accustomed to carrying and extended forgiveness to the one who hurt me? What if instead of putting my energy into accomplishing unspoken pressures of a "successful life," I just started to live my actual life - you know, the one I was living, right here and right now - and what if I showed up unapologetically? What if I said, "I'm ready to receive what's in store for my life." That has recently become the anthem of my heart.

What Now?

I am alive.
I am here.
I am awake.
I am ready.

"Tell me, what is it you plan to do with your one wild and precious life?"
~ Mary Oliver

Okay, since you asked, here are my answers, Mary. I plan to continue to show up for my own life and make memories whether I arrive solo, or accompanied. I will allow myself to "feel the feels" when there is a void or a longing, but will not let it consume me. And instead, I will relish on the blessings that abound all around. I will celebrate success by my own

definition. I plan to live, keeping my eyes wide open in expectation and anticipation as my life unfolds in front of me. You will see me continue to do the work to uncover the hopes and dreams that were placed in my heart from the beginning of time; stripped of any expectations from outside sources. I'll continue to pack my suitcase and explore life's playground, with or without the built-in travel companion I thought was a prerequisite. I will repeatedly get back up when life knocks me down because maybe, just maybe, life is supposed to be less about avoiding the bruises, but collecting the scars to prove you actually showed up for it. I will remind myself as many times as I need to that life is a gift - because I know what it feels like to be dead before I have been buried, but I also know what it feels like to have breath come back into my dead, dry bones.

MY HOPE FOR YOU

Maybe you don't recognize the world you're living in right now. It could be that life looks nothing like you imagined it would, or maybe your dreams have recently been shattered into a million pieces. Perhaps you don't feel like you belong, or life feels heavy. Maybe the dreams your family have for you don't actually fit the dreams YOU have for you. Maybe you are struggling simply to inhale. I feel you, friend.

"You can change or stay the same, there are no rules to this thing. We can make the best or the worst of it. I hope you make the best of it. I hope you live a life you're proud of. If you find that you're not, I hope you have the courage to start all over again." ~ F Scott Fitzgerald

It might feel like you're starting your life over from ground-freaking-zero. And maybe it's because you are. The debris may just be settling, and you're clinging to the hope that something beautiful can be made out of the ashes scattered around you. You may not see it today or tomorrow, or even 8 years from now - but someday, I hope you can reflect back on your days and see how your world crashing and crumbling was in fact the most precious and important pieces of your life falling into place. And when you feel most defeated, may you be

engulfed by love, helping you to put one foot out of the bed, and then the other, instructing you to stand up and punch back. May the deep ache of your heart be eventually transformed to unexplainable joy. May you know that you are loved to your core – not for what you have done or what you haven't done, but simply because you are. **May you take ownership of the desires of your heart and pursue them unapologetically as you seek to live your actual life, the life you're living right now.**

Finding The Courage To Do What Makes You Happy

BY KIM SANTILLO

"Do More of What Makes You Happy"
~ Unknown

KIM SANTILLO

WWW.KIMSANTILLO.COM
LINKEDIN: KIMSANTILLO
FB:@ACHIEVEYOURVISION

Having worked in a high pressure, competitive medical sales market for over seventeen years, Kim has a keen sense for what it takes to build trust and credibility, establish long-term relationships, and successfully run your business effectively and efficiently. Kim graduated from Penn State University and then obtained her MBA from Robert Morris University.

She has always enjoyed business strategy, managing teams and projects, and organizing system and processes. The thought of starting a business has always been a dream. Deciding to put all her passions together and build a job and life she truly desired - Virtual Sanity was created. Kim enjoys partnering with business owners to help them put the systems and processes in place, and then help manage their teams and projects so they can focus on achieving their vision.

"The best feeling is when someone thanks me for being a crucial part of reaching their vision and goals."

Kim wants to empower other successful corporate women to break through the mold and truly create the life they want. She truly believes that as women, we are strong and powerful, and the only thing that can stop us is ourselves.

She lives in Pittsburgh, PA with her husband Greg and two sons – Ethan (12) and Matthew (8). Besides running her business, Kim is passionate about travelling, wine, fantasy football, purses & shoes, and is an avid Pittsburgh sports fan! Check her out on social media and say hello!

I'VE ALWAYS BELIEVED THAT MOTIVATION comes from within. I mean yes, there are great leaders who can really motivate people and there are great motivational speakers, but have you ever listened to one of those motivational speeches? Yep - you leave feeling all pumped and raring to go, and then in a day or so the hype has died down. I firmly believe the desire to succeed and do more is a self-trait. So, after graduating from Penn State University, I immediately started thinking about what I could do next. Maybe that's part of my problem, I am always looking for what is next instead of enjoying the now. I used to call myself a life-long learner, but I now believe it was just a thirst for wanting more. So, I decided to immediately get my MBA a few months after completing my undergrad.

At the same time, I started my corporate work history. I was in medical/pharmaceutical sales – a very lucrative and rewarding job. I cannot even count on my fingers and toes combined the amount of times someone would tell me, "Wow, you're so lucky to have that job. It's a GREAT job!" Those sentiments would weigh on me heavily as I progressed through my career.

In my 20s, I followed the typical plan as I always saw it - I worked a fairly demanding corporate job, got married to my wonderful husband Greg, bought our first and then second homes, and had two boys who are part of my "why" - Ethan and Matthew. It's hard to balance a job, house, and kids, but I did it and I must say for the most part, I pulled it off. Quite often, I'd have people ask me, "How do you do it all?" I do have a tendency to overextend myself, but somehow I always pulled it off.

As I got into my thirties, I changed companies a few times - mostly always for good reasons - for a promotion, to gain more demanding skills, go to a start-up, etc. And then somewhere in this career progression, it happened - I cannot really pinpoint when it occurred, but I got burnt out. I didn't love my job anymore - yes, the industry had changed a lot, but I got annoyed with the mindset of the corporate world. So, I started investigating and looking at other options. I was successful at my job and had built great relationships, but I just had a different feel and mindset.

STOP WORRYING ABOUT WHAT YOU HAVE TO LOSE AND FOCUS ON WHAT YOU HAVE TO GAIN.

I quickly got tied into a network of women who were trying to find ways to work at home. In typical Kim fashion, I started studying my options and taking courses to help guide me. I probably could have jumped in and tried to make a go of it in 2012, but it was scary. Remember those people who reminded me how lucky I was to have this job? Yes – those voices kept telling me I was better off just staying the course. So, I wanted to be more in charge of my schedule, whom I worked with, and what work I did and didn't do, but this is where many women struggle – that safety blanket of a good salary, plus bonuses, benefits, a company car, 401K, and paid vacation. It is very easy to talk yourself out of making that leap. And that is exactly what I did. I told myself it's not that bad, and I pushed that idea to the back burner.

Now from 2012 to the time I decided to start my business, there was a life changing moment – my dad was diagnosed with brain cancer and fought a brutal, yet courageous nearly two year battle before he passed. So, yes, sometimes life does take turns you don't expect; but, that wasn't why I didn't move forward with starting my own business. However, this experience perhaps helped me finally take the chance a few years later.

I continued to work and still wondered if there would be a right time to make a move, and start my own business. I started going back to my WHY versus my WHY NOT. **Sometimes no matter how big your why is, the WHY NOT is so loud that it wins.** My WHY NOT was it's scary – to give up that guaranteed pay check and benefits. What if I start my own business and it's not successful? But, what if it is? A lot of my WHY was a bit selfish – I mean, yes, I wanted to have more control of who I work with and choose work that is personally satisfying to me, but I also wanted to be able to work from anywhere. I wanted to be able to take my kids to the pool in the summer last minute – not around when I can get a day off. I wanted more freedom and control. I was tired of the corporate mentality – plain and simple. A friend told me about someone who left the industry and said he just got sick of chasing a

number. YES! Maybe that was it. Maybe it's because the death of my dad proved that there are no guarantees in life. There's no guarantee that five or ten years from now will be the "right time" to start my business. We're not guaranteed anything including another day on this earth. Would I regret that I never gave this a shot?

I think what finally propelled me to make the jump was a combination of all the above. That, and a belief that women are awesome, and I am awesome. I had been very successful throughout my life - I could do this! **I firmly believe it's possible to create the lifestyle we want and deserve, because women can juggle a house, kids, activities, and a successful career.** I'm the girl who has always strived for more.

SO, DID I JUST QUIT MY JOB AND GO FOR IT?

Hello NO! Please realize I am a conservative person. I don't like risks, I try not to take them. I have a list for everything, and I'm a planner. So, I can assure you I had a (or should I say five) plans in place to make this transition happen. I am a planner by nature – that's just what I do. Tell me you want to have a themed birthday party, and I will start to create the plan. Decide we want to go on vacation, I will start planning.

I am not a person who can just make rash decisions. I envy those women who quit their job and throw all their energy into starting their business. I wish I could have, but I am a planner and I am responsible for a household that includes two little boys. Trust me, there were times when I was busting my ass to execute my plan, and I would look at my sons and think, "Please God, tell me I'm not making the wrong decision. I want them to continue to enjoy this lifestyle we have been fortunate to provide."

I remember one night, my husband commented on how much I'd been working - because when you're working full-time and trying to build a business on the side, that's just what you do! You work, and work, and work. My oldest son Ethan, looked at me and said, "Yes mom, you are a hard worker. You and dad both work really hard!" I smiled and said, "Hard work gets you where you want to go." And I knew then and there, I had made the right decision. Because working hard was all I knew –

maybe it's because my parents are hard workers? I am not sure, but if you want something bad enough, you need to work hard.

So yes, while working full time, I decided to try to get a few clients. I got one, and then I decided it would be very difficult to take on many more, so I set a transition plan into place because, yes, I'm a PLANNER! I looked at my calendar and picked a "corporate quit date" for six months later. I decided to work through May because then I had the summer with my kids - something I've never been able to enjoy (like most people who work corporate jobs!). Next, I started focusing on learning the skills I wanted to offer in my business and networking. Oh, and I recommend that when you are ready to do what I did - tell people! You see, I'm a private person and just like to go about my business. But the funniest thing happened when I started putting myself out there by attending networking events, and talking to people about what I was planning to do - tons of opportunities that I never even knew and dreamed of came about!

Before I knew it, I had three, then four, and at one point seven clients I was working with. I spent hours during the evenings and week-end to make sure I kept up with my clients' work because one thing I pride myself in is providing excellent service. I take great pride in my work. I was also able to find work I enjoyed doing, and work I didn't enjoy. Finally, I found areas where I wanted to really focus my business. It was exciting, yet scary to think that I was giving up a guaranteed paycheck. Keep in mind however, when you work for someone else, nothing is really guaranteed either, but it was exciting that in a short period of time, I felt like I was building and creating what I wanted. I always had hopes of a certain income to be at when I quit and that didn't happen, but I had much more focus and clarity in what I wanted. Yes, it was a LOT of work, but as the old saying goes, *"Nothing worth having comes easy."*

Did I have any regrets? Maybe, that I would have taken the leap sooner. **We spend so much time in a day working, why waste it doing something that doesn't make us happy?**

"The things you are passionate about are not random – they are your calling." ~ Fabienne Fredrickson

My goal is for even a few women - women like myself - successful at our corporate career, juggling so much other "stuff" such as family, house, and activities to read this and think - YES! I can build the lifestyle I want and deserve. It inspired me when I met other women - lawyers, doctors, sales and marketing women from big corporations leaving it all behind to start a company they loved. I too want to inspire others by sharing my story and plan.

Your plan to make the transition can be simple. Find what you want to do, join some free groups that offer support, look at your finances and make sure you have a cushion, and slowly start growing your business, but put a liberal timeline in place. Then, work on your mindset. To me, that is the key in being able to make this work. I had talked about this entire plan a few years before I actually did it – what I didn't have in place was the mindset. I had to really write out my WHY, and make it so specific that when those voices of doubt crept up, I would say no way, sorry, I know this is what I'm meant to do. Then start your transition plan – I wrote out what it would look like for those next months. Depending on what type of business you want to pursue, this looks different for everyone, but it involves you building your new life while slowly weaning away from the old.

Find something you love to do... a passion and run with it! I created Virtual Sanity, and now help small businesses with their online business management and project management so they can focus on their zone of genius. I love partnering with businesses to help them achieve their vision. I am at peace with my decision to finally be able to feel comfortable to leave the corporate stigma I carried around for years.

Lastly, get a support system to help you. My husband Greg, was very supportive and instrumental in my decision, and my mom, sister-in-law, and friends were very supportive as well when I told them of my plan. It was nice to be able to bounce ideas around, and have a cheering section to keep me going when times got tough.

Oh yes, and one more thing – know that it won't be easy – there will always be tough times; times when you think you cannot do it all; times when you doubt your decision; times when you think you are going to go crazy because you have too much going on. But know that it's worth it in the end. **Anything worth having, is worth fighting for!**

CHAPTER 12

The Imperfect Me

BY JESSICA DOS SANTOS

"Perfection is the willingness to be imperfect" ~ Lao Tzu

JESSICA DOS SANTOS

WWW.JESSICADOSSANTOS.COM
IG: @JESSICA_DOSSANTOS_
FB: @JESSICADOSSANTOSMOMPRENEUR
T: @JESS_DOSSANTOS

Jessica dos Santos has always been a dreamer. As a child, she would dream about her wedding day, her kids, her dream job, that big house with the white picket fence, and the happily ever after that follows. Everything she believed in and always envisioned came true. She wanted to become a teacher, marry her high-school sweetheart, have that million-dollar family and that perfect work-life balance. Jessica received her bachelor of education at the University of Ontario Institute of Technology in Oshawa, Ontario. She quickly got hired as an elementary school teacher, married her high-school sweetheart and was ready to start that dream family. Little did Jessica know that her idea of what she thought to be the dream life would drastically change after having her first child.

Ever since she was little, Jessica pictured herself teaching along-side raising a family. However, she began to question if she could be be good at both. She felt lost as she hadn't pictured her life being a stay-at-home mom.

From this, Jessica has found a way to do both, teach part-time and be home with her little ones as much as possible through discovering the world of network marketing. An educator to the core, she now mentors other moms striving to live a life of their dreams by building a home-based business that brings freedom and choice.

THERE I WAS IN MY TWENTIES. At first, I was juggling school, applying for that real job, learning how to live with my boyfriend in our first home, and planning a wedding – getting ready for that adult life. Then, all of a sudden, I was a mom taking care of two kids, two Chihuahuas, bills, cooking, dishes, laundry etc... struggling to make it through each day, and completely losing myself in the process.

Let me rewind for a second. Ever since I was a little girl, I dreamed of being a school teacher and having a family of my own. I remember putting on my sister's communion dress and pretending it was my wedding day. Achieving those dreams became my life purpose. Little did I know that my whole life's purpose would be changed forever after having my son.

Being both a mom and teacher was not quite like I had pictured it would be. As my maternity leave was coming to an end, I began to question if I could be both a good teacher and a good mom. Don't get me wrong, there are a ton of great teacher moms out there, I just honestly believed that I couldn't be good at both. I knew I would feel like I was not being enough for my students and for my son at the time. You see, I have been a perfectionist for as long as I could remember. I was in a pretty traumatic car accident during my college years, my doctor suggested that this could have triggered this type of behavior. It is really hard for me to let work go that is less than perfect. I was *that* university student who cried about getting a B, *that* teacher who redid bulletin boards my co-op students would put up that were crooked, *that* professional who reread emails fifteen times before hitting the send button, *that* wife who planned out her whole pregnancy straight down to the gender, that mom who spent hours researching what the best stroller was to add to my baby registry. I even bought a book that rated every baby gadget into three categories good, better, best. I only registered for the "best" items obviously.

The thought of daycare was also excruciatingly painful. The thought of sending my son to daycare made me hyperventilate. No one could ever take care of him like me. Gathering the courage to actually go and look at a few centers actually made things worse. How was my twelve month

old going to sleep on a cot when he was still in a crib at home? How was he going to get on and off of the little chairs for lunch if he wasn't even walking yet? And what would he eat if he had sensitivities to dairy, soy, and tomatoes?

So I was left with a choice that I had to make. This is how my journey of striving to be a stay-at-home mom began. Little did I realize that in my journey of striving to be a stay at home mom, I would first lose myself, in order to find myself - who I was now, not just as a teacher, but a teacher and mom.

First, I needed to figure out the babysitting situation. Since I wasn't ready for the daycare route, I asked my grandmother to move in until I felt he was old enough for daycare and he grew out of all of his allergies. She stayed with us for about three months.

Next, I needed to figure out a legitimate way to earn an income from home. This is when I was introduced to the wonderful world of network marketing (something I never envisioned for myself). I knew this would be my ticket to having that time freedom with my family. I have always been a go-getter, so I knew that if I was willing to do the work and stick with it, I would be able to create an income from home on my schedule.

Secondly, I needed to get pregnant again so that I could be on another maternity leave. We wanted a larger family and the timing couldn't have been more perfect. This made the thought of returning back to work a little less daunting since I knew it would only be for a short time.

So, my maternity leave ended, I headed back to teaching three days a week, joined a network marketing company two weeks later, and became pregnant the following month. Everything was going as planned.

As mentioned earlier, being a teacher was my dream job ever since I was a little girl. Before my kids came along I absolutely loved my teaching career. So I had no idea how returning to it could have been so hard. I was not the same person anymore. Teaching was my life before kids. I'd arrive early, stay late, get home, and prep for the next day. I found great satisfaction and passion in everything that was related to my teaching career. Then all of a sudden, bam! I was counting down the minutes to finish the work day to pick up my little guy from day care. All I could think

about was him. It didn't help that I was still breastfeeding and needed to pump in the storage room multiple times a day. Everyone keep telling me that it would get easier, I still have no idea what they were talking about because for me, it never did.

The rest of my twenties consisted of me striving to be that perfect work from home mother. It didn't take long for me to become tired, over-whelmed, exhausted, and to experience what felt like complete loss of identity. This came as a total surprise to me, because my whole life I have always had that all or nothing mentality. Everything always went "right" in my life. Imperfection, failure and weakness were not in my vocabulary. Every time I'd accomplish one thing, it was on to the next. So what was different this time?

Now, my new life purpose revolved around my kids. Meaning I did everything for my kids, and nothing for myself anymore. I not only did everything for my kids, but I felt like I needed to do everything myself. I also rarely left my kids with anyone. It was always that week to week struggle to get it all done - story time, bath time, swimming, karate, soccer, cooking dinner, doing laundry, cleaning the house, bedtime, lesson planning, growing a global business and the list goes on. When would I have time to squeeze my needs in there? And why would I? I was no longer a priority. I completely let myself go. I was lucky if I got my face washed on some days. It's not that I stopped caring about how I looked, it's just that I didn't come first anymore. I was too focused on being that perfect mother that I had no time to be that perfect me.

I remember being on a call with a friend of mine and she told me that I seemed different, not the same happy self that she was used to. She asked if I was experiencing postpartum depression. I began to think to myself maybe something was wrong. This call was definitely a wake-up call for me. I know this was a hard question for her to ask me be-cause of how she asked it, but I commend her for speaking out. Maybe I wouldn't have seen the signs, or would have continued to ignore them if she hadn't pointed them out to me. I was heading towards a dangerous path. My energy and mental resources were depleted. I was burnt out to a crisp. I realized that my lack of energy wasn't allowing me to be

that perfect mom that I was striving so hard to be. In fact, I often went to bed feeling guilty for not having enough energy in my day to enjoy my kids. Sometimes I felt guilty that even though I was home with them, I didn't give them enough attention, or I felt guilty for being a little impatient at times. I hated waking up each morning feeling drained. I felt like I was failing. I began to realize that me not taking care of myself wasn't good for anyone, and that the perfect gift for my family would be doing just that.

I know that I am not the only thirty-something year old dealing with exhaustion, struggling to figure out what the right answer is for everything - *Should I go back to work? Should I stay home? How about part-time?* - putting so much pressure on ourselves to be the best mom, wife, business women (whatever it is, sometimes it's struggling to figure out which one of those we actually are) because if we make the wrong decision then we start beating ourselves up. Who wouldn't experience some of the same pressures when we are all constantly bombarded with what raising children, a happy marriage, and having a successful career should like on social media on a daily basis.

I know this may sound silly, but I am grateful that I had the chance to experience what being a burnt-out mom feels like. It definitely was a horrible time feeling both physically and mentally exhausted, however, it really taught me a lot of things.

It only took me until I turned thirty to realize that taking care of myself was just as important as taking care of my kids. This has translated into me focusing on discovering and learning what my hobbies, interests, and talents are. Below are some of the ways that I have been able to better manage and prioritize being a wife, mom, teacher, an entrepreneur, and most of all, being able to be ME.

SCHEDULE ALONE TIME

Now, most days I wake up an hour before the kids to read a book, scroll through social media platforms, listen to a personal development audio, or just to get prettied up for the day. Some days, it's just asking for some alone time at home to watch a reality TV show or to take a little cat nap.

Other days, it's a visit to the gym to recharge my body and brain.

Psychologist, Dr. Christina Hibbert, says, *"I know the research, and the research is clear: Alone time is essential for emotional/mental/ spiritual/social/physical health, and a key element of true happiness."* [10] Do something everyday that you enjoy, and that lets you be yourself.

ASK FOR HELP, ACCEPT HELP

I have now learned to ask for help and say "yes" when help is offered, because I now know that I can't do it all. I have hired someone to help clean and reduce the mountains of laundry. I've also been asking relatives to watch the kids occasionally so my hubby and I can reconnect over date night. It's okay to leave your kids sometimes. Sometimes, it may be to a nice restaurant, other times it's just a trip to a furniture store. Relationship expert and psychologist Seth Meyers says, *"The happiest parents are those who are disciplined about integrating their old life with their new life."*

MOMMY NEEDS A TIMEOUT

I even learned that it is okay to tell my three year old that, "Mommy needs a timeout." And sometimes, that just means locking myself in the washroom to sit on the floor for a couple of minutes and catch my breath. Children will imitate us, and imitating a calming strategy is a good little tool for them to have in their pockets. As a school teacher, I know that self-regulation is one of the most important skills a child can possess. So give yourself that timeout when you need it, it's a win-win.

SLOW DOWN

Most importantly, this experience has taught me how to truly savor every minute with my kids. What I mean by this is making sure that when I'm with my kids, I am fully present. This means that my phone is

[10] Hibbert, C. (n.d). *Physical Health & Personals Growth: 5 Core Areas.* Retrieved from http://www.drchristinahibbert.com/personal-growth-and-self-actualization/physical-2/

away, the house isn't getting cleaned, and I'm not googling everything that I can find on parenting. My children have my full attention, and are my number one priority during this time. I learned to slow down and treasure these moments with my children. I've learned to capitalize working on that to-do list during pockets of time when the kids are sleeping. At the end of the day, that to-do list will always be there; however, these moments with our babies won't.

Now that I know what my limitations are, and how and when to ask for help, I am a much better mother. And for that, I am grateful.

Although right now, I am not sure where my thirties will take me, I am okay with that. What I do know is that I love teaching and inspiring others, I love being home with my children, and I love living a life of choice. I am now more than ready and excited to explore the unknown, the unplanned and the uncertain rest of my thirties, as I continue to embark on this journey of self-discovery, entrepreneurship, part-time teaching and motherhood.

SECTION 4

I'm 30, I Survived!

Featuring
Natasha Manchester, Amy Rempel, Nichole Cornacchia, Christa Pepper

OPENING COMMENTARY BY KY-LEE HANSON

Section 4 Opening Commentary
BY KY-LEE HANSON

WE HAVE EXPERIENCED and lived through loss, pain, confusion and self doubt. Some of us experience judgement, racism, sexism, inequality, lack of respect for diversity and physical abuse.

Emotional abuse and external expectations play a big role on our bodies. When our physical body has ailments, we feel even more pressure to perform successfully in our life and career. Often, the expectations that family life has of us, the effects the medical system has on us, and how our parents set us up for life, all play a part in our success and happiness.

The next section is a diverse one, full of different kinds of pain. There is emotional family abuse, forms of violence against women, physical pain, and expectations of the family, and mental and physical pains that come with postpartum depression. A common thread in this section is the lack of social support on all these subjects and how alone a woman can feel and truly be. As women, although the stereotype is that women express themselves more, the reality is that a lot of us keep anything that does not fit the cookie cutter mold of social conventions to ourselves - be it a tumultuous childhood, a failing marriage, experiencing grief and depression, or even feeling upset or hurt. Remember though, we have all felt pain in one shape or form. It is not something to carry with you or feel ashamed of. It is not something to hide. Writing, sharing, or vocalizing it and asking for help, from multiple sources will help the healing process. Knowing that you may need help and asking for help is a sign of strength, a sign of awareness, a sign of taking the first step towards healing yourself inside out. We, as women, must rally together, support one another, empower one another, and listen to one another. Through collective and conscious empowerment, we can rise up, heal ourselves, and be a source of strength and healing for ourselves and those around us.

CHAPTER 13

Balancing Not Giving a F**k, Yet Totally Giving A F**k

BY NATASHA MANCHESTER

"Do not go where the path may lead, go instead where there is no path and leave a trail."
~ Ralph Waldo Emerson

NATASHA MANCHESTER

IG: TASHITA_MAMASITA
FB: NATASHA MANCHESTER
IN: NATASHA MANCHESTER

Natasha Manchester realized in her late twenties that she didn't want to die with regrets. She didn't want to look back on life wishing she would have travelled and done more with herself. She strives for new challenges and takes to change with absolute pleasure and confidence as it approaches. Following rules wasn't easy for Natasha; she wanted to do things her way and learned the hard way, getting to her next destination by determination, patience, loyalty, honesty and commitment. She enjoys teaching others through her direct hands on approach and common sense. She is constantly embracing and willing to learn from the revolving door of other inspirational human beings that cross her path.

Natasha had a vision to be a powerful and independent woman and nothing could stop her from achieving whatever it was she wanted. She has had careers within the financial and marine industries, and worked well over twenty years in all areas of hospitality and a variety of restaurants, including a super yacht career all over the Caribbean and Mediterranean, and being a butler to some of the wealthiest and successful families in an estate in Florida and Canada.

Natasha is very fitness oriented and loves the sunrise. Her passion is to motivate and encourage others to follow their dreams, knowing that anything is possible if you want it bad enough. No matter how you were raised, true success comes when you believe in yourself, and no one in your life can stop you from getting what you want.

YES, IT IS A STRUGGLE to balance not giving a f**k, because you have to give a huge f**k in order to follow your dreams. It means compromise, including our closest relationships. There are many sacrifices, failures, and rejections in life. However, if our desire to succeed or our need to explore or create is compelling, be it our daily activities, career, love, kids, word, art or visual, we have no choice but to pursue, eliminate, and rightfully gain. Otherwise, we will always yearn. It is a dilemma, but the dilemma happens when you don't even try, often being crushed by the people who don't believe in you – including yourself. If you persist past the sacrifices, you gain achievements and master accomplishments, and in return, I can assure you – you will be proud of yourself. Success and happiness are controlled by your own mind and can be easily halted by the influence of others. Learning how to balance the entry of your own thoughts and feelings versus that of others is an absolute art, and is by no means, easy. I believe that by mastering the ability to accept or release the information given to you by others, you are able to dedicate energy to things and people that matter most to you. I call it learning how to not give a f**k, yet learning to use up some of your stored f**k offs!

It may sound a bit harsh and carefree, but you will be really surprised at the things you achieve once you start to not give a f**k about the useless actions of others, or their view on life. You may have been told to not take things so personally or to let it go. I am not saying I'm an expert on other people and their own lives, but as a strong minded independent woman, who absorbs energy, good and bad, it's challenging to truthfully define the two – personally and professionally. When you disregard useless information from external sources, it gives you room to push forward with your own goals, crush dreams and reach beyond the stars. This doesn't mean that you are emotionless or unavailable, it just means you have the abilities to push negative energy away and have space for positive feelings and thoughts. No f**k's given.

Do you ever feel like you're a person who cares so much? I cater to the rich and famous, making sure every day is perfect. Perfect may not be possible, but getting close to it is a great start. Do you feel drained

because you care about everyone else, but there is nothing left for yourself? It could seem like a flaw, but it's not. Caring is sincere and delicate, but if you care about what others say too much, or what, and how they are doing all the time you might miss out on what you need, or what you can work on. This is when it's a great idea to give some good old "f**k offs."

In the professional realm, it's actually rarely ever the owners or the bosses who tend to be difficult; it's the staff, the people, acquaintances or your team and co-workers. For example, when I went into my last role as the service and housekeeping manager, similar to a butler. Everyone kept giving me instructions on how to do things, to not incorporate change or to insert my personal approach to the family. I became so confused on how to actually be me and how to deliver my duties naturally. Once I started not giving a f**k what everyone else was saying, I became less nervous and more sure of my decisions, which resulted in an overall win. I took the valuable information from those who sincerely offered and combined it with my own. It's so easy to get consumed by the way other people think you should do things. In my world travels, I found that cultural differences can prevent you from cooperating as well, it's okay to not like everyone and normal to not want to listen to everyone. That is what makes us original.

I have always hated to believe the fact that business comes before friendship. If people kept friendship at the forefront of their interactions, maybe the business side would be much more pleasant. On the other hand, what I've come to both realize and ask myself at thirty years of age is that do you really want all those friends to be friends? Do you actually give a damn? Probably not. Have you truly lived for yourself, and done what you wanted to do? Or do you do what everyone else wants you to do? Now is the time to stand up for what your gut is telling you, and start ticking off those dreams you have. Following one's dreams and feeling happy while looking back on them are qualities that many of us truly lack.

I realized that being selfish in life isn't all that bad, I remember reading a quote along the lines of, *"If you have never hurt anyone, then*

you have truly never lived." Of course, that resonated with me when I was about to leave a five year relationship to follow my dreams, but now it's related to me in many other ways as well. It was my first real woman, "I don't give a damn" moment. Everyone told me I was being stupid to just give up everything, yet it's opened my eyes to the world and what is possible when you believe in yourself. It's nice to be selfish. Take the time for YOU.

You will always come across people that will try to stop you from almost anything. Most often, they are either jealous of you for whatever reason, or they are intimidated by you or scared because they don't have the guts to do it. I often heard that they were just jealous, I thought this was said to me as a means of letting me down easily. But this is actually true. Then, there are those who are afraid to do something with their lives; afraid of change; afraid of you coming in and doing things better. Honestly, these people need a good f**k off because usually they are the ones who are truly unhappy with their own lives.

I grew up in a broken family, lost my dad to alcoholism followed by him committing suicide when I was four years old. I had sisters that left home before I was in my double digits and had step dads entering my life as though it were a revolving door. I'm sure I moved close to 100 times, and went to nine schools in twelve years. When I was six years old, my home was burnt down to the ground. I personally believe that everything happens for a reason.

All we want as a kid is someone to hold our hands telling us they are proud and that they believe in us. We want our parents to lead and show us the way, hoping they pick us up when we fall. All the experiences I have encountered in my life got me to where I am today, and the childhood I had only made me stronger. Instead of dwelling on the past, be grateful for life, and the present moment as I've seen too many go to soon.

In my home, perfection wasn't good enough; hard work was the only option. My step-father wasn't easy on me, I had to grow up fast. Anything I did was rarely praised because it meant that there was always something or some way that I could do it better. I had three

jobs by the time I was twelve. The hatred for rules forced me to leave home when I was just about to turn sixteen and completing grade 11 in high school. Thank you to my twenty-three year old stepbrother for letting me move in. He was someone I knew I could always count on and encouraged me to be better. Plus no rules, lots of freedom, house parties, and skipping school to go snowboarding! Those were the best times of my life!

No matter how hard you try, some people will never be happy and that doesn't mean you have to live that way too. I was taught to work hard, to fight (sometimes against the grain), rules were made to be broken (because to me most of them sucked) and with that I learned to stop giving a f**k.

On the other hand, my mother's experiences took my breath away when she confessed what her life had been like, yet she taught me to appreciate life and to be positive. She supported me through my wild days as I did for her when I was a young vulnerable child, and I am forever grateful to her for giving me my life. I would have never been alive to see the woman I have become today. I often cross paths with women who have had similar childhoods, yet they feel that the world owes them something. A life of uncertainty and struggle gives character and strength, which is why it saddens me when people play the blame game. I have no time for it. Change comes from within.

People will give you advice on almost everything such as what you're wearing isn't cool, or that pastel colors shouldn't be worn in winter, or your music is too loud, or the style of music isn't hip, or that you shouldn't quit your job to travel the world, or break up with your boyfriend because you've dated for ten years, or quit your unsatisfying desk job for the seasonal gig across the world, or how to raise your kids, or eat that bag of chips. **People will always have an opinion. Now, if you listened to everyone – you would never get anywhere.**

Stop giving a f**k about the jerk who cut you off, or the extra glass of wine you had, or the expensive shirt you just bought with your last few bucks. You have one chance at kicking the can in life, so be the kicker! Don't let life hand you a bunch of f**k offs.

Now, let's talk about how to release the negative first. In life, you must get through negatives to reach the positives. Once you start to understand "the art" as I so call it, the ability to shift your brain to think positively becomes easier. All we ever want is an easy answer. Are you happy? If yes, stay the same. Are you unhappy? If yes, then change it. There's also a fine art to that! I'd really recommend not running away every time you are unhappy. Rather, it's just a matter of shifting your brain and blocking out the negative thoughts.

Have you ever been called a runner? Maybe it's true, or maybe you should pat yourself on the back for realizing that the situation did not actually fulfill the things you need in your life. However, I will admit that most times we blame others for our unhappiness because they upset us. It's difficult to not take things so personally, but it's easier to let go of their negative energy than to allow them to affect you in that way.

When I look in the mirror and I see what my reflection staring right back at me, I feel proud and I know I'm a good woman. I didn't get there by waking up one day automatically thinking I loved myself. It's so important to work on you first, and to do what makes you happy.

Loving ourselves is what we have might have lacked the most before our thirties. Our thirties are the best times of our lives – we are mature enough to make dumb decisions, smart enough to make mistakes, young enough for everything we have messed up on, and eager enough to live happier. It's never too late to try.

When you're thirty or looking back at your thirties and you've taken risks, been scared shitless of the decisions that might change your whole life forever, and come out ahead, you soon realize that anything is possible.

Ironically enough, my aunt wrote me an email during the time of writing this chapter. She is in her mid fifties. It read:

> "I am still living out of boxes. Sunny has cancer, and work feels like hell, and I'm in a legal battle with the developer of my new home. I am exhausted and in the brink it really feels. At times, I let the house go to hell, and my appearance too, and I just paint. You can put a

> hurdle in my dreams, but I will keep going. Despite all the
> stress, my art feels good. I have jumped my creative hurdles
> too, it's an oasis. I am glad you have a creative pursuit. Writing
> is very cathartic. The great thing about a creative outlet is that
> you can use it as a vehicle for all emotions. Good or bad ones.
> You can touch the raw. I want to so badly quit my job and
> follow my art. It is so powerful. But the mortgage. I'm getting
> older. Need a pension. It is much harder to pursue now and to
> sacrifice. Do it now girl!"

For me, her words of advice are raw, and if my chapter or my Aunt Kathleen's words haven't encouraged you, then I don't know what will.

Everyday is a new start, and a new chance. Don't get angry over past events nor dwell on things you cannot change. Your whole life can turn around in a day with a positive outlook and the ability to start not giving a f**k. As you shower in the morning, think of it as a renewal, a cleansing of the debris of negative thoughts and negative people, while welcoming the freshness of a new day, and maybe a new life.

BE POWERFUL AND EFFICIENT

Believe in yourself and what you want to achieve. You will be surprised at what is possible. Reach out for support and advice, but be strong in your mind. Whether it's a new job, a new career, a relationship ending or beginning - whatever it is, follow your heart, move forward, and believe in yourself. People who mind don't matter, and people who matter don't mind.

PROTECT THAT SWEET SPOT

That sweet spot is your life and your needs. Don't die with regrets. Where do you want to be right now? You must ask yourself these questions and figure out a plan to get there, quick - because when you are forty or fifty and look back, it could be too late. Start racing for the finish line! Grab life by the balls and start using some of your f**k's that you've been saving up all this time!

BALANCING NOT GIVING A F**K, YET TOTALLY GIVING A F**K

GO GET IT

We get self confidence and strength by loving ourselves first. What is it that you're lacking in order to get there? Who are you surrounding yourself with? Are you unhappy in your job? Then try something new, apply for another job, switch careers, or turn that passionate hobby into an entrepreneurial venture. Is your relationship dragging you down, then kick them to the curb. Are you feeling sluggish or tired? Then get up an hour early and join a gym. Do something different that you aren't already doing, because if you are already unhappy, then you really don't have anything to lose.

When you look in the mirror and you see yourself, do you like what you see? If you don't - then let's work on this.

I used to look at myself, and what I saw staring back was missing a piece. I became addicted to working out, counting calories, shopping and nothing worked. For me, it was the sense of dying with regrets; I was so afraid to die, and not live a life of happiness, excitement and being truly fulfilled.

So many people don't like what they see in the mirror and I've personally asked friends, family and boyfriends this question. I am still surprised with the answers I get, even from the people that seem the happiest. For me, the switch was at one point a year or so into my super yacht career, I could truthfully look into the mirror and feel proud of the risks I had taken. I knew from then on out, nothing was impossible. Love yourself with confidence, deliver some f**k offs, take risks, be okay with being scared ideally, and you will soon see that things can really fall into place.

LOVE YOURSELF

Take 1-2 min on Monday, Wednesday and Friday and look at yourself in the mirror. First step is gaining eye contact with you. What is it that you don't have? Is it positive self image, patience, or the people you are surrounding yourself with? Don't worry about money, because money comes and goes.

It may be that you work so much at life, being a full time mother, a good wife. Or it may be that you are stretched way too far, to figure out

157

what you truly need. Write down all the things you want to do in your life, but be realistic. We all want to win the lottery, travel the world, drive fast cars, and have the best life anyone could have, but being happy with yourself is the most important.

Truthfully, all those other things may not make you happy anyway. Try to achieve small things, and don't be afraid of change – it's what keeps us on our toes. As Rick Warren once said, *"You can make more money, but you can't make more TIME."*

SURROUND YOURSELF WITH PEOPLE WHO MAKE YOU A BETTER PERSON

It is so important to surround yourself with positive people. These are the people from "awesome town" who you should be enjoying your life with, and most times these are the people who don't give a f**k.

Change is like driving a new car – feel it, allow it, embrace it, encourage it, grab it, let go of it, and fly with it. Be scared, and go try something new. Failure is okay because the worst thing you can do is look back and wish that you would have done more, lived more, travelled more, smiled more, and evolved more.

Don't lose yourself in someone else's dream. Life is beautiful. Authorize yourself to feel and to let go. Channel your focus, release negativity, and gain fulfillment while raising your head high in efforts to change the world. Okay, maybe not the world, but if anyone tries to tell you that you can't, then reach into your back pocket and give them a good old "I don't give a f**k."

If I could help just one person, even to take just small steps in gaining confidence to put towards achieving their dreams then I've succeeded. It's sad to think that people miss out on such exciting things in life, especially since each and everyone of us has so much potential. I was scared to leave and afraid to fail, but if I hadn't taken the steps outlined in this chapter, I would have looked back with regret because I listened to those who told me I couldn't. I still get scared, but now being scared excites me because I know that success is right around the next corner.

CHAPTER 14

Who Am I? And Why The F**k Haven't I Figured It Out Yet?

BY AMY REMPEL

"Look back at where you came from and let yourself feel proud about your progress. You. Are. Killing. It."
~ Inspiredtosing.com

AMY REMPEL

WWW.HEALTHYHEARTMERRYMIND.COM
HEALTHYHEARTMERRYMIND@GMAIL.COM
FB: @HEALTHYHEARTMERRYMIND
IG: @HEALTHYHEARTMERRYMIND

Amy Rempel has her degree in communication studies and is a certified exercise nutritional advisor. She is a mother to Asia and Will, and has a very supportive and loving husband, Ben. They are her cheerleaders!

She is a well versed entrepreneur with over ten years in the health food industry and owner of Healthy Heart Merry Mind which helps others with managing their chronic pain and stress. She has a passion to help others achieve success with health and wealth by offering a course called 90 Days of Change through a partnership with Inspire Haus that helps people start their own business on the right foot.

Amy loves dogs, is an actress in her community, and has sponsored two children (girls), providing them with the protection and care that they need in their own country.

Amy believes in empowering women to be the best versions of themselves by practicing self care, something that she teaches her team and family. She is inspired by, and lives by the biblical quote, "Above all, love each other deeply." Just be sure to include yourself in this philosophy as well.

THE STRUGGLE TO FIGURE OUT WHO WE ARE IN OUR THIRTIES IS REAL. We come from all walks of life, and struggle with various issues and outcomes from the decisions we made in our twenties. But why do so many of us still question these life decisions? Is it okay to not have kids? Is it okay that some of us want kids, and not a career? Maybe we start to get sick and tired of what we do for a living? Maybe we followed what society has conditioned us to "want," and got married first, had two kids and a dog next, and now feel a little lost. The thing about our thirties is that a lot of us are in the thick of motherhood and let's face it, no matter how much we love our kids, we tend to lose ourselves. I know I did. I feel like my thirties has been a different kind of exploration than when I was in my twenties. In my thirties, I finally figured out what I wanted to do with my career for example, teaching me that sometimes we need to experience life before we find what we were meant to do. Or maybe, it's a struggle of how to intertwine who we are as independent women, and also mothers. I have also become wiser in my thirties and have allowed new thoughts and ideas into my life. I'm not as stubborn and set in my ways, which is strange because usually that doesn't happen as we get older, or so they say. I believe that as we age we realize how little we actually know, and therefore are open to learning new things. I think part of the problem of not understanding who we really are when we fall into the role of wife and mother is because it can take over. Sometimes, it becomes ALL we are.

HOW TO STILL BE YOU!

To stay true to myself, I have started to realize how important self-care is and have even made it a part of my career. Am I perfect at it? Nope. But I understand how important it is now, and make more of an effort to do things that are going to relax me and also bring me happiness. When you can do something that you love, it will make you happier; you will smile more, and therefore release those endorphins and feel great! **When we do the things we love, we have purpose and tap into our real selves. We then bring this happiness back home because our cup has been filled, we just feel good!** This also means the rest of the

household will also be happier. I think this all accumulates as to why we are still trying to find ourselves in our thirties, because as our kids get older and we have more time and are no longer sleep deprived, we start to think. We think about the things we used to do that made us feel fulfilled. There are so many ways nowadays that can fulfill that need and desire. The statement "happy wife, happy life" is no joke! When we feel satisfied, we can be better mothers and spouses. We set the tone. When I'm in a bad mood, the whole house is as well! I know you know what I'm talking about! Here are some suggestions that might help you: Join a fun sports league, join a choir, get set up on Meetup.com and find groups in your area that are aligned with your interests. I have done most of these!

EXERCISE TIME!

Get out a piece of paper or your journal and write three things that bring you joy, and have nothing to do with your kids. Don't worry, I know you love them and being with them, but this has to be about you! Once you have those three things written down, I want you to find a way to start one of those in the next two weeks. Need some account-ability? Email me! Tell me what you want to do, and I will check up on you to make sure you are doing it! It can be anything, as long as it's something just for you for at least one hour per week.

WE NEED A LIFE TOO!

Moms these days are so much more diverse; I have girlfriends who are stay at home moms, and many who worked, and still work full time and have flourishing careers. There are also a portion of them working part time. A common trend among my friends' is that work not only provides some extra income, but also gives them some sanity. It's true, it's so nice to have a break, speak with adults, and feel valued. Let's face it, motherhood is not that valued in the home. That comes later when the kids are grown up and realize what douche bags they were! It gives us purpose and meaning in our life, and I think this is how we stay true to who we are. This can also mean volunteering somewhere,

and not just being at a paid job.

Even when my kids were quite young and I was in full mom mode, what didn't change was the need to still have some independence, to have my own life. A great way to keep true to ourselves is to find those girlfriends who you can relate to, and who won't judge you. I'm pretty blessed to have found those. I met my first group of mom friends when my oldest started JK, and us moms were dropping our kids off to school. We bonded over *The Bachelor*, and got together EVERY Monday night to watch it with wine. This is also when I learned how much moms could still drink! We started hanging out once in awhile on weekends, and with our families too. It was so nice to have friends who could relate to you, help you out, and just be there for you when you need to think and talk about other things besides what the kids ate today, and where someone pooped. Oh yeah, I said *where*.

My "mom friends" kept it real though; I could be, and still am SO honest with them. They weren't those moms who had this high stand-ard that we all had to live by, and put our kids in a million activities to "look" good. Nope, we were raw. Sometimes a little too raw, but it worked! What I learned from them was to not believe in the word balance. I especially despise it when a rich celebrity who has two nan-nies talks about it. UGH! There's no such thing ladies, and guess what, that's okay! I have learned that we have seasons in our life, at times we are just going to be moms, who clean bums and make meals. That was something a very wise woman by the name of Hilary Price told me once and helped lift a weight off of my shoulders. I hated that I wasn't doing "more" within my community. She said, "Your job right now (while they're little) is to be their mom who loves them and teaches them to be amazing leaders in our world." Wait a second, so I can put this other stuff on hold and that's... gulp... okay? What a relief! So that's what I did, because I was so tired of TRYING to be supermom. Now that my kids are in school, I'm in a new season where I get to focus on my career and work on plans of being more charitable with my time. This is also when I realized I needed to learn more about me.

FINDING OUTSIDE HELP

So much happened from the fall of 2015 through 2016, and it was a pivotal time on so many levels. I met this amazing woman named Cherene Francis who changed my life. I met her and her husband at a meetup they were hosting and they helped me tap into my deepest desires, needs, and what was holding me back, and why. It was incredible! For the longest time, I couldn't figure out why I would get so comfortable, and why I wouldn't excel. One night at a workshop with Cherene, she asked me, but why are you comfortable? So if this sounds like you, answer that question for yourself as well. I'll wait, get that journal or a piece of paper and a pen and think about it. Write it down, get it out of that head!

I told her I had to think about it and didn't have an answer on the spot. As she went around the circle talking to the different ladies that were present, it came to me! I'm comfortable with being AVERAGE! I started thinking back to how I always just got by and was fine with it, especially when it came to school. I never won any awards, but I got into all my universities because I was so active with the school clubs. I had a 74% average, but I looked GOOD ENOUGH on paper. It was the first time that I knew I had to change to be a better version of myself. I knew that this was my time. I started diving into personal development, asking more questions on how to change my thought patterns. I noticed that by doing so I started to feel happier. More content. Now, I was dealing with chronic pain, osteoarthritis in both hips, so that didn't help much and that did hold me back, but on June 24th, 2016 I had my first hip replacement. On September 30th, 2016 I had my second hip replacement. Although the recovery took awhile, I knew I was on the path to being my WHOLE self, and getting rid of the pain was only going to catapult me!

I knew this alignment was coming, but I always seemed to have the time line off. God does take care of it. Things do happen the way they're supposed to. Being pain free had to happen in order for everything else to come to fruition. Having a clearer mind has brought about more joy, and I now understand the phrase "enjoy the journey." For

the first time, I am!

PAIN CAN HAPPEN

Even though being in our thirties is still young, I have been surprised at how many other women my age have experienced chronic pain, either through an injury or genetics, I thought I was such an anomaly! Sometimes there are extra hurdles that come into our life that we need to deal with on top of being a mother. Something like this really changes how we live our life and raise our children. Being in chronic pain for years, it was all that I could think about. Everything I did revolved around that pain, or the pain that would follow a certain activity, because I needed to get through the day in one piece. Chronic pain and what I have (Collagenopathy 2A1), defined me for so long, it outlined my entire day, and dictated my emotional and mental state. I missed out on going to places like Centreville, which is on Toronto Island, running around at the park, and mountain biking through forests with my kids and husband. It's interesting to note that when we are in the thick of something so intense, it is difficult to see anything clearly, but now that I am much better, I can see I was definitely dealing with situational depression. It would have been so great if I was able to sit back and listen to other parts of me and be vulnerable, but that didn't happen. I was too focused on getting things done, and consumed by "dealing" with the pain and not lashing out at my kids. I was so impatient with them that I would just completely lose my shit. I would actually feel my pain more when they weren't listening, or when they were stressing me out. I know it sounds weird, but it really happened! I wish I had known as it was happening so I could have gotten proper help. The depression wasn't very visible either, so I'm sure no one else picked up on it. I have a very strong mental state and personality, so I think I just put that in overdrive to cover up any emotional wounds that this disorder was causing. I didn't want pity or this stupid disorder to separate me from what other moms could do, I just wanted to be and feel "normal."

Something I'm sure many can relate to is that I used food as my comfort. I ended up gaining a lot of weight in 2016, because not

only was I dealing with the depression, but my physical activity had subsided, and to top it off, my anxiety went through the roof! This was all due to my pending surgeries. Thankfully, this was something I noticed because it had physical side effects, and I was able to get help from my amazing naturopath! But being an emotional eater is something I still battle with! I eat when I'm hungry, bored, sad, tired, angry, stressed and happy. I always wished I was one of those people who wouldn't want to eat when their boyfriend broke up with them and then miraculously lose 20 pounds! But no, I never had that problem, I was like, "I need a burger!" Hmm burgers...

SO WHO DO I THINK I AM?

I was, and I still am a pretty strong woman. I am very decisive, thrive on change, and I know what I want. More importantly, I go after what I want. I have always pictured myself as the breadwinner, and never thought I wanted kids until I was married for about six months, and suddenly things changed. So yes, I am also a mother to two wonderful kids, and a wife to an amazing, loving husband, but I am so much more and I know that now. I think it is really important to understand that there is one thing that is guaranteed in life and that is change. Enjoy the ride, because this is the way it's going to be for a LONG time.

When you start to have that extra time, remember, it's your turn and there is nothing wrong with that. Go take that class you used to love, start that business you have always wanted to do, or find that dream job! We have to allow ourselves to evolve as individuals, we are never going to be the same going forward. So the good news is, just because we might be trying to find ourselves again doesn't mean that it is a bad thing. We weren't who we were in our twenties, and we will probably change again in our forties. **Whatever it is, you can find it; embrace it, and use it for your purpose!**

CHAPTER 15

The Imperfect Pursuit Of Balance

BY NICHOLE CORNACCHIA

"We are all living in the gutter,
but some of us are looking at the stars."
~ Oscar Wilde

NICHOLE CORNACCHIA

ETSY: LOVESTITCHSHOP
IG: @BLENTACCHIA
FB: NICHOLE CORNACCHIA
T: @NIKKII3C
IN: NICHOLE-CORNACCHIA

Nichole Cornacchia is a passionate lifelong learner, an avid traveller, and someone who is eternally seeking self-improvement. She is a mother of two beautiful and charismatic children, Jack and Isla, who bring her and her husband, Ennis, boundless joy and happy chaos. With an abiding passion for all things spiritual, Nichole is committed to living mindfully and holistically and also instills these values in her children. She enjoys painting, pilates, kundalini yoga, writing and sewing – and has just recently dabbled in entrepreneurship, with the launch of two businesses, one as a lifestyle coach and the other called LoveStitchShop.

A graduate of the University of Toronto (BPHE 2003) and York University (BEd 2004, MEd 2008), she is currently a vice-principal in the Peel School Board, with aspirations of one day becoming a principal. She enjoys the challenges a school environment brings, and relishes the roles she plays in the everyday lives of teachers and students.

Nichole one day dreams of writing her own book in an effort to further share her story of perseverance against the odds and maybe even help a few people in the process.

Connect with Nichole on one or all of these social media outlets.

YOU KNOW THAT MOMENT when you are about to dive into something new and exciting, yet terrifying, at the same time? Whether it's a job interview, a date, or ironically enough, writing a chapter in a book. We have all had that moment when you feel exposed and empowered at the same time, when you find yourself enter that uneasy, precarious space that can be paradoxically comforting. For me, it's always been that profound and active tension between vulnerability and strength, a tension that we all experience in our day-to-day lives, that has shaped me. Through a retelling of my story, I want to share with you how these two forces have at once crippled me and at the same time lifted me up and brought me peace; working in tandem, like a yin and yang, they have led to my current state of equilibrium, and have afforded me the ability to reconcile my troubled past.

I'm a thirty-six year old mother of two beautiful children. I'm happily married to an amazing, brilliant, and doting husband. Our house is full of life, laughter, and spontaneous kitchen dance parties. By every measure, I have a smooth and easy life, brimming with love, filled with kids crawling into our bed at the crack of dawn, and lazy Sundays. But the road to get here has been anything but smooth. The first twenty-five years of my life, I lived two starkly different existences inhabiting two completely divergent worlds. Essentially, I had two upbringings, a life I lived with my mother until the age of eleven, and a life I lived with my father from then on. These two lives were always in friction, and like my parents, constantly at odds; they had clear delineations, a beginning and an end. I spent much of my childhood navigating this in-between world, always striving to ensure these diametrically opposed universes of my parents never intersected. Beyond me, they had little in common: no shared values, no common threads, and were devoid of any continuity. These two worlds, and the unique challenges they both produced, are my foundation - rocky and sturdy all the same - and form the basis of my story, my struggle. This is my unvarnished account of a childhood spent navigating in the dark and how my earliest experiences have shaped me to become the person I am today.

THE DARKNESS

An addict. A liar. A master manipulator. An irrevocably wounded mother of four children, all from different men. A life spent on social assistance, living in sub-standard social housing. Transient and anything but stable. This is my mother. Apartments ranging in size and bleakness, but all with that unmistakable smell of cockroach fumigation, smoke and booze (*I can still smell it*). Never sure if there would be food on the table, let alone food in the fridge. And that's only scratching the surface of this sad, hopeless picture of childhood.

We were constantly on the move. I didn't spend one full year at a school, always being shuffled on before the year was completed. I had teachers that would try to help, try to intervene and dig a little deeper, but before anything could happen, we would be gone. I learned how to make friends quickly and adapted to new situations with ease and swiftness. But there were constantly things I could not escape, painful memories, now permanently etched in my brain: the sight of a cockroach crawling out of a bowl of cereal; a sink permanently full of filthy dishes that often spilled onto the counter; preparing dinners for myself and my brothers; weekly visits to the food bank; opening the door to armed uniformed men, with a warrant for an arrest; waiting by the windowsill wondering when my mom would come home; witnessing my pregnant mother being physically assaulted; finding my mother in a comatose state, unsure if she was sleeping, unconscious or if this was yet another overdose, or worse yet, another attempted suicide. Life was full of deceit, neglect and confusion. I grew up quickly.

Raised in this turbulent environment, doubt became a near-constant state-of-mind and I began to cultivate a complicated relationship with the truth. Though I found ways to cope and persevere, I constantly felt lost when trying to navigate my way through day-to-day life. My social nourishment consisted of interactions with heroin addicts, the police, drug dealers, and prostitutes. I feigned a brave exterior, but I often felt heavy, angry, sad; like I could emotionally unravel at any moment. Looking back, I now know why I had those overwhelming feelings, but in those moments, completely disoriented, I had no idea I was entitled

to feel this way.

In this hopelessly fraught existence, there was one saving grace - my grandfather. Periodically, he would rescue us and bring us to his house to eat and sleep. To replenish and refuel. He was the only reason we didn't live on the streets. However, I'm sure even he had limits. A retired police sergeant, he tried everything he could to protect my mother, but he couldn't help her avoid abusive relationships and evictions which eventually forced us to live in destitution.

Yet, despite all of this, I do harbor some fond memories of my mother. Adoring her; watching her every move; studying her in the hope that I was going to play the part one day. I laughed when she laughed. I cried when she cried. I wanted her to stop doing drugs, stop running away, stop killing herself. I wanted her to do it for me. I would love her; lie for her; steal for her. But most of all, I wanted to be the one to save her. I clung onto this illusion for much of my youth. Anyone and everyone looking in, didn't think I had a chance to make it out of this seemingly impossible situation. Yet there was one person who tried to save me - my dad.

GIVEN A CHANCE

It was as though all my efforts, all the energy I was unknowingly spending on saving my mother, were somehow conserved and redirected in order to save me. My father spent thousands of dollars in court trying to win custody of me. A Stockholm Syndrome[11] child, I was too brain-washed, I protested against leaving. I couldn't see the forest amongst the trees. I did not know how dire the situation truly was because I lacked any reference of a better life, a more stable world. It wasn't until Children's Aid Services (CAS) came in and took my brothers and I from my mother that I was forced to live with my dad. I remember being

[11] Lambert, L. (2016, November 27). *Stockholm Syndrome. Encyclopædia Britannica Online.* Retrieved from https://www.britannica.com/topic/Stockholm-syndrome

resentful, lonely, and scared. I didn't know what to expect because I had been fed so many lies about my father; deep down, I was afraid of this new unknown. But with time, I learned to be grateful for being rescued from the lies, manipulation, and addiction that were the norm for so many of my early years.

Life with my father was not all idyll, but I did not have to worry about essential needs like food, safety and clean clothes. Here, I was given a chance; I was presented with opportunities. My dad was a huge proponent of tough-love parenting and it kept me out of trouble, mostly. I continued to feel this tug of war of trying to understand where I belonged. Plucked out of the city's poverty-stricken social housing, I had a difficult time blending into the steady hum of suburban life. Incomprehensible to me now, I even toyed with the idea of moving back into social housing with my mom. Looking back however, I think this was more of a rebellion from my father's strict tendencies rather than a genuine wish to return to the chaos of my mother's world. In the end, it took an intervention from an unlikely source, my uncle, to convince me that life with my father was a better option, warts and all.

After coming to terms with my unbridled thirst for independence, I worked really hard to make my father proud of me. Whether it was athletics or academics, I suddenly found plenty of places to channel my energies. With a story I yearned to share, I eventually decided I wanted to go into teaching. I was a girl on a mission. I had something to prove. I wanted to do everything I could to avoid the trajectory of my mother. To chart my own course. With a deliberate focus, I continued to put myself in situations that challenged me. I wanted that feeling of accomplishment; of certainty; of stability. I wanted to be in control of my future, maybe because I had no control over my past.

A BALANCING ACT

Despite finding my footing and rooting my ambition, I still struggled to truly open up and be completely honest with those closest to me. I was so afraid to be rejected because of all the emotional baggage I carried. I needed to conduct a personal *Truth and Reconciliation*

Commission, to reconcile my past and find meaning in my scarred childhood. Once I started to work on myself and heal my deep wounds, I started to see good, positive things happening all around me. I made the commitment to go to therapy, indefinitely (it's been 11.5 years, and I still go on a bi-weekly basis). I made the commitment to myself that my childhood would not become a cycle. I knew I could have a fulfilling life, but only if I healed these wounds.

I had to unlearn all the damaging things I was raised with, and to which I was accustomed. I learned to identify how the *old* was always trying to creep in and smother the new. I stopped apologizing profusely; I stopped over-talking and did more listening; I stopped saying yes to everything. Once I was able to unlearn some of these things, I learned how to put boundaries into place and honor myself. I honed the ability to release and let go. I felt more present, more aware, and more at peace. I started to realize that filling the void within me could only come from within me. I stopped searching externally for this comfort.

During this time, I let go of a lot of relationships. I was experiencing the binary role of birthing the *new* and managing the role of the *old*. This cleanse was a dark, challenging time of grief for me. I respectfully and deliberately ended many of the negative relationships that have plagued me my whole life, the most difficult of all being the relationship I had with my mother. I had to grieve the loss of myself that connected me to them. I unloaded the weight that had been arresting my development and stifling my progress, my personal growth, and spiritual growth. I realized that my experiences, coupled with doing my work allowed me to have a greater understanding of happiness and fulfillment.

FIRST STEPS

"The journey of a thousand miles begins with one step." ~ Lao Tzu

Have you ever yearned to change your circumstances? Have you ever harbored the conviction you were dealt an unkind hand? Even fantasized about the easy and elusive normalcy of other people's lives?

Have you ever thought: *There has got to be more to this life for me?* For me, it's been a lifelong journey grappling with these questions, searching for answers I could rarely find, desperate to make sense of it all. It's kept me awake at night, and more than I'd like to believe, it's often rendered me confused and powerless.

There are a litany of steps one can take, and that I can certainly prescribe here, but it really boils down to motivation. It's my belief that we live on a continuum of motivation; some of us are driven to make a change after reading someone else's story, and some of us need to experience it firsthand. One thing I know for sure, NO ONE CAN DO IT FOR YOU! I'm clearly a strong believer in the power of free will.

Here are a few things I was motivated to adopt to try and steer my life into a positive direction. I took a proactive approach and tackled each need in a prioritized fashion. First, I searched for a compatible therapist. I then dove into the visual arts, wrote almost daily, began to explore my spirituality and meditated regularly, started sewing, and plunged myself into pilates and Kundalini yoga. One overarching principle guided my every decision: I generally began living more mindfully, much more aware of my words and actions.

Of course, none or all of these might appeal to you, but my guidance would be to find activities that bring you peace and pleasure. Ask yourself, what makes you happy? Who are the core people in your life that support you and love you? Surround yourself with them and immerse yourself in positive energy. When you motivate yourself to be surrounded by constructive, happy people, there will be simply be no time for toxic, ungrounded, negative energy to enter your life. You will have built an impenetrable wall of defense to repel any destructive influences.

I wish I could say adopting these changes is a seamless and simple process; a switch to turn on and activate yourself. My journey, for one, hasn't been devoid of hiccups and setbacks. Having just started on my path to healing, with barely 6 months of seeing a therapist, I faced an unexpected challenge: an unwanted pregnancy. At first, I was drawn to the idea of being a mother, clearly spurred by my maternal instincts

and confident I wanted to have a child. Then fear and shame quickly swept in. I wasn't sure how I could face the reality of raising a child alone. My partner at the time was not interested in having children. The decision to not continue with the pregnancy was not an easy one, charged emotionally and fraught with anxiety. Once I reconciled that this was not the way I wanted to enter motherhood, I took the first step in the process of healing: the act of releasing, a deeply personal and spiritual endeavor. In this instance, I asked for the release of the pregnancy at this time and asked the Universe to welcome children back into my life once I was fully prepared, and with someone who was fully committed to building a family. This powerful Shaman exercise is one I have often relied on and tailored to any particular situation, even directing it to unwanted individuals who were bringing me harm, whether directly or indirectly. There is really no wrong way to conduct this exercise. Simply title a page *Things I Want To Release* and/or *Things I Want To Invoke*, list all the things in your life that you would like OUT of your life, and all those that you would like to invoke INTO your life, and (safely) burn the sheet of paper.

I know I'm far from having it "all figured out," but I feel immensely proud of the life I've created. My experiences coupled with the work I have done to improve myself, have taught me to never settle for merely what's in front of me, for that which is convenient and unchallenging. I can now say with confidence that I would never be comfortable "just going through the motions." Having persevered through extreme poverty, addiction, displacement, and hopelessness, I know that I can confidently take on whatever life may bring, the good and the bad. Although I have built a stable, beautiful life with my partner and our children, I am constantly reminded how my past impacts my present state. I have resolved that it has fundamentally shaped me, strengthening my spirit and giving me the gift of resiliency.

"You don't find the light by avoiding the darkness." ~ S. Kelley Harrell

CHAPTER 16

Go Big Or Go Home

BY CHRISTA PEPPER

"Flawsome: adj, an individual who embraces their 'flaws' and knows they are awesome regardless."
~ Unknown

CHRISTA PEPPER

WWW.BODYPOSITIVEPERSONALTRAINING.COM
IG: BODYPOSITIVEPERSONALTRAINING
FB: BODYPOSITIVEPERSONALTRAINING

Christa is the woman who wrote her bio, like a bad dating profile, she likes long walks on the beach (there really are no beaches in Nevada...) candle lit dinners (if only she could find the candles and matches at the same time? And really who has time for that? Just feed her already). She likes to travel... to the beach, and loves listening to music, any music, loudly and has no problem becoming a one woman band while driving - drums, air guitar, back up singer. She is the full package.

Christa found her passion for life, love, and herself, as she navigated through her own personal struggles in her thirties. Tired of faking it, rather than "faithing" it, she developed a sense of humor and her own authentic voice with the hopes to empower women to love themselves, right where they are in their own life journeys. Christa is a NASM Certified Personal Trainer and is the founder of Body Positive Personal Training - a brand which she hopes will inspire women to love themselves right now, instead of when they lose a certain amount of weight, or fit into that one outfit.

Christa believes that every woman has her own unique power - a voice, that is a gift to be recognized and shared. She knows life is going to give us lemons, from time to time. And she will be the first one to give you a hug, encourage you to keep going... with an added dash of salt and a shot of tequila.

I HAVE THIS PERSONALITY... a gift... we'll call it. See, I am that all or nothing person... you know, "Go big or, go home"? Yup, that's me, so when I screw up, I screw up MONUMENTALLY, when I do awesome, I do so in an extra sparkly awesome fashion. So, you would think when my husband and I made the decision at six weeks pregnant with our fourth child, that I would give up my retail management position for the glamorous home executive role, I would anticipate how far my all or nothing personality would take me, but I didn't....

I have always been that typical strong personality, go getter, work hard kind of chick, and I loved that part of me; trusty and reliable. I worked hard, and gave my all to my retail management world. For the most part, the women I met, the makeup I got to play...err... I mean, work with, to the girls on my team - I loved it. It was truly an experience that helped change my life. However, as time passed I started to become less and less infatuated with retail management. Split days off, long days, up and down schedules, oh and time off?! That was always a dreaded request! And my family schedule? The dozens of end of school year activities missed, the holidays the kids had off, and I didn't. My kids were in daycare sometimes until 9pm; and by the way, *Dear Boss, the kids have lice again,* yes, for the third time in two months... I need four days off. Something had to give.

So at six weeks pregnant with our fourth child, my husband and I sat down and decided it was time for me to shift into the enticing world of home executive. I was completely in love with this idea! *What a blessing! All those years of missed experiences with my kids! Mommy nap time?! Soap Opera's... do they even exist anymore?! Hmm... I must watch one, just to really delve into stay at home mommy land! A consistent gym schedule? Vacations with my family when I wanted?* Oh, the possibilities were endless! Hell yes! Two weeks notice of my resignation - signed, sealed, and delivered!

At first, the home executive world was awesome! Nap time happened frequently and often, hey, I was pregnant, so I absolutely did take complete advantage of that! Walking my kids to and from school daily, snow days meant a pyjama party with my girls, and *gasp* I even

cleaned the house consistently. I will admit, though I never did get to "Pinterest level" mom with rainbow colored pasta and such... I did pin it, though, does that count?

Life was great! My kids' grades soared, my husband was more at ease, and we got to really enjoy our time, being present and happy, I knew we had made the right decision for our family. Eight months later, our healthy little boy made his debut into the world, and how awesomely perfect he was. We were all smitten, and again that "go big or go home" side of my personality started to show up.

Babies are an amazing gift, and I have been blessed four times over, but it is not always rainbows and snuggle sessions. The sleepless nights, the nursing, and the pumping - I swear my couch had a permanent indent of my ass after the first month of his birth. That moment when you actually have an adult temper tantrum, tears and all, shouting, "That's it! I am taking a damn shower! And no one is going to stop me!" Those umm... conversations you have with the other kids in the vicinity and even your spouse, where you somehow miraculously channel Liam Neeson's persona, in *Taken*, "You wake up that sleeping baby... you best be running... I will find you. And. I will kill you!" Bless you Liam Neeson, who knew that he could portray the plight of us moms so accurately?!

As we all know this exciting, beautiful time moves at such a grueling slow pace, and you start thinking you've officially lost your mind. Thank you, Pinterest and WebMd for ensuring my suspicions lied somewhere between cancer, thyroid issues, personality disorders and postpartum depression. I began experimenting with "at home remedies" for "Honey, you are straight up losing your shit." The vitamins, the oils, the awful concoctions you drink in the morning, and finally I just decided to get my ass to the doctor. My periods were all over the place - here try this IUD to help get your hormones regulated - gain back thirty pounds, and no period. Can't lose that weight? That's okay, here is a prescribed pill for that - don't worry the side effects are only suicidal thoughts, and sleep issues, nothing terribly catastrophic... You know come to think of it, "You might have postpartum depression, we should set you up to see a Psychologist." At that moment, in that

cold, awful room, I sat there straight faced, on that hard table lined with noisy wrapping paper and calmly replied, "I think you might be right, however are you able to watch my four kids, so I can go discuss my feelings with someone for an hour or two?" My doctor was not impressed with my sarcastic response. But it was the truth of where I felt I was. Alone, in my struggle.

I went home that day, feeling pretty damned defeated. Postpartum was a bitch. I started researching it more and more. The CDC states that 1 in every 9 women suffer from postpartum depression (PPD), however, they have also acknowledged that it is not an accurate statistic as they know there is still such a social stigma in the treatment let alone the confession of, I need help. And honestly, I don't need the CDC's inaccurate and vague numbers to know what a mess we are in, I see the news, and read the stories of the moms who didn't receive the help they so desperately needed.

And now as postpartum issues set in, I began to question my VALUE as a woman, as a mom, and as a wife. Was my life really important? Did anyone even SEE me? How come, no one in my house ever noticed that; I did their laundry? How could they not see how shiny their porcelain throne was? Why did I have to point out what I DID manage to accomplish that day to my husband as he walked through the door? "Babe, did you see? I made the bed, today." or "Babe, did you see, I folded the laundry today?" That line of questioning became an everyday occurrence, one that felt degrading, and awful but it would just spew out of my mouth, unchecked, the moment my husband set foot in the house. Desperate and drowning, *Why couldn't my family see my value? Why did I have to beg to be appreciated?*

So after some torturous time passed, I started to really analyze what was going on, without the emotions. I was considered "obese" at this point in my journey... Yay, team - I had inadvertently found an unhealthy comfort to my emotions - food! It was always there for me! Depressed, lost, fat, and all over the place, a feeling in my "obese" gut, started to tell me, I was the only one that truly had the power to fix what was going on in my head and in my heart. I was the only one who

truly knew what I needed. So, a process began, I started to ask myself questions like, Who was I, B.C.(before children)? and what made me - Christa, happy? Outside of anyone else, outside of finances, kids, and the roles I played, who was I exactly? I began journaling again, for many reasons, one of them being that it was something that once made me happy, and slowly as it became habitual again it actually started to become therapeutic and insightful for me. And hey, even better! No babysitter required!

I started to come back to places in my youth, I was physically fit, healthy and active. Living that healthy lifestyle of sports and fitness had been my stress relief, my coping mechanism. I remembered my naive wanderlust of wanting to become a personal trainer on a cruise ship... and thought, *Well, I don't think that's in the cards, now, kids? What kids? But just maybe something even bigger than that was on the horizon.* At my "obese" size, I decided to do something for me. I was tired of throwing money at DVDs, meal replacement garbage, and pills that could literally kill me... so I jumped, I enrolled in my education. I invested into me. Now, I did come to terms with the obvious fact, that after four kids and extra weight, more likely than not, I would have to accept that the only six-pack that would be happening ever again, would be the one chilling in the fridge. And I was good with that. It wasn't really the weight that was the problem anyways; it was my heart that was broken, it was my mindset, it was establishing my value, my standards by myself, and for myself. I realized I couldn't keep begging others to acknowledge my value, because if I couldn't value myself, I had no damn business demanding it from others.

I certified as a personal trainer, specializing in weight loss and behavioral change. For me. To fix me. To help me. And I started my own processes of coping, of dealing, of growing, of changing. But then it hit me, how many other women were like me? Stuck in this awful space of self-loathing, depressed, messy head and heart space. Questioning life and their own value? My company was born, Body Positive Personal Training by an obese trainer. Oh the irony of it, right?! "Hi, I am a fat girl, but I am a personal trainer, and I want to help you

look and feel your best." So, I did what any sane woman would d o, I topped my shallow pride with some coconut oil – rumor is that stuff fixes everything and I swallowed it down, declaring, "Go big or go home, baby." I put myself out there, owning who I was, and I have to tell you, it was the best damn pill I ever have swallowed!

I stepped out and stepped up. And though I will probably forever be on a journey of growth, of physical transformation, and learning daily as to how to be the best version of myself, I admit I am really looking forward to where it all leads! I love where I am, and who I am now. And I am truly grateful that I survived my journey and overcame the entire process. Life isn't always sunshine and rainbows, but I now know that I really do have value! In. My. Own. Eyes. And you do too!

I know for certain that when women learn to finally step aside from our perceived limitations, we in turn become limitless. And some- times, they are not only perceived limitations, but there can be true underlying health issues occurring which could be sidelining us – please always consult your doctor if you suspect something is off! Seriously, hormones are a real live bitch!

Here are some of my tips for "Going Big":

1. **Listen to your instincts!** As women, those instincts are there to guide us, that little voice can sometimes be the only difference between life and death, let her guide you.

2. **Lose touch with her?** Journal! Every. Single. Day. Write whatever comes to mind, talk about how your day went, how certain situations brought on certain emotions, find a quote that moves you and journal to effect of the impact it has on you.

3. **Check your nutrition.** Keep track of everything you eat for a week, start analyzing your emotions before you eat, when you eat, and after you eat. Notice if there is a connection to certain foods aka possible food intolerances.

4. **Hydrate and move your body.** Seriously, put on some *Baby Got Back*, as loud as possible and get down with your bad self! Exercise doesn't need to be the "dreadmill," move your body in a way that's en-

I'M 30, Now What?!

joyable to you! A nice bike ride, a hike in the mountains, swimming at the lake, Zumba, whatever turns you on! Take the belly dancing class, rock climb, nude yoga - MOVE and hydrate! Water is the essential to life, you can live without food for weeks, water? Days. Drink it down! Infuse it with fruit, and every time you put that bottle to your lips, take 5 big chugs! Water helps regulate and flush the toxins, trust me you need this.

5. **Consult with a doctor.** Your doctor, and then consult with another, seek out holistic medicine to partner with - massage therapy, acupuncture, etc... You know deep down what it is you need, trust your own process.

6. **Give yourself grace.** Look we all want to be Wonder Woman all day, every day. But the truth is, you will get sunburned, or a flat tire before that important appointment, you will wake up, dragging ass, your kids will make you cry while you are locked in the bathroom hiding, welcome to life. It's crazy chaos, and you are doing the best you can, I know this. Now, you need to acknowledge this.

7. **Be your own best friend.** Okay, honestly, would you ever say out loud the things you are saying to yourself in your own head to your best friend? Most likely not! Remember that you are her - you are your own best friend. No one, absolutely, no one else, will know you better than yourself. So give yourself the love and friendship you would give to your greatest friends. You deserve that love.

8. **Set boundaries and time outs.** You know you want to get to bed early so you can hit the gym. What boundaries can you set up to accommodate that process? Have you possibly compromised your own values only to cross the lines in your own boundaries? Maybe to appease someone else's wants? Take time out, daily, 2 minutes, breathe, focus and come back to your center, draw those boundaries. Own them.

9. **Girlfriend it up!** Okay seriously, it is so easy to get caught up in our own mind, our husbands drive us crazy - they love us, but they just don't "get it." Whatever "it" is. Get some girlfriends together, go have some fun, do something crazy, women need other women to empower each other.

1⊙. **Faith it until you make it.** No one likes faking anything – friendships, relationships, orgasms... Think about it, when has faking anything ever worked out well for you? Except maybe that "headache" when your husband was making a pass at you, and you just wanted to sleep. Stop faking it. **This is your life, your masterpiece. Have faith that your progress, your journey are all working out in their own chaotic master-piece. Own it and faith it.**

Let me leave you with a little something. **This life you have to live is yours, and yours alone. That special gift inside you that makes you unique? It's there for a reason. Your voice is unique to you, and you have a gift to share - unapologetically, and completely transparently.** The moment you finally let go, step back and get out of your own way – that's when the magic happens, when life begins, where true relationships and friendships are waiting for you. So what are you waiting for? Go big or go home, girl, you've got this. I know you do.

SECTION 5

I'm 30, And I'm Just Getting Started

Featuring
Supriya Gade, Shannon Figsby, Lisa Mallis, Karem Mieses

OPENING COMMENTARY BY KY-LEE HANSON

Section 5 Opening Commentary
BY KY-LEE HANSON

WELL, NOW THAT *THAT* IS BEHIND US... or getting behind us, where are we headed? How are we furthering these opportunities into strengths? How are we going to lead our own lives on a positive note? This roller-coaster we are on - can we drive it in an upwards direction?

This next section is 100% motivation. These women are on the move. Every bump is just another opportunity to be stronger. We have the ability to venture down our golden brick road in the most forward thinking, goal setting, optimistic way, yet simultaneously knowing that we will have obstacles present themselves; not focusing on them or expecting them, but being aware and having gratitude for the moments of clarity. When we have awareness, we aren't blindsided and crushed when something doesn't go to plan. When we have gratitude for the good days and gratitude for the challenges which force us to grow, we become empowered to look things head-on and we can be our own Wonder Woman. Is there anything more powerful than a girl on a mission? You can be that girl, that woman; the superhero of your own life. Leave the weight behind, only taking strength from past pain, yet be humble and remember the lesson that was given to you, then good things will come.

This section is your how-to-do-"life" section! Karem Mieses shares with you what weight you need to come to terms with and rectify, and the weight you need to leave behind. Shannon Figsby, our resilient amazing fempreneur shares her feat, triumphs, and laser focus with you. Truly, it is motivating! Lisa Mallis shares goal setting, achievement, and how to move up while being humble and grateful - the best recipe! And lastly, Supriya Gade leaves us on a happy note through a whimsi-cal story of self talk and realization, and yes, more gratitude! Gratitude is often said to be the key to happiness and health.

CHAPTER 17

We Are Not Our Stuff

BY KAREM MIESES

"We only need so much to survive, but this world we live in tells us we need more stuff to be happy. We're inundated with our televisions, the internet and advertising that says in order to be happy you have to have these things. When you say, 'Gimme, gimme, gimme,' you will always be in short supply."
~ Wayne Dyer

KAREM MIESES

Karem Mieses is an international management consultant with a proven track record of success in process improvement, corporate profitability and new markets development. Since 1996, she has been helping companies optimize their resources and mitigate their risk using her diverse educational background and multicultural influence. Karem has the unique ability to align a company's vision with operational initiatives, enabling companies to achieve breakthrough results.

Nonetheless, after the birth of her third child, her life took a different turn for the sake of her health and that of her son. She developed a system to upgrade her life based on Six Sigma and project management principles she uses to help corporate clients optimize their performance. Her motto is, "If we can measure it, we can change it."

Sharing her applied research on how she lost fifty pounds sustained that transformation led her to start helping others dive deep into their own transformations. Since 2012, Karem has helped hundreds of people upgrade their lives through fitness, joyfulness, and habit management with her commitment to helping other parents attain a sustainable work-life balance utilizing duly researched no-nonsense strategies.

She has a bachelor's degree in accounting, a master's degree in management of science and technology, and has received several business awards for her involvement and initiatives in the business to business community, such as "Outstanding Women" in Puerto Rico Senate, "Most Wanted Business Women" by Business Puerto Rico Magazine, & "Top 400 locally owned companies" by the Caribbean Business Magazine. Karem enjoys training in her garage with her three boys to attend Spartan Races, screaming at Tae Kwon Do, and paddle boarding at the beach.

GROWING UP WITH EVERYTHING at your fingertips sounds like the dream; is it not? At least not to me, not when I had to become self-reliant and a magician at reinventing my life and start over from scratch at ages twenty-six, twenty-eight, twenty-nine, thirty-two, and thirty-eight. Yes, at thirty-eight years old, I had to start over, when I thought I had everything figured out.

My parents are smart professional people that honestly did the best that they thought they could to raise good kids destined to be professionals like them, and possibly become some stereotypical role models. My brother, sister, and I were raised with high standards of education, loyalty, commitment, discipline, and the absolute value of our words. Keeping your promises was, and still is, a big deal in our family. But as I grew up, and I can only speak for myself here, I also developed a sense of protectiveness and making things right. A sense that became deeply keen when at eleven years old, I was told by my mother that my father was cheating on "our family." The words were carved in my soul, "Your father cheated on us." It was heartbreaking to learn that my amazing, grander than life father had another "family." Is there a word for a man that has a mistress with two kids not that many years apart from my siblings and I? I remember that I did not judge, I did not cry, but this moment started a search for something bigger than what I was taught at this point. At that moment, I realized that I was not my family and a sense of detachment from my immediate environment emerged.

Fast forward thirty years, a friend asked me, "How can you keep going?" I asked, "What do you mean?"

He replied, "How can you pick yourself up so fast and just keep going? And on top of it, do all that you do so well?"

"That is a stretch of the meaning of well," I thought to myself.

"I don't know," I said, to which he replied, "Karem, you have a system for everything, you must have a system to detach!"

Hence started my quest to find a duplicable process that I could teach my team, employees, and kids where they could learn to let go and dust off things that hold them back, while focusing on what adds purpose and value to their lives. I have naturally come to find it easy to

start over, either because of an innate personality trait, or because of practice. I find the starting over process of anything accelerating. My left-brain started to work in overdrive because a pattern must have already been established. I did it once, and I did it over and over again. Since I only have a chapter to spark an aha-moment that could enlighten you into overcoming any challenges by becoming self-reliant and having a "just go for it" mindset, let's summarize the times I have started over and catapulted myself towards the next big thing in my life. Each one followed the same pattern to break plateaus, and utilized kinetic energy to bounce back to success; each time faster than before.

1) **We are not our family** - At eleven years of age, I discovered that I had siblings who didn't live with us.

2) **We are not our family's business** - At twenty-six years of age, I re-signed from my career path in my family's business, and moved from Puerto Rico to pursue a master's degree at Oregon Health & Sciences University.

3) **We are not our religion** - At twenty-six years of age, this Latin Catholic -raised girl moved 3,570 miles away from her country with the man who is currently my husband, and father to our 3 children against what my mother, father, siblings, friends, thought of me.

4) **We are not our job** - At twenty-eight years of age, after having a taste of working at a one of the big five CPA firms, my husband and I relocated back to Puerto Rico, and I decided to open my own strategic planning consulting firm because, if I had to start all over again, it was not going to be at another job punching the clock, and trading minutes for less than a dollar.

5) **We are not our career** - At thirty years of age, I made it! Or so I thought, my firm had billed half a million dollars its first year, gained recognition from the industry, and my family members were pouring in. I felt like I was the luckiest girl in the world (*side note: Isn't it ironic how lucky we feel when we work our backs to the bone?*). The joy didn't last four months. My father disappeared, and the family company was about to sink. My mom was about to lose everything she sacrificed

her life for. I decided to put my firm on hold because in my mind "I was just thirty," and I decided to take control of the family business to safeguard my mother's peace of mind and purpose.

6) **We are not our accolades** – In the three years that followed the unfortunate event above, I accomplished what many thought was impossible – reorganizing a local construction company that had USD 136 million in debt by using chapter 11 bankruptcy procedures. I received many accolades from the business community, and even the government. However, I was burned out and ready for an out. I ended up trading minutes for less than a dollar anyway, no peace, no flexibility, more bosses that you could have nightmares about, and I was just unhappy. I decided to move once again to the United States, and started my job hunt, because I needed a break from leadership. I wanted for someone else to call the shots. But I couldn't. The interview process became an excruciating deposition to explain, "But how come you are in a lawsuit for fraud against the bankruptcy court?" If I wanted to get a job, this thing that was a lie had to go down to the third page in the Google searches. **I realized it was up to me to make life happen for me, not against me.** In my determination to be employable, I needed new clients who would recommend me, and generate content that would rank in searches. A new plan of action emerged.

7) **We are not our businesses** – All my life, I defined my success by the titles I could have such as the car I drove, the places I lived, the parties I got invited to, the clothes I wore, the clients and contracts I landed, the people I hung out with, the destinations I travelled to, and the money I made only to discover that what truly matters is who we really are, how we feel, and how we make others feel. When my first boy was born, I was so worried about what daycare, school, and high school he was going to attend, and the places I would take him to see. I was again trading a minute for a dollar again, and it was not until my third and youngest boy was born that I decided to really live, love, and matter (as high performance expert Brendon Burchard emphasized).

The above is intended to give you a perspective on embracing life as a collection of ever changing events where we are defined not by our

abilities or circumstances, but by our choices. It does not matter how big or small that one event we are facing or have faced is, it is up to each one of us to release the pain and lovingly see it as a learning experience. Gabrielle Bernstein brilliantly describes obstacles as detours in the right direction in her book *The Universe Has Your Back* - these challenges are assignments to be lovingly accepted and completed so that we can learn, evolve, and grow stronger. **The faster we let go of our attachment to the feelings produced by unfortunate, unwanted, and unplanned events, the faster we can bounce back.** Approaching my life with this perspective has helped me move from one stage in my life to the next with a feeling of pure joy and success, and without any regrets.

As a strategist in process improvement and business optimization since 2001, I am innately inclined to think mostly with my left-brain, I intuitively map out what I need to do to get from where I am, to where I want to be. Therefore, I have a checklist for everything. As I transitioned from an education in accounting and management to entrepreneurship, there was always a map that I followed. Looking back, I've been teaching other entrepreneurs to morph their businesses in an ever-shifting economy to optimize their profits. **All those maps that I have used to advance in my life have a key denominator: detachment.**

HOW TO DETACH FROM THE OUTCOME AND WORK OFF A PLAN

A. **Inventory Of Current Assets** - We tend to focus on what we lack, or on our weaknesses. It is human nature to lean towards negative reinforcement to learn faster, because we are designed to survive. Therefore, fear is an emotion that triggers an immediate response to act.[12]

[12] Vaish, A., Grossmann, T., & Woodward, A. (2008). Not all emotions are created equal: The negativity bias in social-emotional development. *Psychological Bulletin, 134(3), 383–403.* http://doi.org/10.1037/0033-2909.134.3.383

This is why **it is very impactful to write an inventory of what we have, and what we have accomplished focusing solely on our strength.**

B. **Your Balanced Formula - Life does not have a one size fits all blueprint.** I have found through many courses, mentors, experts, trials, and errors that *IF* **we do not define what a balanced life is at a very personal level, then the chances of living a numb and unsatisfying life are greater.** Also, the frustration for lack of results seems to increase because we are not addressing the key areas that affect us most deeply. Many people fall into the trap of getting more books, courses, and coaches to get unstuck; and though, all the information collected might be golden, it may not be the right one to unravel the desired result. So, when I re-visit all the experiences above during an inventory of my life, I discover immediately that I am all pumped. I am ready to put a magnifying glass on the ten key areas of my life that make it whole and balanced. The exercise consists of rating from 1 to 1O (1O being in total control and rocking it, and 1 is total chaos and discomfort) your physical health, emotional health, environment, friends / family, romance, spirituality, purpose / career, finances, AND circle of influence / growth. It may feel tedious at first, but sometimes we must slow down to go fast.

C. **Key Priorities - Our key priorities are the key to unlocking our happiness.** Though they change as life changes, they are what we must work on right now to get everything else in balance. This is the place where we need accountability, and is the one area where we tend to score the lowest in the exercise above. For example, in my life changing events above, I could bounce back faster because I grabbed my key priorities by the horns. I didn't second guess what needed to be done, including asking for help or learning something new.

D. **Define A Clarity Statement** - Have you ever set goals or resolved on finally doing something that you knew was going to change your life, however, life happened, and it all fell through the cracks? I learned this boot-camp style while reorganizing my father's company under the chapter 11 bankruptcy code. **If you want to follow through, you must make some serious commitments.** This is when having absolute clarity on the importance of our priority is key to uphold the transformation desired. I call this statement my "North star" because it keeps me focused and

guilt free. To write your own "priority clarity statement," think about your key priorities identified in the prior step, and write an answer to each of these questions. The outcome is an affirmation that will guide you through the change process, and will help you to make the better decisions as challenges and opportunities present themselves to you. Start by writing *"I know that I am honoring [insert your key priority], when I [insert answer to questions below]"*:

(1) What activities need to happen?
(2) How would you feel?
(3) What do you need to do daily?
(4) What do you need to stop doing all together?
(5) What activity do you commit to doing, and how frequently will you do it to honor your key priority?

Here is my clarity statement as a guide to you: "I know that I am honoring the time with my family when I do not multitask while spending it with my children, or my husband. I will put the cell phone in a different room when we are doing homework, playing outside, or watching a movie. I commit to working on creative work from 5am to 6am and checking emails, social media and messages at lunch and at 8:30pm. When I honor my family's time, I feel in control and at peace."

E. **Accept The Imperfections** – Though the next step in this process is to decide on your goals, I will skip to a more important part: **perfection is an illusion, because it is defined by individual perspectives.** As Brene Brown teaches in her book, *The Gifts of Imperfection*, perfectionism hampers success since it is proven that it leads to depression, anxiety, addiction, and life paralysis; whereas, healthy striving allows us to set boundaries to lay down our shields, and pick our lives with courage and self confidence that we are sincerely doing the best for us at an individual level. Realizing that gives me peace.

F. **Get Ready To Let Go** – I take great pride in my plans because I pour myself into them. And if, after dedicating so much time and energy into something, things do not go accordingly, it's a hard pill to swallow. Many

give up out of frustration, or lack of understanding, or for not trusting in the process. However, those that stay on the ever-changing path to success, know that life happens while we wait for that one big thing to happen. **What I have experienced is that the doors to new and exciting opportunities open up when I am living in full gratitude for everything that I have now.**

"Success occurs when opportunity meets preparation." ~ Zig Ziglar

CHAPTER 18

Reinvention At 30 – It Is Possible!

BY SHANNON-LEE FIGSBY

"Our job is not to deny the story, but to defy the ending – to rise strong, recognize our story, and rumble with the truth until we get to a place where we think, Yes. This is what happened. This is my truth. And I will choose how the story ends."
~ Brene Brown, *Rising Strong*

SHANNON—LEE FIGSBY

WWW.ACADEMIEDEDANSEELITE.COM
WWW.STUDIO—COUTURE.COM

FB:@ACADEMIEDEDANSEELITE IG: @ACADEMIEDEDANSEELITE
@FITMAMASHANNON @FITMAMASHANNON
@WEARESTUDIOCOUTURE @SHANNYDANCER
FACEBOOK.COM/SHANNON.FIGSBY @WEARESTUDIOCOUTURE

Shannon knew from a very young age that she wanted to spend her life creating. Her formal education came in the form of a bachelor's degree with a double-major in journalism and communications from Concordia University, while also spending nearly twenty years training for a career in professional dance.

Shannon is now the proud owner and director of the nationally-recognized dance studio - Academie de Danse Elite Inc. in Ile Perrot, QC. Before her career as a dance studio owner, she worked as a professional dancer for many years, appearing in Montreal area stage shows, commercials and music videos, including the Montreal production of "Viva Casino." She is also a former professional CFL Cheerleader for the Montreal Alouettes Football Team.

At age twenty-nine, Shannon had her first child and endured an intense struggle to lose the seventy pounds she gained while pregnant with him. As such, she started a second company called Fit Mama Shannon, which centered around health and wellness with a specific focus on helping women, particularly mothers, become their best selves. Shannon knew she had a gift she could offer to women who may be struggling like she was as well. She now owns a third company - one that bridges her first two - called Studio Couture, a dance and fitness wear company.

Shannon truly believes that women can have, and do it all - as long as they hone in on what, exactly, it is that they want. Shannon lives in a suburb of Montreal, QC, with her husband, Chris and her son, Dublin, 1.

I AM THE GIRL WHO LOOKS GREAT ON PAPER. I am the girl who looks like she's not only got it all - but like she's got it all together, too. I am the girl who looks like she's gotten everything she's ever wanted.

A year ago, I would have agreed with that last statement. In the years approaching my thirtieth birthday, I truly had accomplished and acquired everything I thought I'd ever wanted out of life.

Then, I realized that everything I'd ever wanted wasn't enough. I was about to turn thirty. So now what?

Hence, in the thirty days before I turned thirty, I started blowing shit up. Not literally. You know what I mean.

Stay with me, I can explain!

For as long as I can remember, I have been a goal-oriented individual. Striving for more was a value instilled in me since before I can remember. Raising the bar in every aspect of my life was something I chased, almost obsessively, from an insanely young age. If you don't do it, someone else will, right? I had serious FOMO (fear of missing out) from the GET GO!

During my father's speech at my wedding, he recounted his oft-told tale of the exact moment he knew I was meant to be an entrepreneur. It was in the second grade, when I was in Mrs. Allison's class and I received a Creepy Crawler maker for Christmas. I was the only girl in the class with one, and I loved showing off the jiggly, jelly-like creatures that this critter-version of the EZ Bake Oven produced. Everyone wanted one, but I was the only one with the machine to make them.

Seemed simple enough to me - supply and demand, baby. I had something they wanted. I had an unlimited supply of goop at home. So I started selling them for $2. When everyone had bought one (or two), I started marbling the colors and selling them for a premium price of $3. They sold like hot cakes.

Just as I was brainstorming how I could up the ante, the school sent newsletters home informing parents that direct sales were NOT allowed in elementary school. Oops. Probably my very first #sorrynotsorry.

The thing was, my parents were proud of me, not mad at me. I had

been taught to test the boundaries of society, to push the envelope, to be the first to do something. I was one empowered eight year old. I knew that I could, literally, accomplish anything I wanted.

You're probably thinking, *This chick has the best parents in the world.* And I would agree with that statement completely. As an adult, my parents are two of my very best friends. But as a child, although that empowerment was such a gift, it also left me with this enormous feeling of pressure to be different, to be special and to be, well, perfect.

By constantly striving to be better, to get further, to accomplish more, I developed a complex of not being good enough, as is. I was always trying to create Shannon 2.0. Or, like, Shannon 175353.0.

Thus, I became really good at setting goals and smashing them. I rarely tried things if I knew I would fail. I was, and have always been an all in or all out person - there is no in between.

In grade seven, I knew I wanted to become class president by grade eleven. So I did. In grade ten, I knew which university I wanted to go to, and in which intensely exclusive programs to major in (yes, programs, multiple – I needed a double major or else I'd just be like everyone else). So, I hustled my ass off in CEGEP while most of my friends hustled at the bar, and I got in.

It was worth it. I was offered a position on the spot at the very first newspaper I interviewed at after graduation.

I wanted to become a renegade journalist by day, and a professional dancer by night, but I wasn't ruling out a masters in business or law. Although, my ultimate dream was to own a dance studio, I also really liked to argue. So I kept my grades insanely high, while lapping up internships and teaching twenty dance classes a week for three years straight.

It paid off. At age twenty-three, I opened my own dance studio after the studio I had been teaching at for four years pulled a fly-by-night close. I took another instructor at that same studio as my new business partner, and we threw together a business with a brick and mortar location in six weeks without taking a loan, private or otherwise, from anyone. We turned a profit our first year in business.

I also knew pretty much since birth that I wanted to be a wife and a mother as well, so I pretty much shunned casual dating unless I thought the male in question had husband potential, and didn't give a rat's ass about the snobbish reputation I had garnered when it came to men.

I got engaged at twenty six to an amazing man who is the ying to my yang, the low-hang to my high-strung. I got married when I was twenty-seven, was pregnant when I was twenty-eight, and had my son when I was twenty-nine.

Wife, mom, business owner, and all-around badass girl boss before thirty. Everything paid off. I got it all. Everything I'd ever wanted. Everything.

I had this one major goal, though, that kept eluding me. I wanted to leave it out of my story, but I can't, because it shaped such a major part of who I have become, so to gloss over it would be inauthentic. Someone once told me that whatever it is I am most afraid to write, go write THAT. Then the fear has no power. So here it goes.

For as long as I can remember, I had wanted to become a Montreal Alouettes cheerleader. A professional dance team, and not a "cheer-leading" squad, as the name suggests, these girls were everything I aspired to be as a child. Darlings of the city, present at all major charity events for the team and way beyond, insanely beautiful and known to be some of the most talented dancers that Montreal had to offer, I wanted, no, I NEEDED to be on that team. They were so special.

I anxiously waited for the day I turned eighteen so that I could audition. I prepared like crazy; took new classes, had new headshots done, bought new outfits and, practiced interview questions. The day of the audition came. Out of hundreds of girls, I was selected for the final round, which included the twenty eight girls who were on the team last year, vying to keep their spots from any hungry newbies.

I did not make the team. I convinced myself it was because of one of two things - I did not speak French well enough (I did), or I was too fat (I wasn't).

I auditioned the next year. I made the finals again. This year, though, I was determined not to let anyone know I was an Anglophone (as if the

name SHANNON wasn't a dead giveaway!). I answered the interview questions asked by invited judges from the media in French. And I did so, flawlessly.

Again, I did not make the team. So, in my head, it was definitely because I was too fat.

So I handled it like I would any other goal that I saw slipping away from me. I went drastic. I developed a raging eating disorder that would last until my husband and I decided to get pregnant, and impact many of my decisions and relationships in the years to come.

As I lost weight over the course of the year, I received SO many compliments.

I auditioned for the Alouettes again. I am nothing if not relentless.

I spoke English. I was myself. I made the team.

End of story, right? Wrong. Now, it wasn't about not making the team because I was too fat. It was about making the team because I was skinny.

Eventually my coach sounded the alarm on the issue. Of course, I vehemently denied having any sort of problem after receiving a phone call from her letting me know that she had been approached by some of my teammates who were worried about me. I assured her I was fine, and that I had many people in my life around me who would obviously notice if something was wrong.

I left out the part about my (now) husband already knowing and about the fact that I had been lying to him about being "better" now. Oh, and my parents, too.

Thankfully, after much help and work on myself and my soul, I am a healthy woman, with a healthy body and mind.

So, if you've stayed the course, you're probably wondering what this all has to do with turning thirty. It has everything to do with turning thirty. Because thirty to me meant one thing:

It is now or never. It's going to stay this way or it's not. But it's up to me. If I wasn't bold enough to design my own life, I could be damn sure no one else was going to do it for me.

The dress rehearsal was over.

After I gave birth to my son in November of 2015, a month and a half after turning twenty-nine, something inside me shifted. I was not okay with life as I knew it. And I wasn't OK with that, either. I did not have postpartum depression – in fact, I had the exact opposite. I had postpartum awakening.

I loved being a mom from day one. I loved it so much, in fact, that it made me question why, and how I had fallen out of love with so many other things that were so important to me at other times in my life.

In the early months of my son's life, we spent a lot of time nursing on the couch, and I spent a lot of time on Pinterest to pass the time. One morning around 4 a.m., I came across a quote, uploaded by an anonymous user:

"You are the author of your own story. Edit it frequently and ruthlessly. It is your masterpiece, after all."

Game changer. That was everything.

So I did a life audit. I examined my life pragmatically, at what was working and what wasn't, and analyzed the reasons for both. Based on this analysis, I - you guessed it - set goals.

The deep, fire in the belly passion I once had for my dance studio was waning, not because of my students or clients, but because of the deteriorating relationship between myself and my business partner. I felt undervalued and dismissed. Any progressive ideas I had for our studio were met with an underwhelming negativity. I felt stuck. I felt like I had lost my voice. I felt like I was losing my dream. So, that had to change. Not my business, but my business partner. Besides, I only ever took a partner because I didn't think I could do it on my own. I could. I can.

Part of the reason why I loved being with the Alouettes so much is because of the amazing people whose lives we got to touch through our charity work. I missed being able to make someone's day better. I didn't miss performing - I no longer sought out the validation of a cheering crowd of 25,000 that I once needed, but I missed the

interactions with the fans. I missed working with adults, even though I still love working with kids. So that had to change. Not the performing, but the ability to impact someone's happiness.

My marriage was suffering, and not just because of the stress a new baby inevitably brings. My husband has supported me through every single thing I have ever wanted to do in the nearly eleven years we have been together. But in doing so, he put his own dreams on the back burner. I'm not sure he even knew what those dreams were. I don't think I had allowed him the safety to dream, because he needed to provide the stability for our family while I was out there chasing all mine down with a pickaxe. So that had to change. Not my husband, but my willingness to take a back seat to his dreams for a minute.

My finances were a mess. Somehow, along the way, all this creating got really expensive, and a combination of poor decisions within my business, and my need for instant gratification landed us in a debt of nearly $50,000. So, that had to change too. Like, yesterday.

Looking at everything laid out like this, one thing became glaringly clear. It had been YEARS since I had a goal I was focused on achieving. I had become so complacent in my own life, that I became downright bored. I had nothing to strive for, so nothing to risk. **Without risk, there could be no bravery, no reward. And fortune always favors the brave.**

So, to put it formally, I officially started to blow shit up.

• Three months before I turned thirty, my husband and I had a serious heart to heart about what he wanted out of life. It turns out he had the same entrepreneurial spirit that I do. The next week, he applied to and was accepted into university for building engineering, with the goal of becoming a real estate developer.

• Two months before I turned thirty, I launched a new business, focused on helping postpartum women achieve their health and fitness goals. When you become pregnant as a recovering anorexic, you do not restrict yourself. I sure didn't. I gained an unhealthy seventy pounds that took a year to come off, but I did it. I knew I could help

other women do the same. And I knew I could make an income while making an impact.

• A month before I turned thirty, my business partner and I had a sit down discussion regarding our visions for the future of our studio and our partnership. They did not match. She suggested we go our separate ways, and I purchased the studio. I learned that it was okay to be ruthless in the pursuit of whatever it is that sets your soul ablaze. As long as you can live with your decisions, f**k what anybody else has to say about it.

• My purchase of the studio along with the income I was bringing in from my new business allowed us to get rid of our debt, in full, before 2017 began. This was one of the most freeing turn of events in my life.

For me, turning thirty was just the beginning. It was a time for glorious reinvention. For the first time as an adult, I felt like I could truly do anything I wanted to do, and be anyone I wanted to be. I could be ALL things.

Setting goals for yourself doesn't mean that you aren't good enough the way you are. It means that you value evolution, that you are constantly striving to better yourself, and to enrich your world. Seeking out all this life has to offer doesn't mean you need to be perfect. Trying to be perfect didn't work out all that well for me.

But being real? That sure did.

CHAPTER 19
The Motivation Proclamation

BY LISA MALLIS

"The road to success is not straight. There is a curb called failure, a loop called confusion; speed bumps called friends; red lights called enemies; caution lights called family. You will have flat tires called jobs. But, if you have a spare tire called determination; an engine called perseverance; insurance called faith, and a driver called willpower, you will make it to a place called success!"
~ Unknown

LISA MALLIS

PHOTODAY.IO
FB.COM/LMALLIS

Lisa is a wife to Rob, and mother of two daughters - Carly, 7 and Caitlyn, 5. She enjoys live music, kitchen dance parties, martial arts, cooking, singing, and playing guitar. She is also a diehard Jacksonville Jaguars fan, and just recently gave up her season tickets for annual Disney World passes.

Lisa Mallis's passion for the photography industry began eighteen years ago as a graphic designer at a small service bureau. She's worked alongside high volume photographers establishing new sales plans and workflow improvements. Lisa has also helped many photographers turn their unique vision into reality by creating marketing materials, websites, social marketing plans, products and by simply bringing new ideas to life. Lisa's strength lies in her amazing network of professional photographers and vendors. Her goal is to inspire and motivate photographers to achieve their goals through branding, networking, and sales training.

I RECENTLY READ A BOOK entitled *The Enneagram Made Easy.* It came recommended to me by my therapist. Ouch. Yes, I have a therapist. I like to refer to her as my life coach. After my first few months, she told me I was a #7. I had no flipping clue where she was going with that, hence, the book. So in this book, it breaks down the nine personality types of humans. Apparently, we all fit into these categories, and we can have traits from the neighboring categories. I really felt like this book explained life to me at the time I needed an explanation, especially at this point in my life.

I had recently switched employers after sixteen years. The very first thing I discovered at my new job was that there actually is such a thing as being too loyal. The next thing I discovered was completely frustrating and why I started therapy. I'll get to that by the end of this chapter. Let's talk about my "old job." I worked for a small, family owned company in the photography industry. I started out as a graphic designer. Then, I worked as a production artist in the studio. Then, I helped on various photo days at dance schools, leagues, in-studio sessions, etc. I went on to work for the sister company, selling digital cameras, printers, and software. After that, I worked for the pro lab selling services to professional photographers. Then, I ended up managing the lab sales and helping with the studio sales growth. After a couple of years and lots of growth, I ended up general managing everything, in addition to nearly everything else I just listed prior. I was completely overwhelmed, and I lost my sense of direction and purpose.

See, I once thought advancing your career meant carrying more and more responsibility. The more responsibility, the higher the risk, the higher my pay would go. But I was never satisfied. I was just, overwhelmed... every single day. Not to mention, I'm also a mother, wife, sister, daughter, and friend. There were never enough hours in the day for everything. As a woman in an industry which was predominantly male dominated, I yearned for the professional respect of my knowledge. I wanted people to call me for business advice, not to just hear my voice. I wanted to help them. My network was growing, I was listening to people's problems and helping them get through the everyday struggles.

Eventually I was so consumed with issues and solving them, I felt like my children were growing up without me. I had enough and just walked out of my career of sixteen years. It probably wasn't the right way to do things, but it worked for me. I stopped on the way home that morning and bought a sewing machine. It was October, and the school was hosting a fall festival with costume contest. My daughters both picked characters to dress up as and I couldn't find ready made costumes anywhere on the internet. So I decided to make them. I focused all of my energy on learning how to use a sewing machine. After about seventy hours and a couple hundred dollars I ended up with two cute pirate fairy costumes and two happy girls.

After the fall festival, reality set in. I had to go back and face the boss, and co-workers I walked out on. I was nervous, anxious, scared and upset - but I knew in my gut, this was the right thing to do. It was time for me to move on. So I did.

I waited a couple of weeks to start looking for another job. In the meantime, my colleagues and clients were calling me, wondering what happened. I never imagined so many people considered me an integral part of their business. I had no clue. NONE. They gave me a new insight on what I wanted to do with my career. With their support and advice, I started working for a smaller photo lab.

This environment was completely different. My new employer had been around much, much longer. My new boss has an impeccable repu-tation in our industry. During conferences, he introduced me to so many industry leaders and my network expanded even more. I'm definitely an extrovert, and combined with being a Virgo and a #7 personality type, I finally found my calling.

Let's talk about the enneagram for a minute. I strongly suggest learning about this if you haven't already done so. It explains why people do what they do, think how they think, and feel how they feel, according to their type. Ever since I started studying the enneagram, I have a better understanding of how to work with those around me not only just in my personal life, but also in business. My personality type is the enthusiast or adventurer. Just from reading the name of the

enneagram personality type, you can probably already understand why I've jumped around so much in my career. Have you ever felt stuck or misunderstood? Maybe you're living your life every day as someone you're not, or working a career you're not meant to be in. Finding the right path is knowing yourself and trusting your gut.

I knew I wanted to help people. I knew I wanted my job to be challenging. I knew I wanted to change the way things were currently being done in our industry to ultimately solve everyone's problems. So I stepped up to the plate and started researching everything and anything about our consumer, current workflow solutions, marketing methods, B2B (Business to Business) workflow, B2B2C (Business to Business to Client) workflow, etc. I talked to everyone I could, and gathered as much information as I could.

I was in Orlando at a brand new conference with 100 young (under forty) photographers. I came across this organization via Instagram. I was curious and I loved the passion behind it. I wanted to support it. There were only three vendors there.

It was at that conference in Orlando I learned the next generation of photographers were extremely passionate, innovative, and completely out-of-the-box. I started piecing my thoughts together. The previous six months I had spent preparing for our annual workshop. I decided to do a presentation on "Marketing to Millennials." It was the information that I gathered for my presentation along with my experience in the industry that led me to scarily predict the future of volume photography.

Being a mother of two elementary aged children, I receive Tuesday folders every week. Inside of the folders there's lots of paperwork: permission slips, homework review, calendar of events, and most of all, fundraisers. So many fundraisers... from books, to booster-thons, spaghetti dinners, PTA funds, local restaurant happenings, candles, cookies, and more. Historically, photo-day has always been the largest fundraising event for our youth. Today, it's shrinking, rapidly. Participation is down. Most people don't even realize making a photo-day purchase with your school or league benefits the organization more than the photographer! And it's going away! Less and less people are

purchasing, and why? Some say it's because of smartphones. Some say it's because the next generation of parents don't value photographs as much as previous generations. I say it's because it's a complete hassle for me as a parent to stop and get cash or fill out 145 microscopic boxes on a paper form to get my child's photographs, only to slice them up and have to purchase stamps and mail them all over the country to our transient relatives. That's SO MUCH WORK!

The idea popped into my head and I used Mel Robbins' 5-4-3-2-1 rule[13] to execute it. The 5-4-3-2-1 rule is this:

> *"If you have an instinct to act on a goal, you must physically move within 5 seconds or your brain will kill it. There is a window that exists between the moment you have an instinct to change and your mind killing it. It's a 5 second window. And it exists for every one. If you do not take action on your instinct to change, you will stay stagnant. You will not change. But if you do one simple thing, you can prevent your mind from working against you. You can start the momentum before the barrage of thoughts and excuses hit you at full force. What do you do? Just start counting backwards to yourself: 5-4-3-2-1. The counting will focus you on the goal or commitment and distract you from the worries, thoughts, and excuses in your mind. As soon as you reach "1" – push yourself to move. This is how you push yourself to do the hard stuff – the work that you don't feel like doing, or you're scared of doing, or you're avoiding. That's it. 5 seconds is all it takes."*

I got on the phone with one of my most trusted photographer friends and gave them my vision. Then Monday morning, I went to work and pitched it to my boss. Things started happening so fast from that point forward.

[13] Robbins, M. (2016, October 12). *The Five Elements of the The 5 Second Rule*. Retrieved from https://melrobbins.com/five-elements-5-second-rule/

I felt like I had cracked the code to the safe that's been locked for 100 years. But then all of my self-doubt started kicking in. *What if this is not a good idea? What if I am just too good of a sales person, and this idea is NOT good? Why am I the only one who thought of this? I can't be the only one... something isn't right. Me? I barely graduated high school. I never went to college. I moved 900 miles away from my family at nineteen and never turned back. There is no way I could ever accomplish this task.*

Nine months prior, I had an itch to learn something new. I started guitar lessons. I also started vocal lessons, even though I was always told I was "tone deaf." My instructor gave me the encouragement and reassurance that I was not tone deaf, and that I had a natural musical ability. I took what I learned to my presentation on "Marketing to Millennials," and got up in front of a room of thirty people and played and sang Nickelback's *What are You Waiting For?* I wanted to lead by example, and teach people it is OKAY to step out of your comfort zone. And it worked.

But I have the hardest time believing in myself to do so. Practice what I preach, right? This is where self-motivation comes in. Subconsciously, all this time, my entire career of feeling unsatisfied was my way of motivating and pushing myself to the next level. It is a gift that is inside of me. I didn't realize this until recently, and ever since I have, I reflect on it and listen to my gut with every decision I make.

That was the second most important thing I learned from my therapist. To listen to my gut. **Deep down, you already know the answer to every question you have. But you have to stop overthinking it, instead, just take the leap, listen, and go for it.**

So I did. I presented my crazy insane idea to some really smart people, and they all loved and supported it. I finally made the leap, I feel successful. Not financially, but personally. In the grand scheme of things, personal success is where it's at anyway, right?

I've never been more scared in my entire professional life than I am today, but I also have never felt so accomplished, appreciated, and heard. It's a wonderful place to be. I strongly feel if I keep pushing

forward and focusing on the positive, solving problems as they arise and using the 5 second rule to get myself over any hurdles, I will succeed.

Listen to your gut. Do what's best for you. Be unique and find your purpose. Your passion is your purpose.

CHAPTER 20

And Then, You Live

BY SUPRIYA GADE

"The two most important days in your life are the day you are born and the day you find out WHY." ~ Mark Twain

SUPRIYA GADE

BUSINESS CONSULTING: WWW.FOURDISCIPLINES.COM
PERSONAL COACHING: WWW.ROHITRAAMAN.COM

Supriya Gade is a professional by day, an artist by night, and a dreamer throughout. She is a physician by background, and is currently a doctoral candidate for the healthcare administration program with Central Michigan University. She has dedicated her life to empowering everyone around her to make their life better - one step at a time. In the professional sphere, she simply does it by helping to improve the quality of healthcare service delivery. In the personal sphere, she does it by being a big sister, a good friend, a loving wife, and just being herself through her blogs and poetries. She is a creative soul and has done some lyrics writing work in the past for a Bollywood album. She has also been featured as an author in *Dear Stress, I'm Breaking Up With You*, an Amazon bestseller for stress management in February 2017.

She was born into a typical, traditional, middle-class, Indian household where being a woman meant fulfilling societal norms at all cost. Moving beyond that paradigm and in true search of self-expression, she has established herself as a successful professional in the healthcare field. Her life journey has taken her from Mumbai to Houston TX, to Windsor ON, before finally settling down in Toronto, ON. Making the most out of her experiences and her expertise, she runs a business consultancy on the side helping non-profit organizations with their operations. She is also a co-founder of a personal coaching business that she manages with her husband.

An Indian by heart and a Canadian in the making, she embodies the essence of both - freedom and enlightenment!

MY THIRTIETH MILESTONE SORT OF ESCAPED ME. Mostly because I was busy uprooting my life from one country to another, getting married, and starting a new job. I don't remember ever reflecting on the feeling of being in my thirties. There was never a panic attack... until that day.

One fine evening, I was sitting on the couch relaxing after a challenging day at work and started browsing through magazines, and came across a silly survey. At the end of the questionnaire, it asked the reader to choose an age group. Amongst many other options there were "25 to 32," and "33 to 39". And it then just hit me. I have to choose the latter. *I AM IN MY THIRTIES NOW! Oh my god, when did this happen? And why have I never realized the gravity of it? Everything came crashing down in a second. Gone are the days of my twenties! I can't be that 'devil may care' person. Gone are the days of childhood innocence. I am an adult in my thirties now!*

As silly it may sound, it was an instant depression. I did not know how to react to this newfound sense of doom. I filled my wine glass to the brim, and sat on my favorite armchair looking out of the window staring into the horizon. I was completely happy with my life and everything I had done so far. But in these past years, I hadn't ever taken the time to reflect and realize what has gone past. *IS IT ALL DOWNHILL FROM HERE?* I asked myself. I looked at my potted plant on the end table. The lonely sunflower looking straight at the sun! No fear. "There is nothing to do, but waiting to be wilted," I said. Sadness filled my heart.

And then the doorbell rang. I wiped my moist eyes and opened the door. The figure standing in the door frame was extremely familiar. "Who are you?" Even before I could finish my sentence, the woman was already inside. As if she knew how to maneuver around my home, she went straight to the cabinet, got her a glass and poured some wine for herself. Taking a sip, she gave me a gentle smile. If she was some-one else, I would have dialed 911 by now. I was instantly taken back by her audacity. Is she a relative that I have forgotten? Why is she so familiar?... Before I could scratch my brains anymore, she took my both my hands in hers and said "I am you silly! I am a forty-five year old

version of you from the future." Aha! She looked exactly like me. She was even wearing the same jewelry that I wear - my mom's earrings and gold chain that she had given me years ago.

Ignoring my complete disbelief, shock, and surprise, she confidently dragged me near the kitchen sink. I knocked over my sunflower plant in the process. Not even allowing me to pick it up, she continued relentlessly, "Now go wipe this crying face you silly. Crying over something so stupid! I am here to get you out of this slump. I have three guests for you with some unique gifts. Hurry up." She stood there with one hand on her hip - just like I do!

I tried to grapple with the reality. It was a twilight moment. She was a spitting image of me - well, a bit older and more graceful one! This must be a dream. I wondered. My over-analytical and probably sleep thinking brain sneered at the power of its own imagination. Now, what's next – time travel? I decided to pinch myself to come out of this cha-rade. And just then the doorbell rang again. "Here come the guests," Forty-five-something-me said. This was getting so interesting. I decided against waking myself up to see where this "supposed" dream was going.

I opened the door, and there was a young girl with a shoe box, a teenager with what seem like broken wrist watch in her hand and a young lady with an old raggedy toy. This time it didn't take me a while to realize they were the five, fifteen, and twenty-five year old versions. And this time, I was not surprised. I could tell there was a theme going on in this dream. I invited all of them to the living room.

My youngest version handed me the shoe box which contained old pages of handwritten bill. "Do you remember this day?" she asked in her sweet voice. Indeed I did. When I was five, I had a fight with my best friend at the school. I came home crying. My dad was busy scribbling on the papers. I asked what he was doing. He said, "Paying bills."

"What are bills?" I asked. He went on explaining how water, elec-tricity, telephone, and TV, etc. are services that need to be paid for in money. And if one didn't pay, then one would not have nice things.

"So if I don't pay the money, then I won't have ANY-THING?" I asked a naïve question in a panic laden shrill voice.

220

"Well, that is not true," my dad chuckled and said, "There are some things in life for which you don't pay in money. You just pay in love and kindness. You have got me; you got your mom, and family. You have the great school, and you even have this best friend. Maybe you had a fight today, but as long as you pay her in love and kindness, you will always have her as a friend. Won't you like that?"

I took it to my young heart. I went to my room and made a long list of everything I had that I did not need to pay money for - which was basically everything I had at that age! I signed the bottom of the list with "Paid in love and kindness." I handed it to dad next day and said, "I paid my bills too!" Dad gave me a big hug and said, "Bills or no bills - you will always HAVE us sweetheart!"

That was the beginning of the realization of what *having* something in my life meant.

My fifteen year old version interrupted my reminiscence by clearing her throat for my attention, and then giving me a broken watch. "I hope you never forget this day," she said. Indeed, I hadn't. It was a summer afternoon. I was thirteen. Our family used to spend most of the month of May at our village home which hardly had any city amenities or stores nearby. As a begrudging teenager, I resented every second of it because I would rather spend my school vacation with my friends back home in the city. But trying to make most of it, I was actively preparing for a marriage ceremony that we were going to attend tomorrow. I had planned an elaborate outfit with every detail to its tee.

But guess what – my mom had rushed me into packing, hence I had forgotten to bring my red watch that went with my outfit along with couple other things. One more reason to be mad at my parents! I did not speak with my mom the whole day. Trying for the truce – my mom offered to go to a nearby store, which was a thirty minute bus ride away! Our village was quite remote. At the time, we did not have any phones. The way to commute was the rickety old government-run bus every two hours. I pretended as if I didn't care when my mom took the 5pm bus to the nearest city.

Now it was 8pm. My mom was still not back. My every other emotion

started melting. 10pm... 12am... still waiting! All of the family had gathered in the front room. My dad and uncle went on a search with a borrowed motorcycle. Nothing. It was as if someone had ripped my heart out of my chest. I cried to no end. I was never going to forgive myself. All for the need of some silly watch!

Finally, at 1am, a stranger dropped my mom off at the door. She informed us that her purse was stolen, and it took her a while to get help to find her way back. I hugged my mom in tears and loud cries. She said, "Hush now. Isn't this what you needed?" and handed me that new red watch. I was too emotional to realize the hint of mockery and sarcasm in her voice. All I remember doing next is hugging her even tighter and throwing that watch to say, "That is not what I NEED!"

That was the beginning of the realization of what it meant to need something in my life.

Bringing me back into the current moment, my twenty-something-version gently tapped me on my shoulder and handed me an old torn toy. She said, "You must cherish this day, every day for rest of your life." Indeed, I have been. It was a day during my medical internship. I was posted in the pediatric ward. Our attending professor wanted to provide us an exposure to all sorts of cases. In the morning, we would review all difficult cases, and he would then assign or reassign them to us based on our interest and need of the ward.

The internship was a very difficult time for me. I just could not connect with medicine as a physician. I always thought I was following my calling when I pursued medicine. But when it came to practice, I was frustrated over things that were beyond my control. I am a systematic thinker, and am better suited for solving large-scale problems. I was passionate as ever about health, wellness, medicine, and seeing the healthcare system change for the better. I just wanted to help people on a bigger scale. That is not said to diminish the jobs of doctors because we do need them. Today I have changed my profession, and I work in the home and community care sector in the capacity of a healthcare administrator. I ensure that care is delivered in a way that is meaningful to the patient. But coming to this side of the profession was not easy.

In that pediatric internship, I had a patient with suspected case of tetanus. He was a little eight year old boy. He would get involuntary progressive muscle spasms, and his body would contort to very painful and awkward positions. He was particularly sensitive to outside stimuli, which would trigger the attack. He was clearly not doing well and was on a copious amount of pain medications to keep him alive. One day I was on my night rounds. The boy was feeling okay and was speaking after a long time. He was in a controlled environment to avoid any stimulation to the body. While I was reviewing his chart, he pointed to his toy on the counter.

I explained that he needed to rest. He became very upset. "But I want to play, Doctor." I insisted that he sleep. "I am feeling good after a long time, Doctor. I may not ever feel this good again. Can't I just have a little fun?" I smiled and nodded a NO again. Then, he asked for his mother who was outside the room. I mentioned again that he needs to sleep with minimal distraction.

"Do you want me to get bored to death, Doctor?" He smiled, "Is that what you want, Doctor?"

I came to the ward next day. The boy had passed away in his sleep. Like mechanical robots - as doctors are supposed to be - I continued with my day with heaviness in my heart. I attended our morning case discussions. The attending professor started assigning cases. He looked at me saying, "Bed 32 - Epilepsy case - Is that what you want, Doctor?"

I got up and walked out of the room – is that what I WANTED?

That was a beginning of the realization of what wanting something in life is.

I returned to my current reality. My eyes were welling up with tears remembering these past events. I had come a long way! I have had many life lessons! The forty-five year old version of me took my hand in her hands and said,

"Dear girl, it has been quite a journey, hasn't it?

On behalf of all your future versions, I am here to help you step into this new wonderful life after thirty!

Everyone goes through this. The first decade of your life is spent figuring out what you HAVE. It's your parents, family, community, intellect, capacity - there is so much to discover about what you already have. Then in next decade, you shift your focus on what you NEED. These are things that are important to sustain you in this life. It can be love, relationships, money, career, adventure, and stability. And finally, the third decade of your life is spent in finding what you really WANT. It is what makes you complete - the purpose of your life. It could be as simple as providing for your family, or something a bit complicated such as making a difference in cancer research through working in a lab. These three decades are the building blocks to truly start your life. **Your life before age thirty is an exploration. And the life after you turn thirty is an application! Every decade henceforth, is reconciling what you have, what you need, what you want, and then expressing your true-self through it!**

For example, you are a very smart and caring individual. Intellect and empathy are what you *have*. You pursued an education in medicine and then business. The degree is what you *needed*. You would like to ensure that healthcare is delivered in a meaningful way in your profession. Making a difference at a systems level is what you want. Now, you get to connect all the dots together. Now, you get to design your life to match your true values. Without these values, you would be aimless today. But all that 'homework' is already done. **This is the most beautiful time to live. Feel proud that you are here in this decade."**

I didn't know what to say. I closed my eyes to soak it all in. My depression was gone. The world meant something. I felt complete. I felt energized to take on this exciting new chapter of my life. Slowly, I opened my eyes to thank the forty-five year old version of me - and I found myself on the sofa with a glass in my hand. There was no one around. The lights were off. The sun had set.

The twilight moment was over. I put my glass down - pondering on what had happened. I looked over at the end table. The sunflower pot was in the shambles on the floor.

I said to myself – *I'm 30 – now what?... err... wow that was something!*

IN CLOSING...

We Are In Our Thirties, And Finding Ourselves

BY KY-LEE HANSON

"The world will be saved by the western woman."
~ The Dalai Lama

KY-LEE HANSON

WWW.GOLDENBRICKROAD.PUB
IG: KYLEE.HANSON.BOSSWOMAN
FB: FACEBOOK.COM/KYLEE.HANSON

JOIN THE SOCIETY: WWW.GBRSOCIETY.COM
FB: GBR SOCIETY

BOSSWOMAN | VISIONARY | CREATOR OF OPPORTUNITY & MOMENTUM

Ky-Lee Hanson is the kind of individual who was glad to turn 30. She didn't even rewrite this to fit this book! She is a mature soul who gets the big picture and lives her truth. Ky-Lee enjoys people. She finds them fascinating. Her studies in sociology, human behavior, stress management, nutrition and health sciences has led her to have a deep curiosity and understanding of people.

Growing up, she had a hard time understanding why people couldn't seem to live the lives they dreamed of. Often thinking she must be the main character in a world similar to *The Truman Show*, because nothing seemed to make sense; she always saw things differently, and found it hard to relate to people. This ended up sending her into a downward spiral in her twenties, when she felt she had no choice but to settle. She felt suppressed, limited, and angry. Ky-Lee has the ability to hyper focus and learn things quickly. She has a power-mind and found the true strength of life through a serious health battle in her late twenties. Ky-Lee took control, and over the years, mastered how to get her power back. She discovered the best way to "relate" to people is not to, instead simply listen to understand their world for the uniqueness that it is.

Ky-Lee is a 3x best selling author, business mentor, and a successful entrepreneur. Ky-Lee has the ability to move forward in life to achieve what she wants. Her character is strong and sweet, meaning she

knows how to get what she wants in just the right tone, making her an impactful leader. She is not afraid to be who she is nor to take on new challenges. Bold and charming, her energy pulsates to others and encourages people around her to move forward with her. Ky-Lee has an open-door policy she learned from her mom, a listening ear, and an opportunity to lock arms and take you down your Golden Brick Road.

WOW! WHAT A RIDE THIS BOOK HAS BEEN! Isn't it amazing to see how individual and independent we are or CAN BE in our thirties? Yet, we all seem to be connected with the same wants and desires for freedom, choice, change, and equality. There really was no guide book (until now) for this generation. I've always considered my generation to be the lost generation and if you remember from the introduction of this book, that was ingrained into me as a child - what a horrible thing to tell a child. I remember in grade 7, I felt a sense of doom. I felt hopeless. We were told that we were the worst class and would not achieve much. There would be no jobs for us unless we create them. How true this became though? Some accuracy. A study from 2015 states, *"...fully 78 percent of adults agreed that: compared to earlier generations... it is currently harder 'for young people today' to get started in life."*[14] Forbes reviewed the study and concluded, *"...even baby boomers agree that it's much more difficult to start a career these days. This is due to a variety of different factors; the price for a college education is higher than ever, yet college education is a practical necessity to enter the job market, the economy suffered a tumultuous crash less than a decade ago, and there's a wider skills gap for workers, making it harder to find an entry point."*[15]

During the economic crash of 2008, our authors were in their twenties. On top of regular coming of age things, we were concerned with an increase of cancer and seeing a world war unravel in front of us, all while trying to keep up with the first-ever seen technological changes. Not to mention - while graduating from whatever post secondary institution with what money we could crumb together, we were hit with the economic crash of the century? Ugh. We had two choices as I mentioned earlier in this book; dream or settle. Although, I don't fully

[14] Brownstein, R. (2015, June 11). *Even Baby Boomers Think It's Harder to Get Started Than It Used to Be.* Retrieved from https://www.theatlantic.com/business/archive/2015/06/even-baby-boomers-think-its-harder-to-get-started-than-it-used-to-be/395609/
[15] Alton, L. (2016, December 22). *Millennials Are Struggling To Get Jobs - Here's Why, And What To Do About It.* Retrieved from https://www.forbes.com/sites/larryalton/2016/12/22/millennials-are-struggling-to-get-jobs-heres-why-and-what-to-do-about-it/#4ff435c54bb0

agree with how *Forbes Magazine* interpreted the generation and why they (we) can or cannot get work. What we know to be true is, times have changed. There is the entrepreneurial uprise and elder employers need to get with the times or, we will just do it ourselves because we are THAT generation for leadership and change.

Gen Y and Millennials want work-life balance and do not want history to repeat itself. We believe in diversification, equal rights, a healthy earth, compassion, and choice. We are sponges for knowledge and change, and have found learning from each other and various cultures to be a win for society. We are the social sharing generation and those younger than us have taken that to an all new level. Here in Canada, the unemployment rate of Millennials aged twenty-five or under, is more than double than that of the general population.[16] For those of us in our thirties, the Gen X-er's and Gen Y-er's and... "Millennials" and "Xennials," we need to lead and help mold the younger generations that are being told they are "selfish" and "egotistic." We should encourage the side hustles and the entrepreneurialism; we should encourage change. We should listen to our peers and the younger generations with an open mind instead of following the elders and blanketing them from a sense of fear instead of aiming to understand. We have a bit more "life" experience and the ability to lead, so let's use it. We were around for the change; we grew up without the internet, yet created internet jobs! How cool is that? We are resilient and adaptable; we are capable - maybe even more so than our elders. Why not own that? Why not use it to better society?

Our generation is doing just this, our authors are doing just this. We understand a world of leaders is better than a world of followers; if only all these leaders can respect each other. In history, the goal was to fall in line, work hard, do an honest job, and achieve some peace. I think for our generation, we are shaking things up. We want to make waves and see global peace. We have the power to do that. This is OUR time ladies. I have heard before that empathy rarely extends past those one personally knows. This is utterly depressing to me, but I know it is true for most of history. People have been glad, "At least, it didn't

happen to me." I so deeply feel our generation thinks differently. I *feel* on a global level, and I know many of the women in this book and in this generation do as well.

We CAN leave the past behind, yet never forgetting it, and bring about a new future. A better future. We create our own happiness through self-care and we create peace through sharing education, being open minded, and aware. If we each do this, and inspire a handful of people, we have collectively made great positive change. There is an old saying that if each person would just look out for one other person, we would all be taken care of. What if we start with just taking care of ourselves to the utmost best? It comes down to this – we all want the same things in life and if we all live positively, doesn't that rub off on others? Aren't we maybe then getting somewhere good?

Amaryllis Fox, a former undercover CIA agent graciously shares with the world, that this is in fact, true. At the core, we all want the same thing, peace, and safety for our loved ones.[17] I truly agree with the Dalai Lama when he says that women will save this world; I believe that with the sense of awareness and compassion our generation has, it will change the world. Not that men will play no part in this, they in fact will, but it will be with our leadership that men too can shine in a whole new light. It is time for women to lead, love, and nurture this earth. That responsibility falls on our generation, and there is no other responsibility I would want to have.

I have always had a burning passion, a mission you could say, to change the world. I have written about this desire in my books in the past – knowing what a challenge and audacious goal it is, but I have never doubted for a second that I would be a part of this great change. So what can we do, as women?

[16] Statistics Canada. (2017, March 10). *The Daily: Labour Force Survey, February 2017.* Retrieved from http://www.statcan.gc.ca/daily-quotidien/170310/dq170310a-eng.htm
[17] King, K. (2016, June 10). *Everyone Is Sharing A Former CIA Agent's Message To Americans.* Retrieved from https://www.buzzfeed.com/kirstenking/everyone-is-sharing-this-former-cia-of-ficers-message-to-amer?utm_term=.vr7QomGlx#.telyj3DrZ

WE CAN LOVE OURSELVES AND OTHERS

A happy woman is a happy family. Women have the ability to extend family past blood. We, at heart, see equally and see all potential. We are naturally optimistic, loving, kind, and nurturing. We can nurture and inspire the goodness in, or into people.

There is talk about women aged forty to fifty being ageless. *The Telegraph* has an inspiring article on the subject.[18] So, what about us "thirties" then? Are we meant to reverse time - to heal time? To change it? How I interpreted the article from *The Telegraph* was, the common thing that jumps out to me is - purpose in the sense of fulfillment, being needed, enjoying life; "living" over wasting away and "aging." Furthermore, "middle aged" (a term soon to be obsolete) women are still active, spontaneous, and living. They are involved in their career and their families' lives. There is a need for them; they *feel* needed. I am quite a spiritual person and the more I embrace it, the more success comes my way, and the more confident I become in myself and my mission. I do the best work when I am most connected with my energy. I enjoy watching programs on Gaia.com, *yes some of it you need to take with a grain of salt*, but it opens your mind to possibilities. The series *Missing Links* speaks of cultures that truly do seem ageless. Women being active well into their nineties, and even the hundreds! The common connection is compassion. They have been grateful for their lives, they are compassionate to others, they feel needed and fulfilled here on earth by family, but also by their community just like the modern "ageless 40-50 women." As I have said previously in this book, we can have purpose and be motherly also to those who are not related to us by blood. There is no one single thing that is going to fulfill us or make us feel identified. Curiosity and involvement is the key to happiness; having a "purpose"; having interests and a mission. Happiness is the key to being ailment-free and living in a youthful way.

[18] Hardy, L. (2017, July 07). *Why women of 40 and 50 are the new 'ageless generation'*. Retrieved from http://www.telegraph.co.uk/women/life/women-40-50-new-ageless-generation/

The ageless people they talk about in these studies and documentaries are female, for the most part. We give life in more ways than one. We facilitate it, we encourage it, we extend it. I recently went to a comedy night where the male comedian was making fun of how men complain about women making them clean up, do better, etc. He said, "How dare this woman try to keep me alive for longer and living better!" Jokes, but how true though.

WHEN WE LOVE, WE LEAD

When we are passionate and compassionate about subjects, there is no stopping us. We will stand, we will rise. We will research, listen, share, and educate. There is nothing stronger than love. As women, we just need to identify what we are working towards and run with it, and I tell you again, our generations purpose is: change and choice. To allow people to have choice. We are choice leaders! My mission is to inspire women to lead, to be positive change - to heal society and our earth. And we are doing so. My community has come together in such a collective way and used our past pain as inspiration and our survival as the strength to persevere. Our books have been a great way to facilitate this and help us grow into our mission. We are just getting started!

I am so pumped right now to be writing this and have you read this. Our energies, I can feel it connecting, and my mind and heart is open to all the possibilities. As I write this the clock displays 12:12. Ask Angels website says, *"1212 is a message to stay optimistically focused on your highest possible future, and a reminder that your angels are supporting you in manifesting your goals, dreams, and life purpose. It's also a signal that you're on the verge of a positive change, or things in your reality have already shifted in a positive way." Spritualunite.com states, "...1212 signifies a dramatic leap in evolution..."* How fitting, right?

We have covered self love, love for others, and purpose. How do we put this into action?

BEING A BEACON FOR CHANGE

Becoming motivated stems from a place of fear and urgency. You can read more on this in the last chapter of my book *Dear Stress, I'm Breaking Up With You*. We create our own motivation as well as momentum. Now, gaining momentum is different. This is a practice of continuing to move towards the desired outcome. We are the only ones that can create this in our lives.

We have to lead it. Others may or may not get on board, but we need to continuously focus on the path even when it feels no one is seeing us or following us. A leader will persevere even if they are only leading themselves.

How to do this:

- **Be "attractive."** Not in the sense of looks (although hygiene and your brand image are both important!), but in your energy. Further subjects of studies I suggest are *The Law Of Attraction, and Attraction Marketing*.

I have an online platform that facilitates this kind of education though an academy like community: www.grbsociety.com

- **Don't push or preach.** Be inviting, listen and explain. Do not debate with people.

- **While being inviting: listen, relate.** Be welcoming. Use your womanly empathy in a proactive way instead of letting it get the best of you. Listen to understand; instead of listening only to reply. I have been told that I am great at "holding space" for those I communicate with. Some share their message to a large audience and some more 1on1; I practice 1on1. Whichever feels best to you, is how you should deliver your message. *More* people does not always mean bigger impact, so do not let the lack of audience or your preference to smaller groups, limit you.

- **GIVE.** I know it to be true that giving to others brings you everything you need. Giving time, attention and support is something very highly respected by the right people. Giving money is something I do less frequently – it has to be given in a way of empowering. I just gave money to build a library: this is a good example of giving money.

Money is an energy and can at times have a negative effect on the relationship depending on the transfer; people can be made to feel less than, inadequate or useless by receiving something for essentially nothing. From another side of giving, I do not believe in giving away a service for free. What are you getting in return? Again it has to be a transfer of energy. If free from money, maybe you are getting experience, helping out a good cause and getting satisfaction and experience back that way, but you aren't helping anyone if it is a client relationship and you are giving them something for free. The product or service is often less respected, not always but often. Make sure you give to yourself first, so you have enough inside you to give to others.

- Stay relevant. Look at different ways you can share your message and do not get discouraged when something does not work the way you wanted it to. Take it as a learning lesson. Everything we do can either build us up or break us down. It is up to us how we utilize the lesson in the experience.

At all stages of your journey to inspire others and become a choice maker, most importantly remember why you are doing this; you are ultimately doing this so YOU can live in a better world. Create that world. Don't give up on yourself. The above tips not only reflect externally but need to live inside you. Inspire yourself first and foremost. Pat yourself on the back. Be prepared for the hardships and calmly move through them, learning from them and know that you can gain strength from it. You are the beacon, so nature yourself.

I cannot stress it enough; people judge on actions, not on intentions. You MUST share your progress even if it feels uncomfortable or as if you are "bragging." I struggle with this sometimes yet, the right people will be inspired. Your purpose must be loud and clear. It has to be so deeply connected to your morals and beliefs that you truly live it. There is no on switch for purpose, there is no on switch for success. They are intertwined and it has to be genuine. You must "live a life of purpose" and have a clear understanding of what that means to you. When you make sharing progress a habit, it naturally requires you to

check in with yourself and see what you have or have not achieved. When you analyze and observe yourself and situations from an outside perspective, you will become strategic with your next steps instead of judgemental.

Self reflection and self guiding is not hard. It is actually the most rewarding practice; *I find*. Just make sure you give yourself the respect you deserve. Be honest and humble with where you are at and what is important to you. Have you stumbled off your path? Could you be moving quicker; could you be doing more for your purpose, mission or cause? Could you be doing more for yourself to be the choice leader your community needs you to be? Are you helpful, are you strong, are you resilient? If not, don't beat yourself up about it or dwell on the past, just discover how you can become. Follow people that are where you want to be. Even though you are a leader, let others lead you in what they specialize in. Admire yourself and admire others. Be open, positive and stand tall, while also supporting others. It is the best recipe. People are going to test you. People will not trust you at first; remember that whole "action over intention" thing I pressed on earlier... Many people think everyone is out to get them, *sigh.* You will face negativity and you will get knocked down – but if that didn't happen, life would be so boring, right?! And how else would one grow? We need to experience the problem before we can become the choice maker with the solution. Take it for what it is – a lesson.

Remember, nothing can stop a woman on a mission; everything either supports her, or she *will* get through the obstacle and come out stronger.

ACKNOWLEDGMENTS

Thank you to all the women out there that have defied the stigmas of aging. Thank you for living life to the fullest and always reinventing yourselves. It is inspiring. ~ Ky-Lee Hanson

Thank you to Nigel for supporting and believing in me and all my crazy projects, and to Ethyn and Freya for always being my #1 inspiration! ~ Nicole Singh

Thank you to my amazing husband for being my biggest supporter in all that I do, and to my parents for always believing in my wild adventures (or at least pretending to). ~ Chloe DeVito de Concha

A BIG thank you to my husband for always supporting me and to all of my family and friends who have helped me in this incredible journey of getting to know myself better. ~ Amy Rempel

Christan: Your light in my life has raised me to another level. Thank you for always being in my corner. ~ Kelly Rodenhouse

To Alexander, Max, and Andres, the best teachers that the Universe could have sent me to become self reliant. ~ Karem Mieses

To my husband for always believing in me, even before I see and believe it in myself, and to my beautiful children for giving me the reason to live. ~ Jessica dos Santos

Ennis, thank you for always being my rock. ~ Nichole Cornacchia

For my husband Jonathan, thank you for loving me the way you do. I'm forever yours. ~ Jessica Gardner

To Greg, for your endless love & support and to Ethan & Matthew for being my why. ~ Kim Santillo

For all my fur-kids (past, present, and future) - you give me happiness and joy everyday, and to James, for being part of Team High Kick with me. ~ Erin Filtness

I dedicate my chapter to each one of my four beautiful children may they always persevere in the face of adversity. ~ Saoirse Kelleher

To all the women who feel alone in your journey, please know you are not! ~ Christa Pepper

For Eric, Blossom, Jen, Gary, Sidi, Ruth, Wendy, Erin, Tiny, and everyone who ever helped me (that includes YOU, everyone I've ever met) ~ Katie Rubin

To my parents, thank you for making me who I am today. Forever indebted and always grateful! ~ Supriya Gade

Okka, thank you for never letting go of my hand, you are my rock. ~ Andrea Lampe

Thank you to my mom for always loving me unconditionally, to my friends who've always supported me and who make me a better woman, and to all my mentors for pushing me to achieve. ~ Natasha Manchester

To all of you, who believed in me, my loving family and true friends. ~ Boryana Hristova

For my husband Chris, my son Dublin and my family. Thanks for taking the long way 'round with me. ~ Shannon Figsby

To everyone who has supported my crazy self along this journey, and especially the team at Snapshots for making the "impossible" possible. ~ Lisa Mallis

A special thank you to Lauren Rotondo, without her support I never would have written my chapter. Actually let's be serious here: without her I don't think would I have survived the craziest days of my life as "sanely" as I did. ~ Sherri Marie Gaudet

Goals, Brilliance and Reinvention

Join us at the social

www.gbrsociety.com

GBR Society is a safe space to bring everyone together (authors, future authors, readers, and supporters) in an academy-like setting; making social media a productive tool focused on practical learning, growth, and friendships. Think of it like a super positive and intellectual online sorority house. Join us and create positive friendships as you flex your skills and learn new ones.

We take part in many charitable events, host retreats, and focus on making reading and self-development cool and fun. See you at the social!

Golden Brick Road
Publishing House

Locking arms and helping each other down their Golden Brick Road

At Golden Brick Road Publishing House, we lock arms with ambitious people and create success through a collaborative, supportive, and accountable environment. We are a boutique shop that caters to all stages of business around a book. We encourage women empowerment, and gender and cultural equality by publishing single author works from around the world, and creating in-house collaborative author projects for emerging and seasoned authors to join. Our authors have a safe space to grow and diversify themselves within the genres of poetry, health, sociology, women's studies, business, and personal development.

We help those who are natural born leaders, step out and shine! Even if they do not yet fully see it for themselves. We believe in empowering each individual who will then go and inspire an entire community. Our Director, Ky-Lee Hanson, calls this The Inspiration Trickle Effect.

If you want to be a public figure that is focused on helping people and providing value, but you do not want to embark on the journey alone, then we are the community for you.

To inquire about our collaborative writing opportunities or to bring your own idea into vision, reach out to us at *WWW.GOLDENBRICKROAD.PUB*

IG: *@GBRPULICATIONSAGENCY*
FB: *@GBRPUBLICATIONSAGENCY*